GOTHAM KNIGHTS

THE OFFICIAL COLLECTOR'S COMPENDIUM

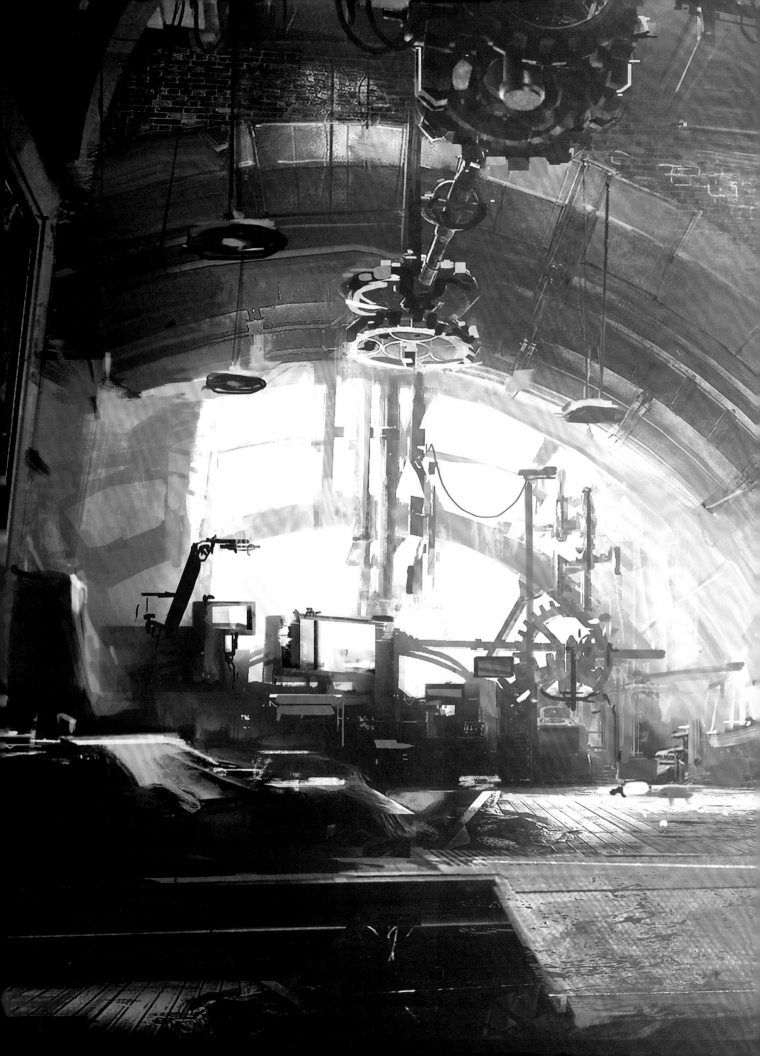

GOTHAM KNIGHTS

THE OFFICIAL COLLECTOR'S COMPENDIUM

MICHAEL OWEN AND SEBASTIAN HALEY

INSIGHT
EDITIONS

SAN RAFAEL · LOS ANGELES · LONDON

CONTENTS

 01

 02

 01

 02

PROCESSING

863

OK

ELAPSED TIME || 02:00:15:46
L.C.L. LEVELS || +000002465.6

FOREWORD

Someone once said, "Every game that releases is a miracle."

This was originally stated in reference to the incredible complexity inherent to any game development project. The constant balancing act between technological constraints, creative, artistic, and gameplay visions, storytelling, player agency . . . as well as, at least in the AAA games realm, the coordination of hundreds of people contributing to the game. Thousands of moving pieces that require perfect alignment in order to form a coherent whole and finally, when they all fall into place, a unique and memorable interactive experience. And I wholeheartedly agree that there is something miraculous in this process.

But flipping through the pages of the book you now have in your hands, this quote suddenly resonates with me in a whole new way. The miracle, to me, is in the sheer number of incredibly talented people who embarked on this journey to create *Gotham Knights* and poured their hearts and souls into it.

We wanted this compendium to be a combination of an art book and a strategy guide. But I hope that while you go through it you'll be able to discern, woven in between the lines and pictures, that it's also telling the story of this incredible journey we embarked on as a team years ago, when we set out to kill Batman, create a whole new Gotham City, and bring to the center of the stage—tasked to save and protect it—those heroes that had been so far relegated to the role of sidekicks.

While our game is about one of those heroes—*your* hero—rising to become the new Dark Knight and taking on the mantle of the Protector of Gotham City, a lot of it is also about family, human connection, collaboration, and mutual support. It's about growing together and being stronger as a team. It's about the family that you choose.

So I want to dedicate this compendium to the *Gotham Knights* team, and I would like to ask of you, reader, whenever you read this book, or play our game, to try and keep them in mind. Some of them might be obvious to you, as they figure prominently in this book: all the artists whose work is displayed in those pages; all the writers who gave depth and meaning to our heroes, enemies, and allies; all the designers who crafted the plethora of game mechanics, crimes, missions, and boss fights; all of them guided by a wonderful team of directors sharing a common vision for *Gotham Knights*. But, out of the spotlight, there are so many other people who contributed their talent and dedication to making this game. Animators, technical animators and programmers, audio and technical designers, lighters, textures, VFX, UI and technical artists, testers, producers, and performers, all of them combining their strength, day after day, striving for excellence and pushing through despite the numerous obstacles on the way (not the least of which was making a game involving the collaboration of hundreds of people during a global pandemic).

Leading all of them was the greatest privilege of my entire career as a game developer.

Every game that releases is a miracle, made possible by the hard work, dedication, talent, and collaborative efforts of amazing people. This book is a collection of evidence of our own miracle. I sincerely hope you enjoy it.

Fleur Marty — Executive Producer

7

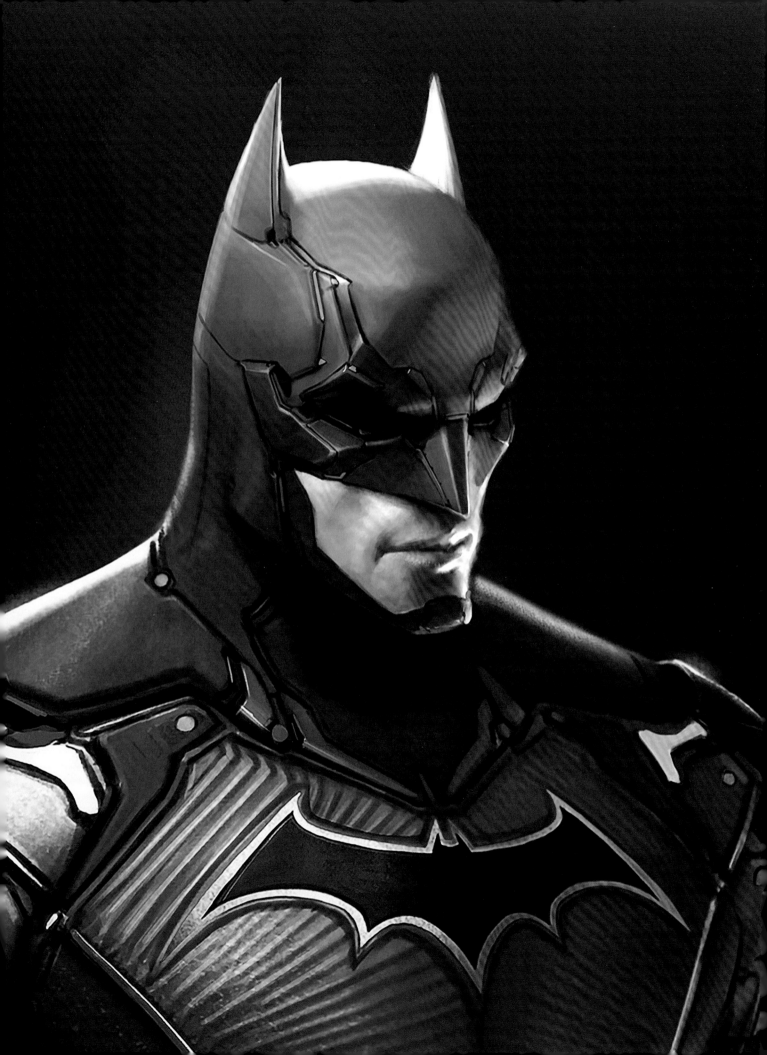

PICKING UP THE MANTLE

Batman is dead, leaving Gotham City without its protector. Sensing its vulnerable state, criminal factions have moved in on the city. Fortunately, the Dark Knight prepared for this day. Setting his contingency plan in motion, a Code Black message is sent to his prodigies: Batgirl, Nightwing, Red Hood, and Robin. With help from Alfred and Batman's extensive resources, the Batman Family must come together to defeat the new criminal element in Gotham City.

In *Gotham Knights*, you play as the four heroes in an open-world, action RPG. Continue Batman's investigation into Dr. Kirk Langstrom, and dive into the dark underbelly of Gotham City.

This book is designed to not only help you face the mean streets of Gotham City, but to provide a behind-the-scenes look at the incredible creativity that goes into creating such a groundbreaking, unique take on the Batman universe. Explore the stunning concept art and hear from the talented minds behind the project, all while learning to take your place as the next Dark Knight.

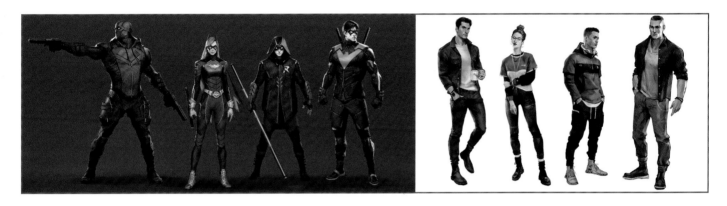

GOTHAM CITY

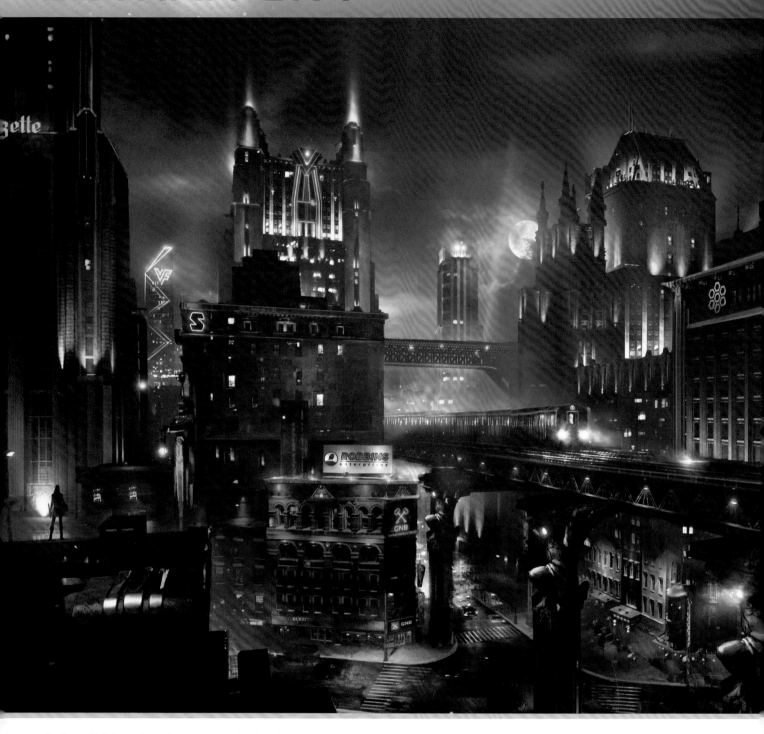

Gotham Knights takes place across the five boroughs of Gotham City: from the hustle and bustle of the Financial District, down to the industrial Lower Gotham, up to academic and mysterious North Gotham. Crime is rampant throughout, and the GCPD is unable—and sometimes unwilling—to keep up. It's up to the Batman Family to bring order to the city from their centrally located headquarters, the Belfry.

LEGEND

1	Gotham City University	12	Tricorner Island
2	The Belfry	13	Wayne Enterprises
3	GCPD	14	Arkham Asylum
4	Blackgate Prison	15	Gotham City Cemetery
5	The Iceberg Lounge	16	S.T.A.R. Labs
6	The Orchard Hotel	17	Quartz Engineering Labs
7	The Powers Club	18	Elliot Center
8	Gotham Gazette	19	Monarch Theatre
9	Chelsea Tunnel Construction Site	20	Gotham City General Hospital
10	Gotham City National Bank Building	21	Dixon Docks
11	Kane Bunker	22	Gotham City Reservoir

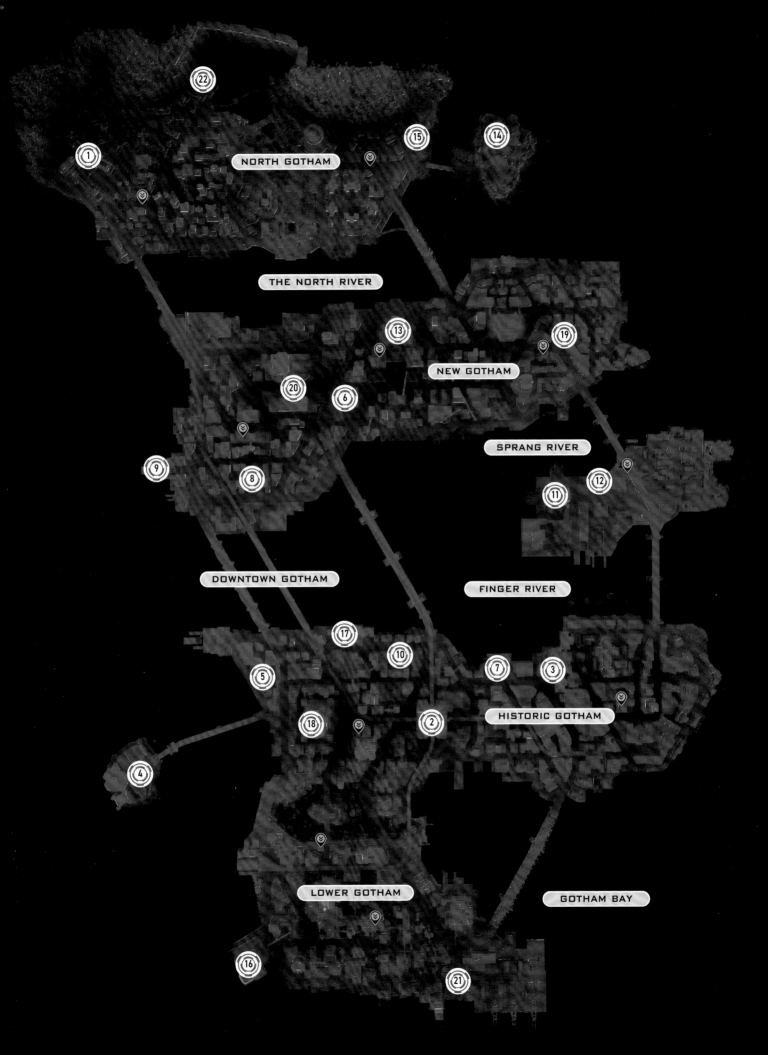

NORTH GOTHAM

THE NORTH RIVER

NEW GOTHAM

SPRANG RIVER

DOWNTOWN GOTHAM

FINGER RIVER

HISTORIC GOTHAM

LOWER GOTHAM

GOTHAM BAY

THE BELFRY

The Belfry serves as home base for the Gotham Knights. After every mission, the heroes join Alfred for a debriefing. There's plenty to keep the player busy while at headquarters. You can switch characters, train, craft new gear, customize the Batcycle, or hang with the rest of the Batman Family. Exit the Belfry to begin a new night patrol with new crimes.

TRAINING

The training area allows the player to practice combat moves and abilities. Interact with the wooden dummy to enter the training space, then select a skill to work on. This is a great way to brush up on combat basics or learn a new ability.

CHARACTER SELECT

The heroes' suits are displayed in the corner, left of the Batcomputer. Interact with a character's suit to switch to that hero. This can be done anytime the player visits the Belfry.

BATCOMPUTER

The Batcomputer sits in the back of the room and can be accessed here at the Belfry or remotely, anywhere in Gotham City. It provides access to the Gotham map, active case files, current investigations, available challenges, character abilities, the informative database, and email.

MAP

The Gotham City map allows the player to scan the entire city to find active crimes, mission locations, and fast-travel locations. Select one of these fast-travel spots to head straight there aboard the Batdrone.

CASE FILES

The Case Files tab lists everything currently active: the current Case File, premeditated crimes, side activities, contacts, and more. If clues are available, use them to reveal the unknown crimes at the bottom of the list. Highlight a file for more information, and press the Track button to follow it. Tap the Activity View button while on patrol, and a list of activities appears on the left side of the display, allowing you to track one without accessing the Batcomputer.

CHALLENGES

All available challenges are listed here, separated by category. Various challenges are often required to push the story forward. Contact challenges from Montoya and Thompkins offer rewards from allies once complete. Villain challenges from Mr. Freeze, Harley Quinn, or Clayface must be satisfied before you continue that Villain Case File. Knighthood challenges reward the player character with special abilities and access to the Knighthood Ability Tree. Training challenges reward the player for brushing up on new skills.

There are numerous types of challenges. Some simply ask the player to defeat criminals, while others target specific factions. Each hero has challenges that require new abilities to be used a set number of times. Keep tabs on active challenges, as each one rewards the player with XP and loot.

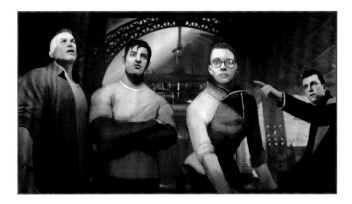

GEAR

Gear can be crafted and equipped without returning to the Belfry.

ABILITIES

As you defeat criminals, complete challenges, and resolve crimes, you earn XP. Reach certain thresholds of experience, and the current character levels up. Each time you reach a new level, you earn a set amount of Ability Points. You can spend these points on new abilities offered on the Ability Tree. A minimum number of points must be spent before abilities farther down the tree become available.

Each hero has four Ability Trees, including Knighthood. The first three trees are available from the start and offer abilities tailored to a specific aspect of that character's fighting style. Knighthood abilities become available after you complete that hero's challenges. This tree includes their ultimate ability, as well as some powerful ability upgrades.

DATABASE

The database provides information on items collected, the Batman Family, NPCs you encounter, villains you face, and landmarks. A game log displays accomplishments in the game.

EMAIL

Read emails from the Batman Family for added insight into the characters.

CRAFTING

The workbench sits next to the Batcomputer, allowing the player to craft new weapons and armor from collected blueprints and salvage. These are acquired by completing crimes, and from chests and challenges. Blueprints provide stats, properties, and abilities, so use this information to craft gear best suited to your play style. Access your gear at the storage station next to the workbench or when dismounted next to the Batcycle.

Blueprints and mods come in six rarities: common (gray), uncommon (green), rare (blue), epic (purple), legendary (orange), and heroic (yellow). The colors assigned to each item allow the player to easily spot rarer items. Rare items offer better stats and a higher number of mod slots, at an increased salvage cost.

Some gear comes with powerful special abilities that can be used in combat. Find the gear that matches your play style, then tweak the items with stat-boosting mods.

There are five types of salvage in the game: polymer, titanium mesh, rare earth metals, graphene fiber, and colloidal crystal. Collect the salvage from chests, as rewards for completing objectives, and from enemy drops. Salvage and crafting materials are shared across all heroes.

STORAGE

Crafted gear can be equipped from storage, or is accessible at the container next to the workbench. Select the Gear tab from the Batcomputer to craft and equip gear at any time.

Mods can be applied to gear in storage to improve its stats. The number of mod slots available depends on the rarity of the item.

A hero's visuals can be tweaked in storage. Alter the look of their cowl, chest, gauntlets, and boots.

EVIDENCE BOARD

The Evidence Board allows you to keep track of the current state of the story and villain arcs.

BATCYCLE CUSTOMIZATION

The bike station allows the player to customize the Batcycle's color scheme.

KNIGHTHOOD

After completing the mission at GCPD during Case File 01, interact with the Batsuit, left of the elevator. Following a conversation with Alfred, Knighthood challenges become available for all four heroes. Track challenge progress on the Challenges tab. Completing the Knighthood challenges unlocks a unique Knighthood ability and access to the Knighthood Ability Tree.

THE LOFT

The Belfry loft is the fun zone. Begin Batgirl's and Robin's character arcs at the chessboard. The arcade machine and game console also provide narratives later on.

NIGHT PATROLS

Each time you exit the Belfry, you begin a new night of patrols. Whether you're following a lead in a Case File, participating in side activities, or fighting crime on the streets of Gotham, the current night continues until you return to the Belfry. At this point, an "End of Night" results screen is displayed, showing how well you performed.

TRAVERSAL

While you're free to run through the streets of Gotham, there are quicker and more enjoyable ways to travel. The **Batcycle** is the primary mode of transportation. It can be summoned at any outdoor location in Gotham City. When you're dismounted, the bike stores equipment for the player character, allowing you to switch out their suit, melee weapon, and ranged weapon without stepping inside the Belfry. Mount the bike to drive around the streets. A wheelie grants a short speed burst and allows the bike to clear short obstacles. Hold the Brake button while accelerating to make tighter turns.

The hero's **grapple gun** offers a great way to navigate Gotham City's urban setting. Use almost any ledge, such as building rooftops and railroad tracks, as grapple points. The hero quickly flies to that ledge. To extend air time, jump before that point or find another spot to grapple to. If Heroic Traversal is unlocked, use that ability to further prolong time in the air—long-distance travel becomes possible without touching down.

At the start of Case File 02, the player must visit Lucius Fox to enable **fast-travel** points around the city. At each location, one to three drones must be scanned to activate it, at which point, the player can travel there at any time.

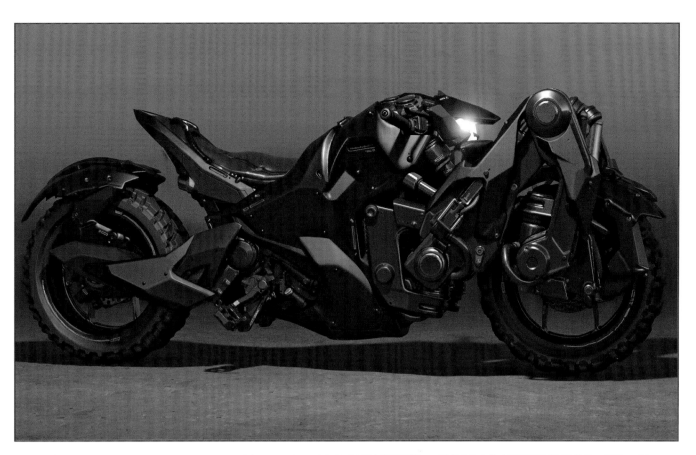

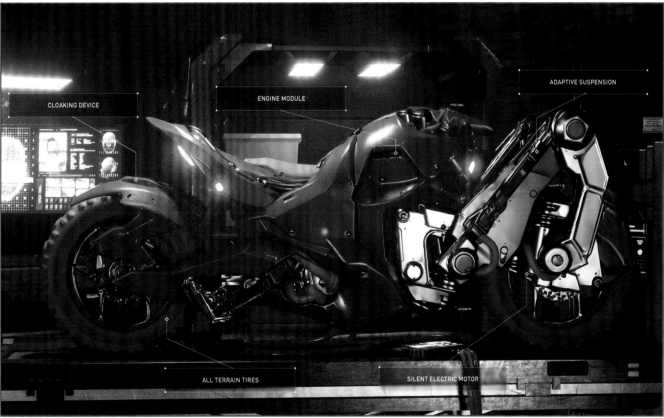

CLOAKING DEVICE

ENGINE MODULE

ADAPTIVE SUSPENSION

ALL TERRAIN TIRES

SILENT ELECTRIC MOTOR

THE FIVE BOROUGHS

The five boroughs of Gotham City, from north to south, are as follows: North Gotham, New Gotham, Downtown, Historic Gotham, and Lower Gotham. These boroughs are split into districts. The story begins in North Gotham at Gotham City University before the team is introduced to their headquarters in the Financial District. From there, the heroes are sent across all five boroughs as they fight the criminal factions in Gotham City.

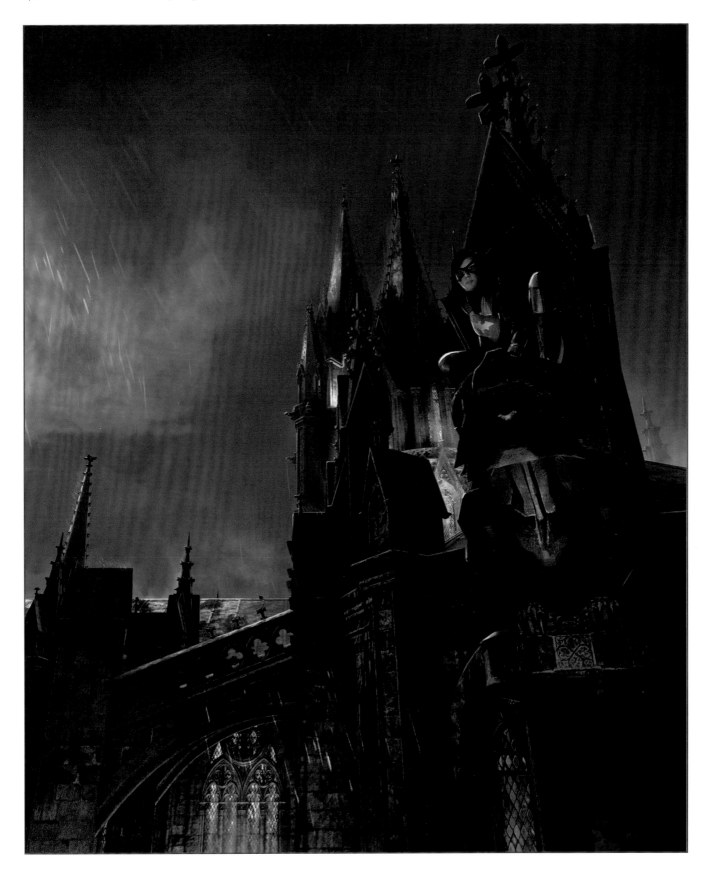

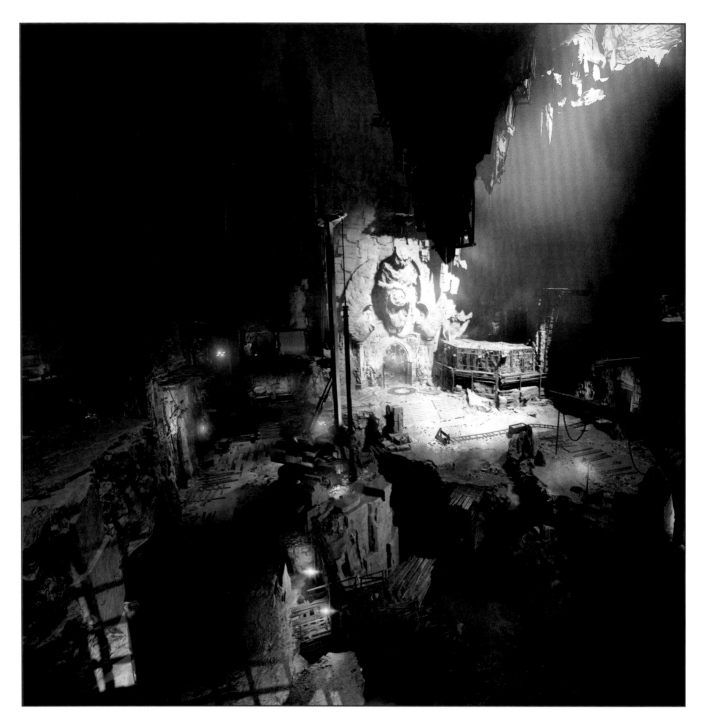

CO-OP MODE

- **Requirement:** Complete Case File 1.2: The Langstrom Drive

After the player completes the tutorials at Gotham City University and Case Files 1.1. and 1.2, Co-op Mode becomes available. There are three multiplayer modes: Open World allows another player to jump into the game, Heroic Assault is a four-player raid that takes place in North Gotham, and Villain Showdown allows players to fight previously defeated bosses at a high difficulty for an intense challenge.

Tap the Social Wheel button to bring up a variety of social options: Express yourself with emotes, join a friend in a quick co-op game, stage the perfect snapshot, and more.

In an open-world game, the two players don't necessarily have to work on the same mission or activity. Story and challenge progress can only be completed by the host, but both players gain character progress.

Track a raid case file to get help finding the Heroic Assault entrance in North Gotham. This leads into the raid lobby, where a hero can be selected and gear changed out. Join three players and fight through all the floors of a raid to reach the boss.

VILLAIN SHOWDOWN

- **Requirement:** Defeat a Boss in a Villain Case File

Each time a villain is defeated, a related item is placed on the shelves at the base of the stairs in the Belfry. Interact with one to launch a showdown with a selected boss to replay boss battles. The bosses get tougher with every subsequent fight, so come appropriately equipped and prepared. Villains increase in level and stats, and they gain new attacks and resistances.

THE BATMAN FAMILY

01

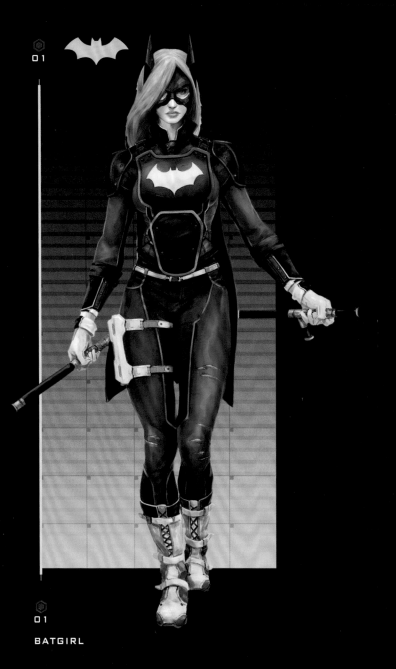

01

BATGIRL

02

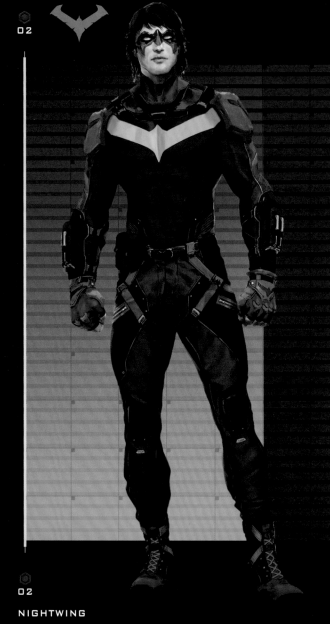

02

NIGHTWING

POSITIVE ID CONFIRMED
THE BATMAN FAMILY

4T

INTEL TYPE	CLASS A
ID	6564548693-51651
SOURCE	GCPD DATABASE
FILE NAME	GCPD_INTEL_65454684_v02в

0 0 0 1

■	OPTICAL SENSOR	ONLINE
■	HAPTIC PORT	ONLINE
■	INDEX PROCESSOR	ONLINE
■	ANALOG TRANSMITTER	ONLINE
■	HTX DRIVER	PROCESSING . . .
■	ONLINE INTERFACE	ONLINE

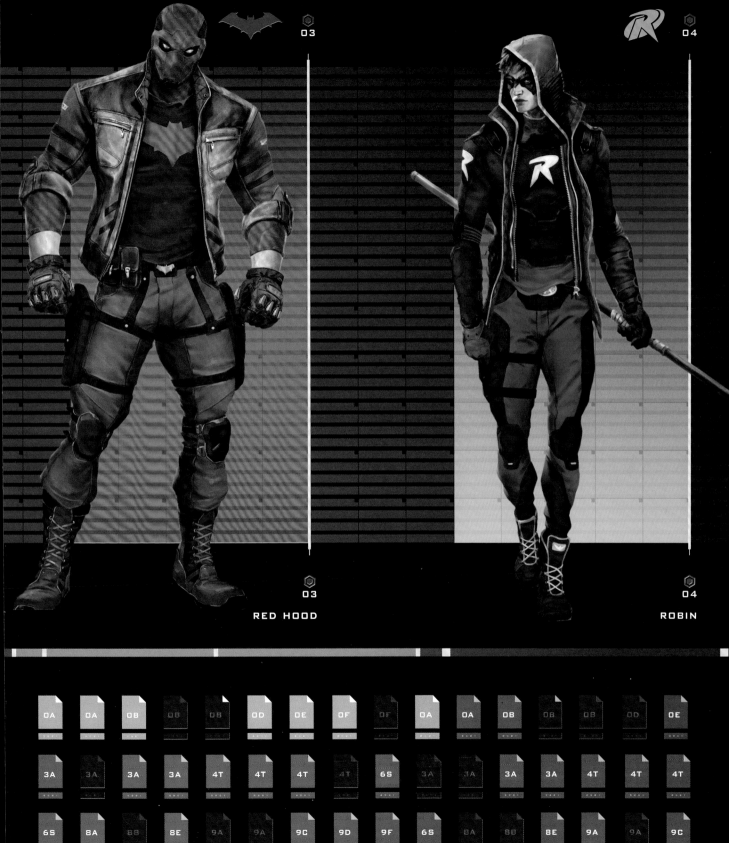

03

04

RED HOOD

ROBIN

Batman has left Gotham City in the hands of his prodigies: Batgirl, Nightwing, Red Hood, and Robin. It's up to them to work together and protect Gotham from the bad actors who take advantage of the Batman-less city. The Gotham Knights have big shoes to fill as the new Dark Knight, but with the right equipment and help from allies, they can take the city back from the criminals.

In *Gotham Knights*, the player can choose any hero at any time. Have a favorite? The entire story can be experienced as that character. Want to experience them all? Switch it up at any time at the Belfry. The heroes all gain experience at the same time and gear rewards for heroes not currently being played are assigned by completing story missions, giving them a jump start on crafting good gear as the story progresses. However, heroes don't automatically spend ability points when they aren't played, so the player will need to do that when switching to another hero. Therefore, the player can switch to a new hero late in the story and still survive.

Each character has their own Ability Tree and equipment that greatly improve with increased character level. Using the Belfry's workbench and a corresponding blueprint, new equipment can be crafted and upgraded with mods.

PATRICK REDDING
CREATIVE DIRECTOR

It's almost surprising in hindsight, but we landed at four playable characters almost immediately. There were really two forces guiding us to that: In terms of the Batman Family itself, it sort of tumbles out of "who *must* answer the call" in the event of Batman's death? Dick Grayson, without a doubt. Barbara Gordon almost instantly joins that list. Then karmic balance demands the black sheep return to the fold, so Jason Todd shows up. And finally, you need an upstart with the invincibility of youth, so Tim Drake makes it four.

The second driver was that, as an action-RPG, we wanted to validate multiple styles of play. We needed a resilient melee machine, and we identified (and prototyped) Batgirl as our strongest embodiment of that. In Red Hood, we had the character with the strongest ranged focus. Nightwing, not surprisingly, emerged as a high-mobility character with good crowd-control abilities. And finally, Robin was our stealth-focused character with a lot of status-effect tricks up his sleeve.

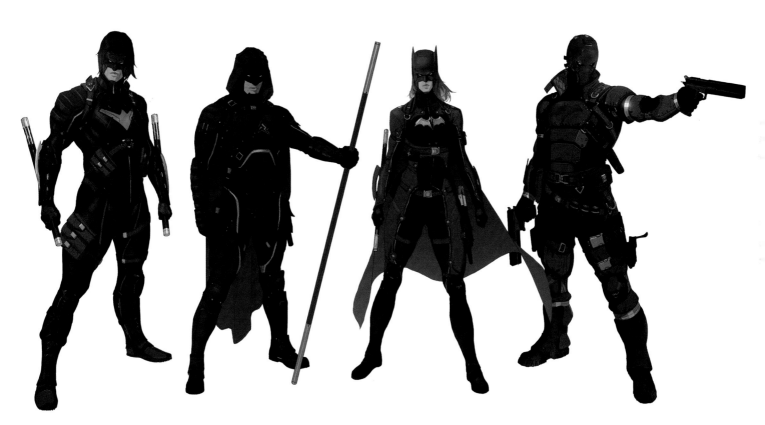

JAY EVANS
ART DIRECTOR (CHARACTERS)

Having worked with the DC brand in our studio for years, we were given ample freedom to design characters. There is, of course, a line when working with branded characters where we have to maintain a certain level of recognizability and key features. We often talk about a "squint test." Can you kind of squint your eyes and still tell who it is irrespective of the details?

KNIGHTHOOD CHALLENGES AND HEROIC TRAVERSAL

After recovering the decryption key from the GCPD in Case File 01, the player returns to the Belfry for a debriefing. At this point, Knighthood for each player character becomes available. Interact with the Batsuit near the elevator to unlock a Knighthood challenge for all four heroes. Complete the challenge to unlock Heroic Traversal, an ability that provides improved travel around the city. As you progress through the story, second and third challenges also become available.

BATGIRL

ALIAS: BARBARA GORDON

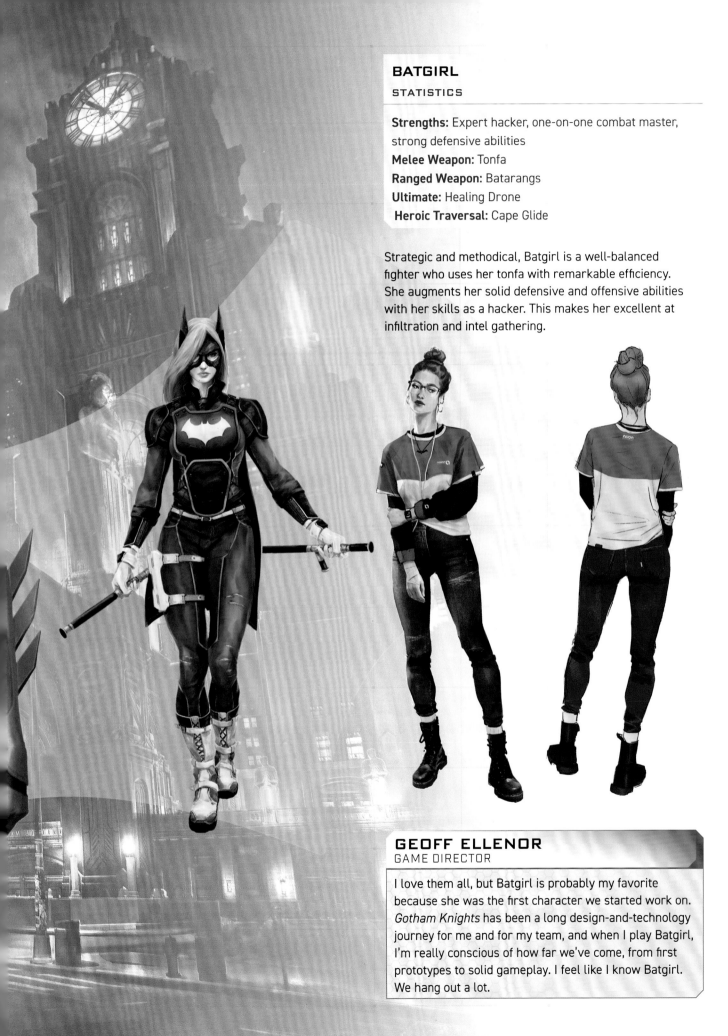

BATGIRL
STATISTICS

Strengths: Expert hacker, one-on-one combat master, strong defensive abilities
Melee Weapon: Tonfa
Ranged Weapon: Batarangs
Ultimate: Healing Drone
Heroic Traversal: Cape Glide

Strategic and methodical, Batgirl is a well-balanced fighter who uses her tonfa with remarkable efficiency. She augments her solid defensive and offensive abilities with her skills as a hacker. This makes her excellent at infiltration and intel gathering.

GEOFF ELLENOR
GAME DIRECTOR

I love them all, but Batgirl is probably my favorite because she was the first character we started work on. *Gotham Knights* has been a long design-and-technology journey for me and for my team, and when I play Batgirl, I'm really conscious of how far we've come, from first prototypes to solid gameplay. I feel like I know Batgirl. We hang out a lot.

ANN LEMAY
NARRATIVE DIRECTOR

Batgirl's character arc allowed us to showcase her eidetic memory and how trauma would impact her. The use of a forensic diorama (which we affectionately called "the murder dollhouse" within the writing team) as she looks into her father's old cases made for interesting visual and character-related explorations within our cinematics.

IN COMBAT

Batgirl is a strong melee combatant with outstanding defensive abilities, but it's her hacking that sets her apart from the others. With the basic hack ability, she can disable security devices for a short period. Improve to the overload ability to turn security devices against hostiles. Her Batarang Barrage does piercing damage which interrupts armored attacks. Add in potent healing abilities, and Batgirl becomes a great choice for any situation.

Batgirl's **Justice** Ability Tree focuses on opportunities to improve combat, including enhancements for her beatdown ability, such as the ability to perform the move on elite enemies.

On the **Grit** Ability Tree, Batgirl shows her resilience. The second wind ability and accompanying enhancements offer life after death, returning her to her feet once or twice per night or raid after being defeated.

The **Oracle** Ability Tree adds abilities familiar to Batgirl from when she was Oracle. Her hack skill allows her to manipulate turrets, doors, cameras, and more. Add the hacking overload ability, and she can make electric panels explode and change the faction of turrets, mines, and cameras. This tree isn't all hacking; it also includes the grapple pull ability, which pulls enemies toward her, and Health Pack improvements that extend the healing ability to nearby allies and improve its effects.

With **Knighthood**, Batgirl augments her healing ability with a healing drone. Launch the device to gradually heal the ally with the lowest health. Farther down the tree, add shock damage to the drone with an area-of-effect ability.

Batgirl's Heroic Traversal ability is a cape glide. Jump off a grapple point or rooftop and hold the Heroic Traversal button to glide safely to the ground. Push up to dive or down to gain a little more height. It's possible to stay in the air for a long duration.

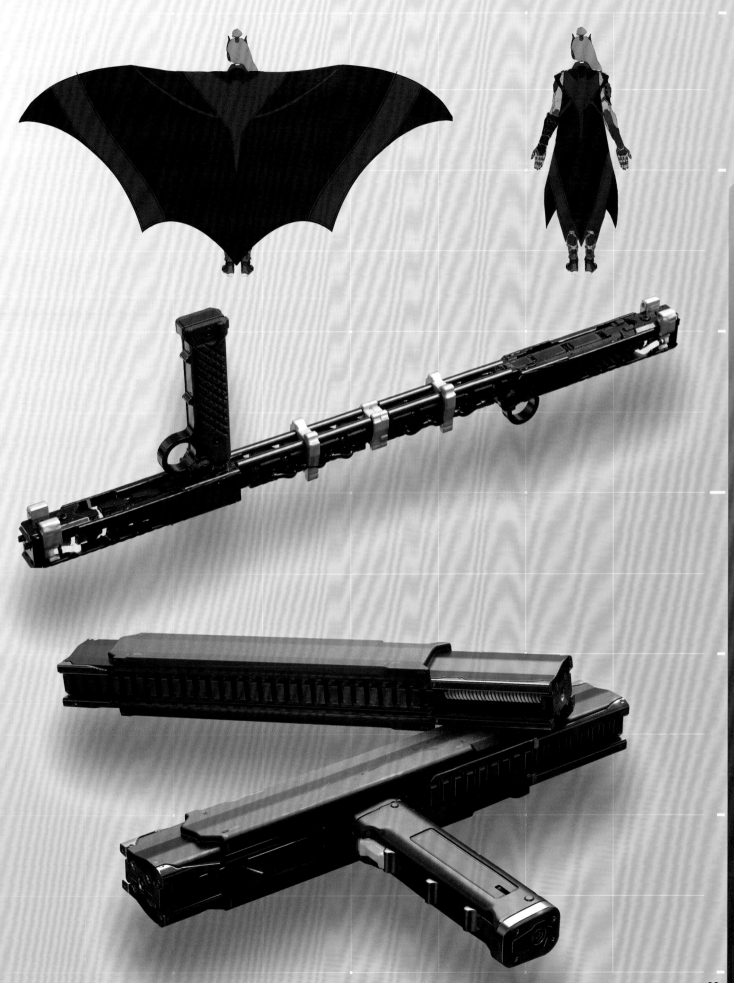

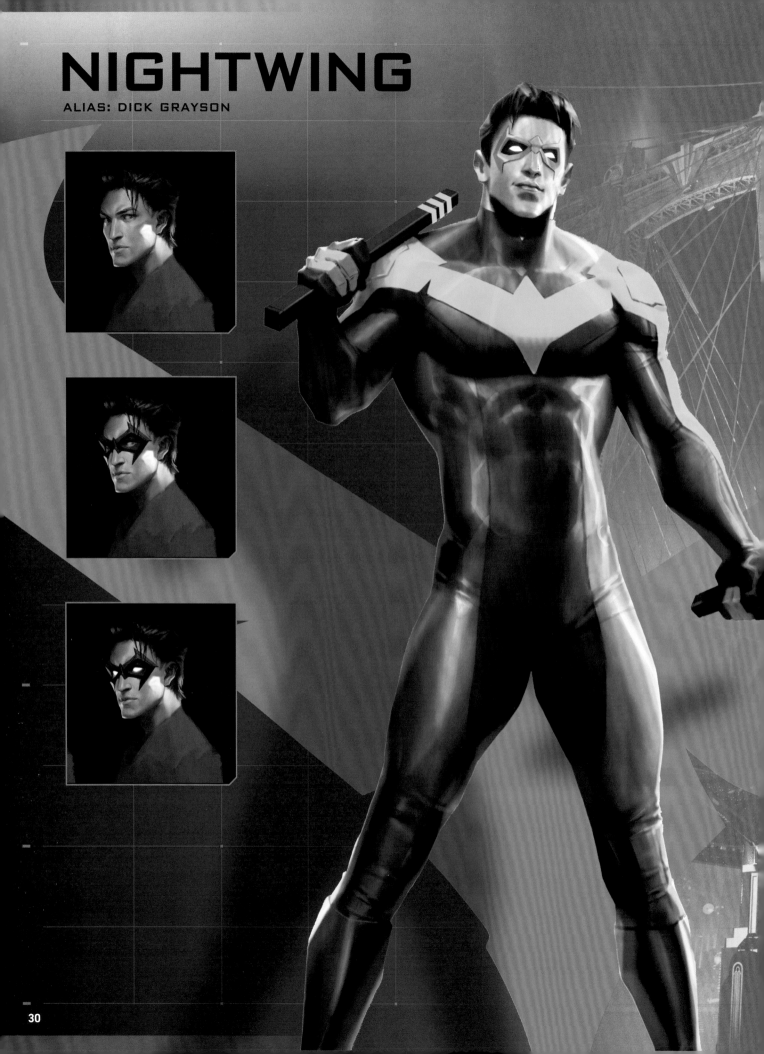

NIGHTWING

ALIAS: DICK GRAYSON

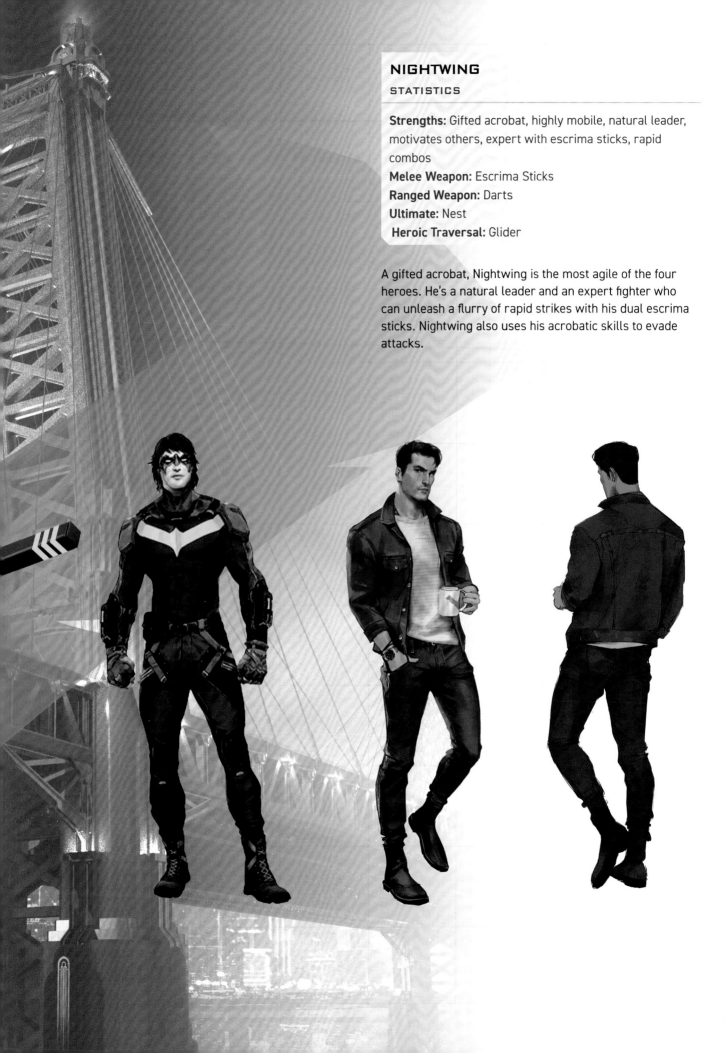

NIGHTWING

STATISTICS

Strengths: Gifted acrobat, highly mobile, natural leader, motivates others, expert with escrima sticks, rapid combos
Melee Weapon: Escrima Sticks
Ranged Weapon: Darts
Ultimate: Nest
Heroic Traversal: Glider

A gifted acrobat, Nightwing is the most agile of the four heroes. He's a natural leader and an expert fighter who can unleash a flurry of rapid strikes with his dual escrima sticks. Nightwing also uses his acrobatic skills to evade attacks.

IN COMBAT

Nightwing's greatest attribute is his acrobatic prowess. His evade maneuver is so effective, a light turret has a tough time getting a bead on him. Master his pounce ability to deal massive damage without touching the ground. Dive into his Pack Leader and Knighthood Ability Trees to find great improvements for co-op play.

The **Raptor** Ability Tree provides enhancements for pounce such as pounce high jump, which adds an automatic high jump on the enemy, allowing the player the option to perform an aerial attack or use his glider, the Flying Trapeze. More enhancements allow the player to bounce off an enemy up to three times and increase damage done by aerial attacks.

The **Acrobat** Ability Tree improves on Nightwing's already spectacular acrobatics. With evade chain, evade up to three times in quick succession. Once more improvements become available later in the Acrobat Ability Tree, Nightwing gains extra momentum and deals damage with his final evade.

Begin the **Pack Leader** tree with Nightwing's heal-over-time and damage-over-time darts. These darts are a great addition for co-op—they heal allies while also doing science damage over time on hostiles. Later, Nightwing's dart can be used to instantly revive an ally from afar. Assassin's mark, available early on the Ability Tree, provides a damage bonus for all allies. Momentum regeneration restores momentum for him and his allies.

With **Knighthood**, Nightwing improves his co-op benefits with the nest ultimate ability. This creates a protective nest-like area for him and his allies. Most of his Knighthood Ability Tree enhances the nest ability, though Nightwing can also increase the number of darts shot at once.

After completing Knighthood challenges, Nightwing downloads specs for the Batwing and builds a personal glider. This glider is used as his Heroic Traversal, allowing the player characters to glide farther than ever with just the grapple. Pull back on the stick to increase altitude; press forward to dip down.

HOVERING

BRAKING

ARRIVING

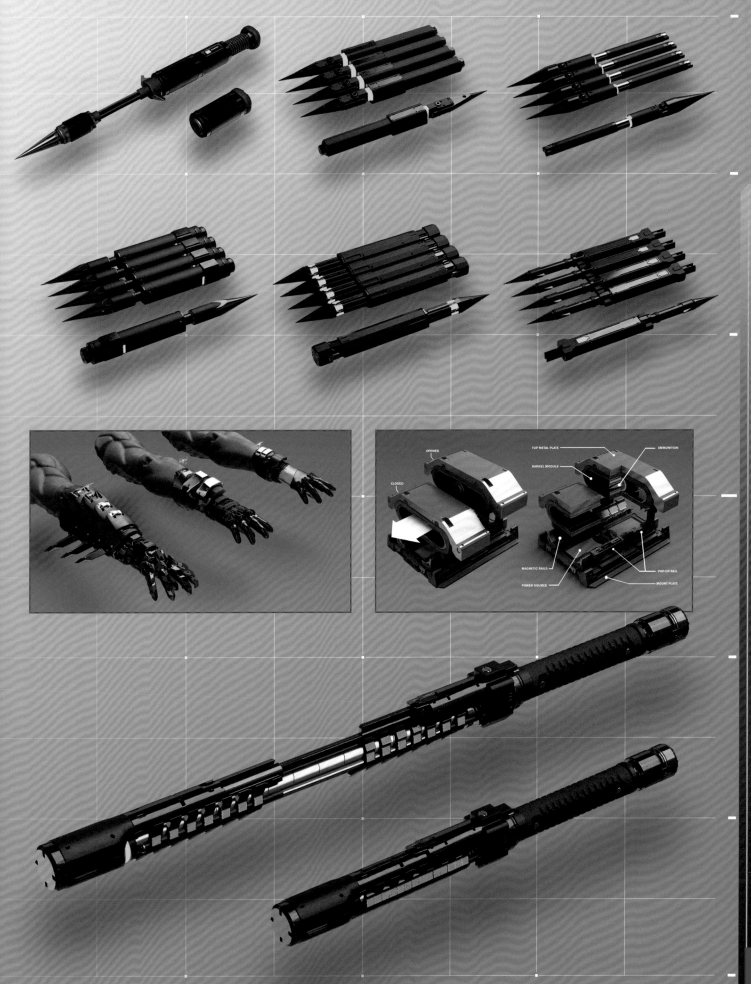

RED HOOD

ALIAS: JASON TODD

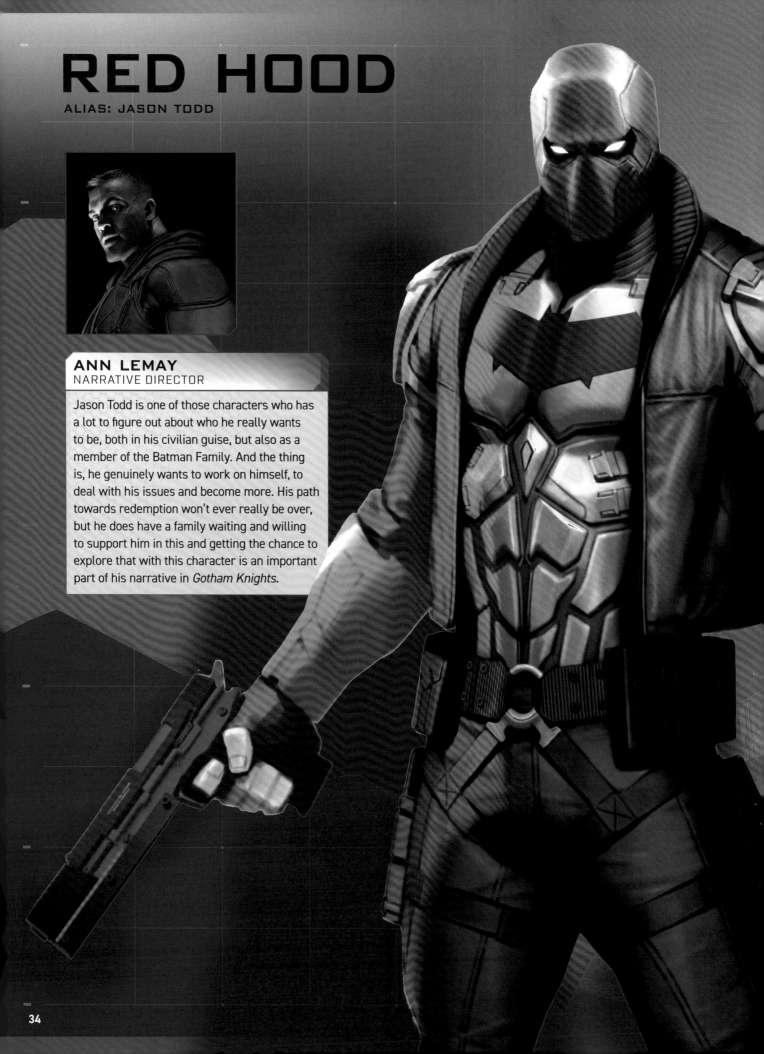

ANN LEMAY
NARRATIVE DIRECTOR

Jason Todd is one of those characters who has a lot to figure out about who he really wants to be, both in his civilian guise, but also as a member of the Batman Family. And the thing is, he genuinely wants to work on himself, to deal with his issues and become more. His path towards redemption won't ever really be over, but he does have a family waiting and willing to support him in this and getting the chance to explore that with this character is an important part of his narrative in *Gotham Knights*.

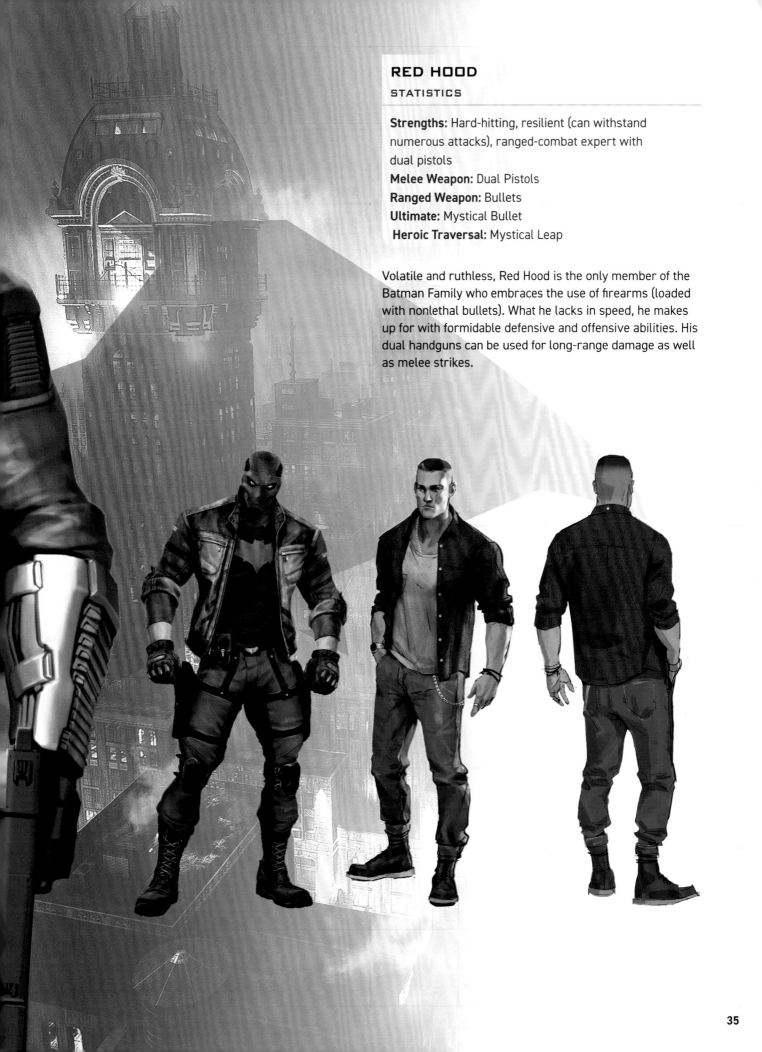

RED HOOD

STATISTICS

Strengths: Hard-hitting, resilient (can withstand numerous attacks), ranged-combat expert with dual pistols
Melee Weapon: Dual Pistols
Ranged Weapon: Bullets
Ultimate: Mystical Bullet
Heroic Traversal: Mystical Leap

Volatile and ruthless, Red Hood is the only member of the Batman Family who embraces the use of firearms (loaded with nonlethal bullets). What he lacks in speed, he makes up for with formidable defensive and offensive abilities. His dual handguns can be used for long-range damage as well as melee strikes.

IN COMBAT

Red Hood is the tough guy of the team, with combat centered around his guns. He uses them to fire a variety of nonlethal bullets and employs them in his melee attacks as well. He's slower and less stealthy than other Batman Family members, but his superior defense and brutal offensive abilities make up for it. He can disable security cameras with one shot from his gun, but nearby hostiles become alerted. His bullets damage light turrets, but again, stealth is sacrificed. Red Hood can deploy a portable turret for assistance against nearby hostiles.

On **Brawler** Ability Tree, Red Hood picks up the human bomb ability and enhancements. He can also greatly improve the grab skill with increased hold time and damage, uninterruptible grabs, and the ability to grab large enemies.

The **Marksman** Ability Tree augments Red Hood's stellar gun play with increased damage, decreased charge time for focus shot, and increased critical chance with quickfire.

The **Vengeance** tree offers bonuses against certain factions: gangsters, the Court of Owls, and the League of Shadows. Look for a couple of stellar improvements to Red Hood's two-fisted reload ability—infinite shots for a short period and double bullets.

The **Knighthood** Ability Tree unlocks Red Hood's mystical bullet, an ability that deals massive damage to his targets with a later enhancement that grants double bullets. Target multiple hostiles by highlighting them when aiming the ability.

Red Hood's Heroic Traversal ability is the mystical leap. Hold the Heroic Traversal button when airborne to bounce off mystical platforms that materialize under the hero's feet. Tilt the character for slight turns. Turn the camera while holding the Heroic Traversal button to make bigger turns. Add mystical leap stomp from the Knighthood Ability Tree to gain the ability to perform a stomp move on enemies below.

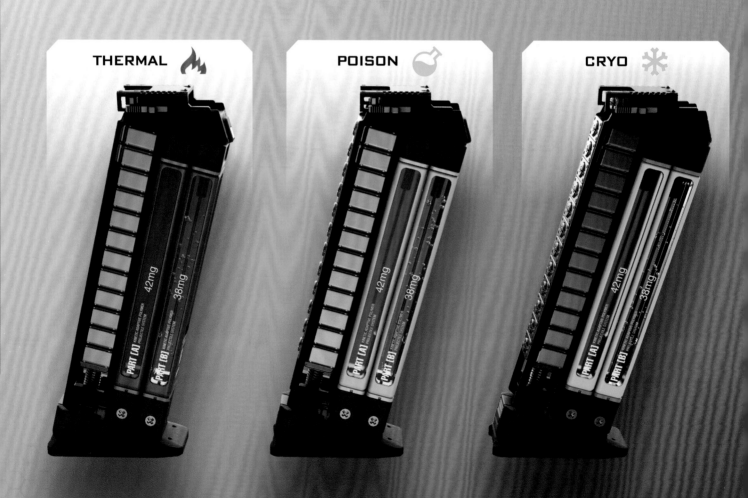

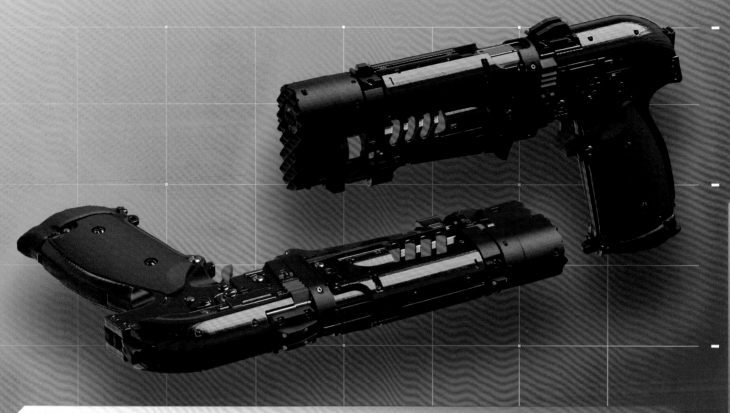

ANN LEMAY
NARRATIVE DIRECTOR

Being able to work with other disciplines is essential when it comes to making games. No discipline is an island, after all. But also—it's an enjoyable, fun, and creative process! Challenges in terms of integrating narrative and gameplay elements help improve everything we do.

Let me give you one specific example of cross-disciplinary collaboration. Once production had started, we began giving our game system terminology a sterner look and one thing in particular stood out for us. Red Hood's gun. It was clear to us that we needed to pay close attention to everything around his weaponry, to not rely on the easy "non-lethal bullets" terminology since it's been proven that non-lethal can in fact be lethal . . . and this was vital to us because we had to make it clear that Jason was in fact espousing Batman's non-lethality philosophy, a core aspect of everything that is Batman. There was just no way around that, it's a critical part of Red Hood's return to the Batman Family, after all.

This is where our collaboration with design becomes essential. Nic, our designer point of contact on this one, loves the lore just as much as anyone else on the team, and he and our writer came up with this brief for us:

Red Hood's signature weapon: The Vortex Pistol, or VORPS

The Vortex Pistol is a custom sidearm.

It fires micro-shockwaves that can adapt dynamically to the hardness of a target, resulting in minimal damage while exerting maximum stopping power. Additionally,

these shockwaves can be augmented with multiphase polymer projectiles to cause distinctive effects on targets.

Detailed description:

Upon firing, the detonation energy produced by the VORPS is augmented by circular vortex accelerators, generating high-pressure micro-shockwaves that can hit a target with great precision.

This shockwave blast adjusts dynamically to produce a kinetically adapted response depending on the hardness of the target encountered, therefore causing minimal damage to soft tissues while providing stopping force against armor.

Additionally, the functionality of the VORPS can be enhanced with multiphase projectiles. Upon firing, these projectiles are instantly shaped from a two-part liquid polymer contained in interchangeable cartridge casings.

The projectiles disintegrate shortly after leaving the reinforced titanium barrel, creating a gaseous cloud propelled by the shockwave blast.

Specialized compounds added to the liquid polymer mixture produce various effects upon the target, including a freezing effect, thermal effect, poison effect, and shock effect.

Sample criminal testimonial:

"It feels like being punched in the face by Batman, but I ain't even bleeding!"

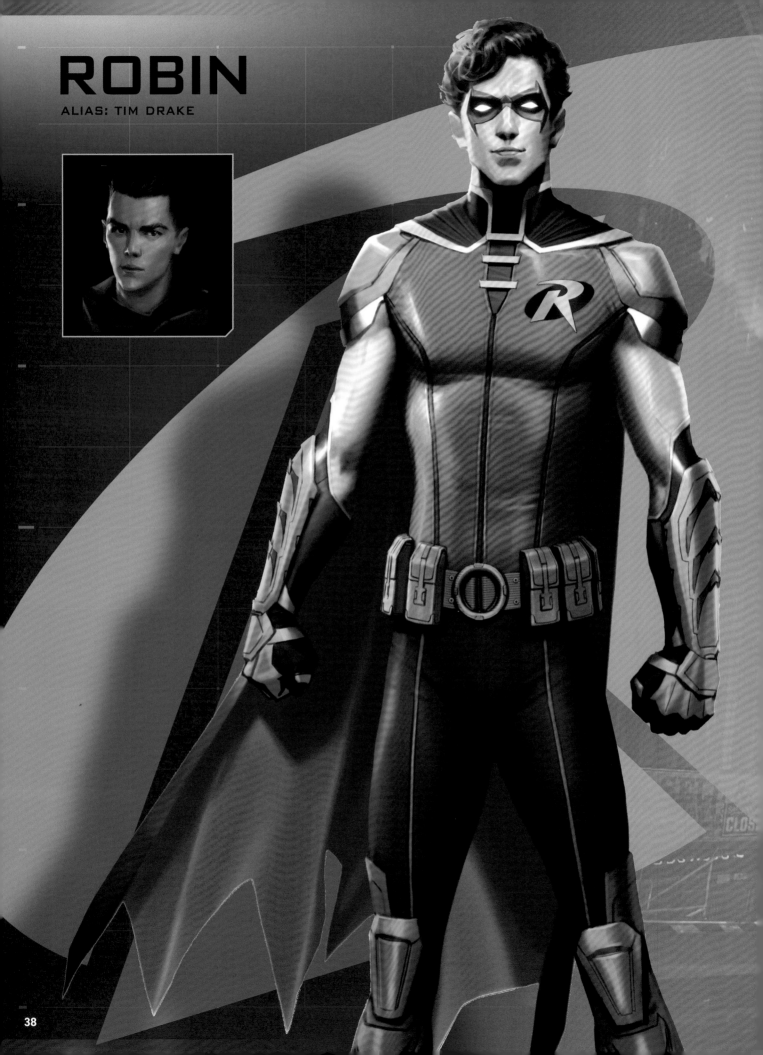

ROBIN
ALIAS: TIM DRAKE

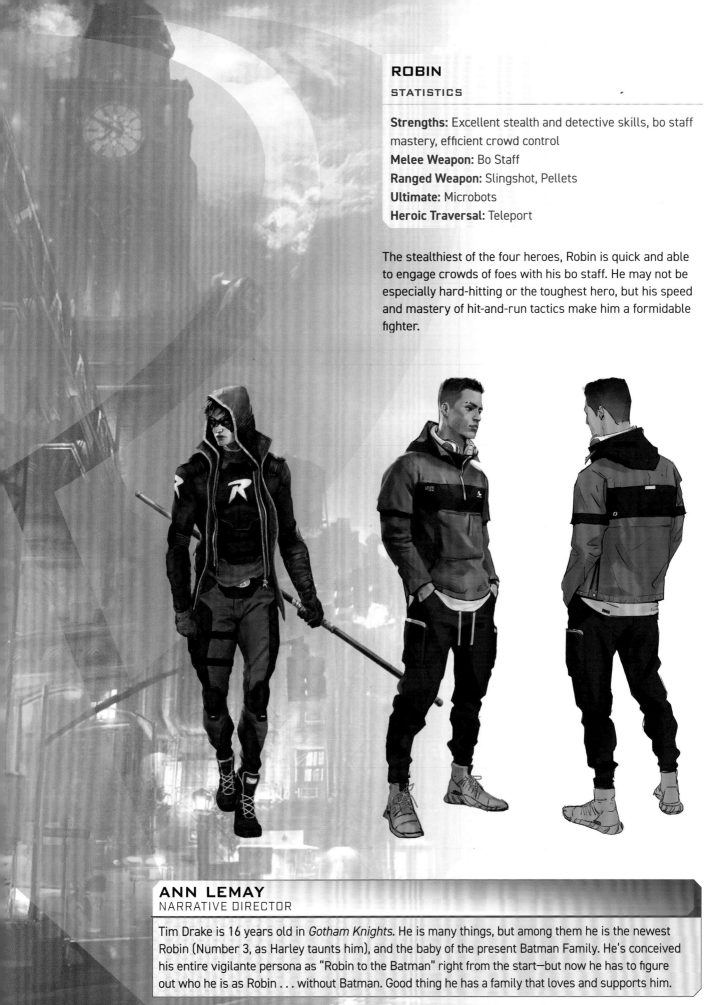

ROBIN
STATISTICS

Strengths: Excellent stealth and detective skills, bo staff mastery, efficient crowd control
Melee Weapon: Bo Staff
Ranged Weapon: Slingshot, Pellets
Ultimate: Microbots
Heroic Traversal: Teleport

The stealthiest of the four heroes, Robin is quick and able to engage crowds of foes with his bo staff. He may not be especially hard-hitting or the toughest hero, but his speed and mastery of hit-and-run tactics make him a formidable fighter.

ANN LEMAY
NARRATIVE DIRECTOR

Tim Drake is 16 years old in *Gotham Knights.* He is many things, but among them he is the newest Robin (Number 3, as Harley taunts him), and the baby of the present Batman Family. He's conceived his entire vigilante persona as "Robin to the Batman" right from the start—but now he has to figure out who he is as Robin . . . without Batman. Good thing he has a family that loves and supports him.

IN COMBAT

Robin's melee weapon has great reach, allowing him to sweep through a group of hostiles. His slingshot flings a variety of pellets. While Robin is unable to disable security cameras, they don't detect him when his cloak ability is active.

Superior stealth abilities, like Robin's cloak and decoy, make him a great choice when remaining undetected is vital to success. He may be the youngest in the Batman Family and lack the strength of other members, but he does possess effective offensive moves. His intellect shows in his fighting style through use of creative and deadly gadgets.

The **Slugger** Ability Tree provides a few combat improvements, as well as Robin's valuable decoy ability. When feeling overwhelmed, use the decoy to distract hostiles, escape trouble, or return to an undetected state. Enhance his decoy with the ability to explode when hit and inflict science damage.

The **Shadow** Ability Tree augments Robin's stealth abilities with upgrades that make him harder to see and cause higher damage.

Spends points on the **Tinkering** Ability Tree to improve science buildup and damage. Science damage can be extremely effective, making Robin a great ally in battle. Tinkering also turns Robin's final missed pellet into a sticky pellet that acts as a proximity mine.

With access to the **Knighthood** Ability Tree, Robin gains microbots. These tiny robots scurry around the area, detonating when they make contact with hostiles. Continue with this tree to increase the number of bots and their regeneration speed.

Robin's Heroic Traversal ability teleports the player character when airborne. Hold the Heroic Traversal button to bring up an aiming reticle. Move it around to the desired jump point and release the button to travel to that location.

MEET THE WB GAMES MONTRÉAL TEAM

Creating such a rich, complex world as featured in *Gotham Knights* is no small undertaking. Meet a few of the key team members who brought this vision to life.

WILSON MUI

TITLE: CINEMATIC DIRECTOR

Favorite Character(s):
Harley Quinn, Talia al Ghul

My primary focus is to define the cinematic vision and to push the visual storytelling onscreen via the cinematics. Throughout the process I wear many different hats during production to make this happen. For example, in pre-production, I focus on overall planning for all cinematics in the game with other directors and work with various departments to ensure dependencies are identified. The next part of the cinematic process entails working with the writers on the scripts, casting actors for performance capture, as well as driving the creative process with my storyboard/mood board team to create 2D animatics. These 2D animatics serve the framework for performance/motion capture planning and moves the cinematics into full production.

Using these 2D animatics to convey the intentions of the scene, I shift to planning and motion capture shoots (performance capture and stunt) and direct our actors on set to bring out the best performances as possible. With this major step completed, cinematic production moves full steam ahead as I transition and oversee the creation of the scenes with my internal cinematic team (technical integration, animation, VFX, lighting, and audio), as well as providing daily direction and feedback to all the internal departments and external teams. Ultimately, I am the last gate for pushing the highest level of quality for the cinematics and it is a very iterative, complex, and challenging process to get amazing content on screen!

JAY EVANS

TITLE: ART DIRECTOR (CHARACTERS)

Favorite Character:
Mr. Freeze

My day to day on this project changes throughout the phases of the project. In pre-production I was making initial concepts, character models, and plans. Later in the project I was building and working with amazing teams to create characters. Finalizing the project involves a lot of reviewing and quality control.

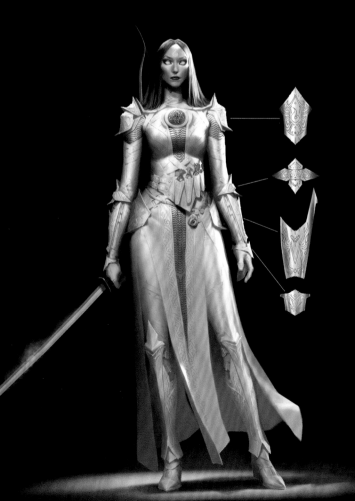

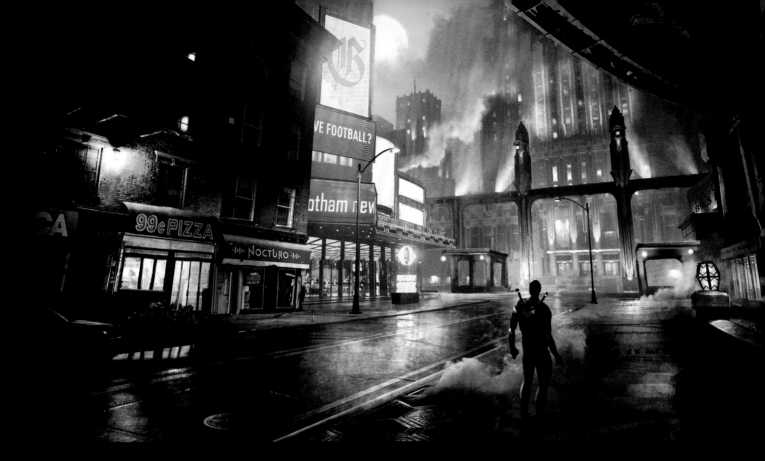

ANN LEMAY

TITLE: NARRATIVE DIRECTOR

Favorite Character(s):
Jason Todd, Tim Drake,
Renee Montoya

The role of a Narrative
Director changes and
evolves depending on which
phase of the project we're in.

Overall, I drive the story, the
development of the characters and the world they inhabit, and
I do so in constant collaboration with the other creatives on
the project. It is vital for a Narrative Director to maintain open
channels of communication with everyone on the project,
and to understand the needs of other disciplines in order to
work together harmoniously with them on a daily basis and
to effectively advocate for the vision of the narrative at all
times. Narrative impacts nearly every aspect of the game
(missions, level art, character design, cinematics, AI, etc.),
and we always work with the team to find optimal solutions
for everyone.

Responsibilities on a project range from hiring writers and
voice designers for the narrative team, working out the
details of the narrative at the highest levels, collaborating
with DC on various fronts, working on blueprints for the
game with fellow directors and leads, giving briefs to the
writing team and nurturing their creative process in the
writers' room, script reviews for cinematics, missions
and barks in the open world content, casting of actors,

being present for mocap, meetings with other disciplines
to maintain a consistent vision, advocating for narrative
across the breadth of the team and production, playing
the game to make sure things happen where and when we
want them to—the list goes on.

On the day to day, I support my team, guide them when
needed and most of all, work hard to empower them in
their roles. I make sure my team has everything they need
to execute the vision for the game and have ownership
over each part of the narrative and realization that they are
responsible for.

While the realities of game development mean that people
may enter or exit a project at any time during a production,
ideally as a Narrative Director you want to be present
right from the start. Getting to brainstorm and build the
foundational blocks of the story right from the beginning
really allows you to dig deep into lore and also, to ensure
consistency across the story on every level—not just dialog
and cinematics, but also gameplay and the actual world the
players experience in missions and exploration.

That said, no initial story survives for long—constant
iteration is a fundamental fact when it comes to building a
story for a video game. From the very start of the project,
there is a lot of discussion, brainstorming. Being able to
adapt to the needs that come with making a game while still
advocating for the story is a balancing act, but one that is
very doable with a good team.

PATRICK REDDING

TITLE: CREATIVE DIRECTOR

Favorite Character:
Harley Quinn

The creative director's role evolves over the course of the project. When we are a small core team first developing the concept, my job is to ask good questions. To put together the right combination of people across different disciplines—Design, art, animation, programming, narrative, etc.—and create a scaffolding for them to attach their contribution in a way that meets the artistic and commercial goals of the game.

I'm never the sole "author" of the game; but I'm responsible for protecting the game's style, the aesthetic experience we want to emerge from play, and often with deciding when a thing does or does not fit the vision.

My ultimate customer is the player; so as we move further into production, I need to ensure that the core fantasy of the game remains coherent and is delivered by the total combination of all the game's elements: its systems, the feel of its world, its characters, the gameplay encounters. This is where, on a AAA title, the creative director relies on the other directors in each discipline and the rapport they have with their teams.

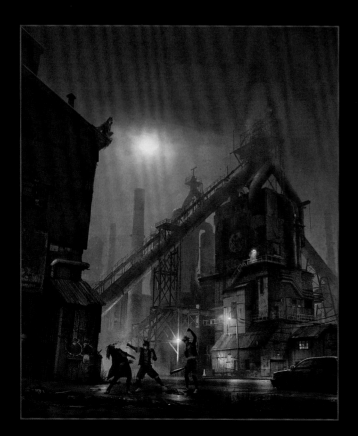

DANIEL KVASZNICZA

TITLE: ART DIRECTOR (ENVIRONMENT)

Favorite Character:
Robin

My responsibility on GK encompasses everything related to Environmental Art. I am blessed with two awesome Assistant ADs that help me to cover cinematics, lighting, and the OW, which is its own beast in terms of workload and attention. These days they allow me to focus more on the linear part of our game involving the mission beats and villain arcs, while spending time on the overall look and feel of the OW.

My usual day starts with a coffee and downloading the latest build, which gets updated at least twice a day with the latest content from our team.

Especially with the work from home situation, my time is mainly booked into zoom meetings that consist of various reviews for art and level design, sync-ups with my fellow directors and collaboration with the art team. I am also involved in some of the cinematic and concept art reviews, as well as any overall look developments for the open world.

Time not spent directly in meetings usually involves setting up art intentions, guidelines, documentation, reviewing concept art teams and supporting the art team with answers to their day to day questions and concerns.

GEOFF ELLENOR

TITLE: GAME DIRECTOR

Favorite Character: Batgirl

My job is to lead the game design team and create fun gameplay mechanics that align with the fantasy of the game. I work with design, tech teams, and content teams to make sure we have something fun that delivers on the game concept.

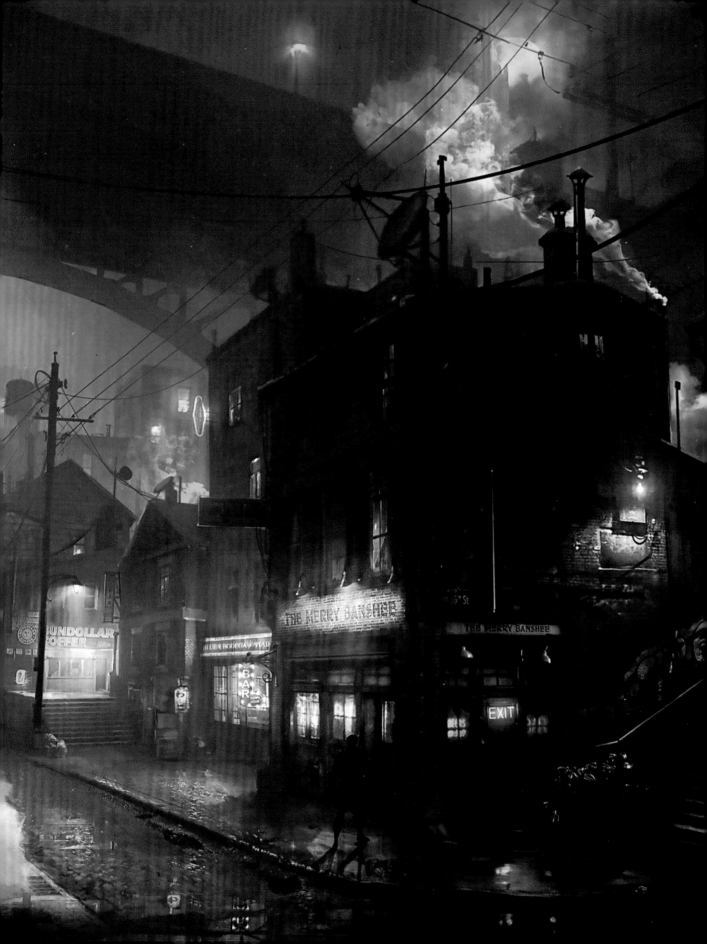

GOALS FOR THE GAME

PATRICK REDDING
CREATIVE DIRECTOR

Our first priority, no question, was to make all four of the Knights aspirational, powerful, and distinct in how they play. That extends to their look, including how that look evolves and can be personalized. It extends to their unique move-sets, their abilities, and the animations that bring them to life. It's in their voices and performance. It includes every nuance of the controls and game camera. And it includes all of the sound design, visual effects, lighting, and simulation details supported by the new generation of platforms.

If the heroes represent one pillar of the game, then another is the enemies they fight. Fighting crime in Gotham City can't be like anywhere else. We need a particular class of adversary. We need villains who are distorted reflections of the ideals embodied by the hero: the wildcard, the monster, the mad scientist. Within the crime factions, we need not just muggers and gunmen but specialized enemies, elites, and mini-bosses who can alter the formula of any fight. And they all have to be able to adapt believably to all four heroes and to varying styles of play, including stealth and gadget-based approaches.

Finally, there's Gotham City itself. *Gotham Knights* is really about what happens when the status quo is disrupted. Gotham City's protector is taken away, and then all of the old threats, the old power structures, attempt to reassert themselves. For players to really live that, we needed to drop them into an ecosystem where everyday Gothamites struggle to survive, and let them explore a Gotham City with distinct neighborhoods and lots of surprises.

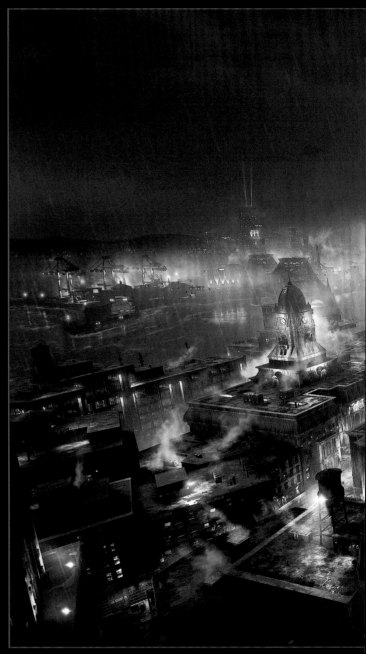

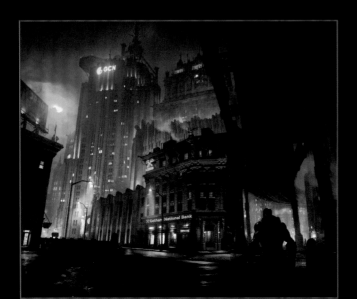

ANN LEMAY
NARRATIVE DIRECTOR

One of the main goals of the narrative team with this game, beyond supporting the gameplay pillars, was to really bring to life the ties of the Batman Family through the characters and their interactions with each other. We start them off from a point of loss and friction. Their mentor (and in some cases father figure) has just died. Using that as our starting point, we take them through the process of grieving while stepping up to deal with a high-stakes situation.

We wanted to tell the story of family that gradually comes together in their time of grief and loss, that finds hope within each other and, through that, the confidence to grow and step into the shoes of their mentor, each in their own inimitable way.

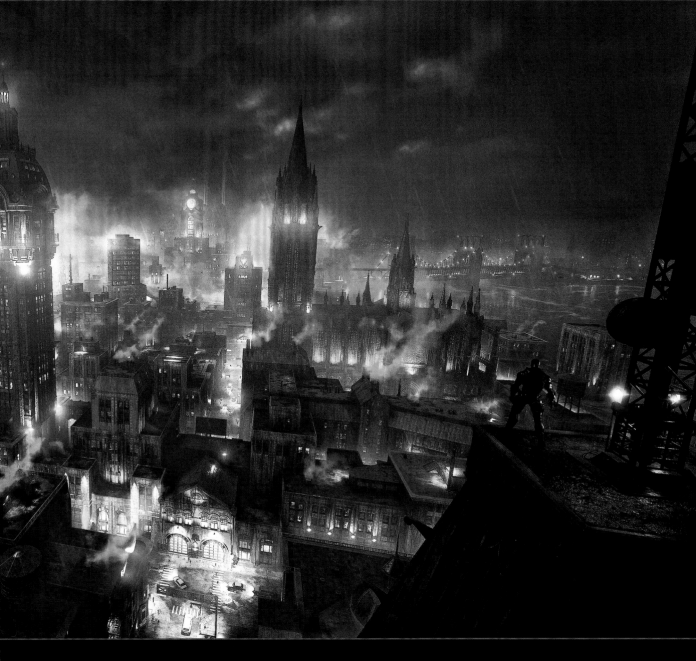

WILSON MUI

CINEMATIC DIRECTOR

The lore in the Batman and Gotham universe spans back decades with countless explorations via comics, TV, film, and animation. To keep our fans excited and engaged, it was clear to me early on that we needed *Gotham Knights* to hit several challenging goals with the cinematics:

- Create engaging and emotional storytelling via humanizing character moments.
- Make our characters (including our villains!) dynamic and believable with evolving character arcs.
- Respectfully sending off Batman in his last moments and segue into the continued stories of the Batman Family.
- Visually push our cinematic storytelling onscreen to make our mark.

While researching the stories of the Batman Family, this led to one of the key questions to explore—who are they outside of their superhero alter egos, especially with Batman out of their lives? With the death of their mentor, family member, and friend as a key traumatic event in their superhero lives, we had a huge opportunity to see the aftermath of this and to explore their human vulnerabilities individually and as a group. Realizing these stories has been an emotional rollercoaster ride as the players experience these emotions through the eyes of Batgirl, Nightwing, Red Hood, and Robin.

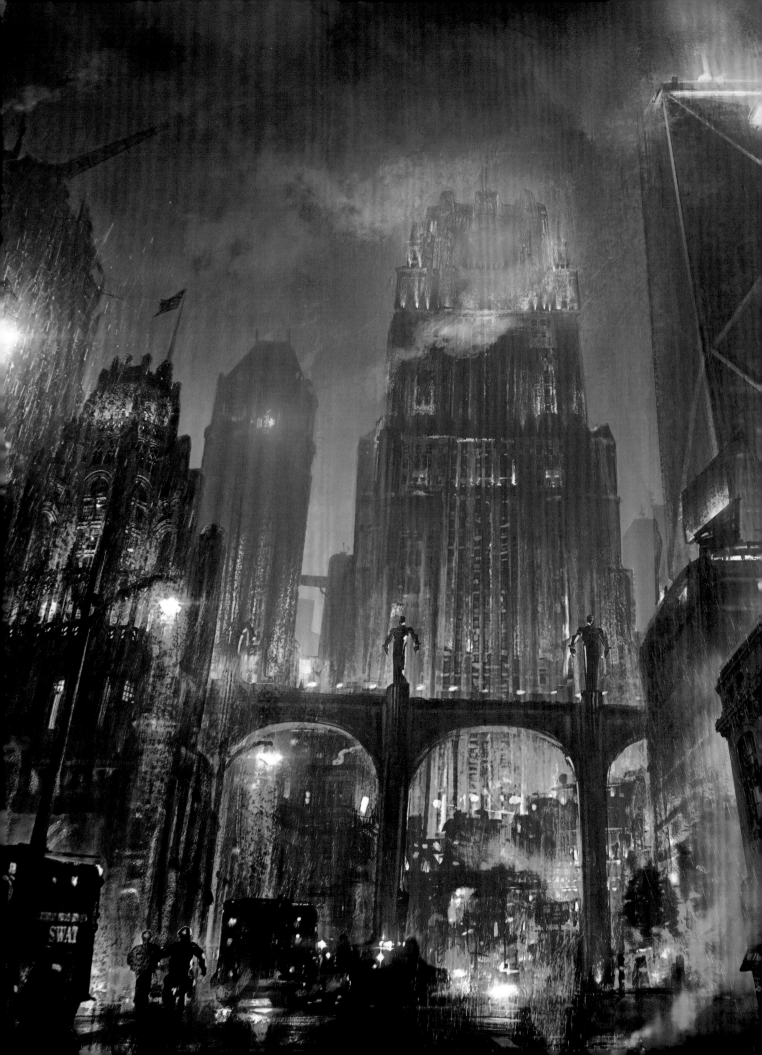

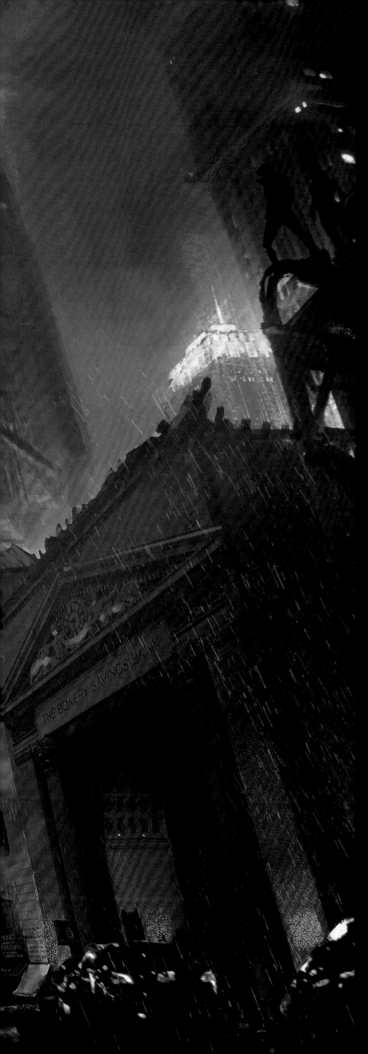

DANIEL KVASZNICZA
ART DIRECTOR (ENVIRONMENT)

Some of those goals we've captured in our art pillars that drive many of our artistic choices:

History: As Gotham in the comics is set in a fictional place in the New Jersey/New York area, we've pushed the visuals to reflect an East Coast American city and drew heavy inspiration from New York City during the '70s and '80s in its roughest moments. We've played with the fantasy assuming the city never recovered until this day—with corruption, gentrification, and a decline of the middle class spinning out of control, resulting in a stark contrast between the rich and poor. This ultimately helped us also to create a stronger distinction and identity between the various districts of Gotham City to reflect various demographics and cultural backgrounds.

Contrast: Showing an extreme contrast between rich and poor helped us to emphasize the fictional history of Gotham. Furthermore, the extreme contrast we've pushed into the art direction as a pillar emphasizing a film noir look, with dark shadows versus light pockets. Warm versus cold tones and complimentary opposing colors to push the visual contrast. In many ways we have cheated the contrast to achieve a more stylized look. E.g. neon lights are exaggerated and spill light into the atmosphere.

Verticality: We've selected architectural styles that support the vertical takedown gameplay more naturally, such as art deco and gothic revival. We have taken some additional artistic liberty to adjust some of those styles to favor vertical lines and introduce horizontal ones for navigation and traversal.

Our primary goal there was to turn Gotham City into the perfect hunting ground as a predator from above. Rather than allowing the player to glide and skip over large swathes of city real estate, we want the player to form a more intimate relationship with the city as a predator who would roam in its perfect hunting ground for prey—in our case, ridding Gotham City of crime and unlocking the mysteries that lie beneath it.

JAY EVANS
ART DIRECTOR (CHARACTERS)

The primary goals for character visual design were:

- Respect the IP and explore the fantasy through character designs that feel aspirational and larger-than-life.
- Retain the spirit and essence of the iconic comic book characters in a believable presentation.
- Accessibility and readability: Characters needed to be instantly recognizable.

CONTACTS

The Bat Family cannot do it themselves. They require help from allies to save Gotham City. These Contacts do not offer the same amount of help, but their assistance is needed to defeat common enemies. Access the Contacts tab on the Batcomputer for more information. Montoya, Fox, Thompkins, and The Penguin offer challenges as the player progresses through the story. Once a set of challenges is complete, return to the contact for a reward. This may activate a new set of challenges.

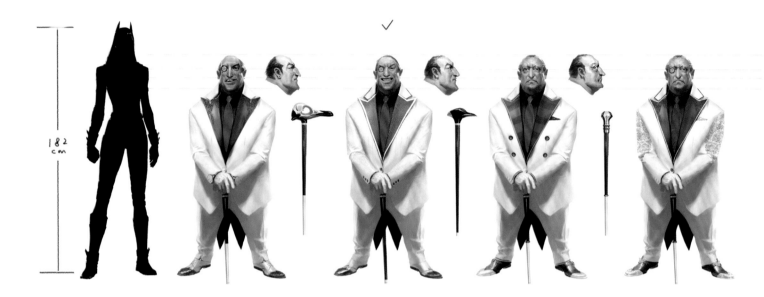

THE PENGUIN

- **First Appearance:** Challenges Unlocked after Visiting The Penguin a Second Time Following Case File 2.1

The Penguin has gone legit. At least, that's what he claims. In fact, he prefers to be called Mr. Cobblepot, or at least just Oswald. He spends most of his time running the Iceberg Lounge and from all outward appearances, it looks like business is good. Insinuations that he's still got ties with the criminal underground rile him up. Of course, while he may not be actively breaking the law, he's still a well-connected person who can prove to be a valuable ally, or at least a frenemy to the Batman Family.

The Cobblepot family is one of the original illustrious founding families of Gotham. Oswald, one of three boys born to Miranda and Tucker Cobblepot, was disliked and unwanted by his father, but doted on by his overprotective mother. He was teased relentlessly for his appearance throughout his childhood and young adulthood, and although the moniker "Penguin" was originally meant as an insult, Oswald embraced it.

In his youth, he was involved in petty crimes, steadily making his way deeper into the criminal underground, eventually being known as a smuggler who dabbles in everything from weapons

to drugs, and all manner of contraband. He is also a shrewd businessman, using the money he inherited after his father's death to purchase the Iceberg Lounge.

Although he served time in prison when he was younger, Oswald insists that he is now a legitimate businessman. By the time Batman died, Penguin had already developed a grudging respect for the caped crusader. The two had also settled into a sort of routine. Penguin would serve as an informant when it benefited him, and Batman would give Penguin a tiny sliver of leeway (typically in the form of a stern warning). They clashed many times in the past but ever since Cobblepot went "legit," his days of actively facing off against Batman came to an end. However, Batman's death has changed the dynamics in the city and Oswald is not above capitalizing on it like any other villain.

After completing Case File 2.1, return to The Penguin. He has his own challenges for the player. Once they have been completed, return to The Penguin to get a reward and unlock more challenges.

LUCIUS FOX

- **First Appearance:** Find Lucius in New Gotham while Completing Leads in Case File 2.1

Bruce Wayne personally recruited Lucius Fox to WayneTech. He was looking for someone smart and technologically savvy to bring the company back from the brink of bankruptcy. Lucius had a reputation for being tough and forthright, and a track record of saving companies that seemed doomed to failure. What Bruce didn't expect was for Lucius to become one of his most trusted advisors, to the point that he even learned that Bruce Wayne was Batman.

Eventually Lucius left to found his own company, Foxteca, but he and Bruce remained friends. And Lucius became part of the plans for what would happen to WayneTech if Bruce died. Lucius returns to the company as CEO, even as Talia tries to take it over. Lucius is calm in a crisis and undaunted by

difficulties. Talia may think she has the upper hand, but Lucius is determined to match her point for point. She may be smart and a skilled fighter, but he has the advantage of knowing the world of business, and he's convinced he'll emerge triumphant.

After the second visit with The Penguin, reach Foxteca in western Otisburg and speak to Lucius Fox who waits on the rooftop. This unlocks the fast-travel Batdrone. Several fast-travel points unlock around Gotham City, but each one must first be activated. One to three drones fly around each of these locations. The player must scan these drones to enable fast travel to that point. Some drones are shielded and can only be scanned once they land on their charging pads. Return to Fox to earn a reward and unlock new challenges.

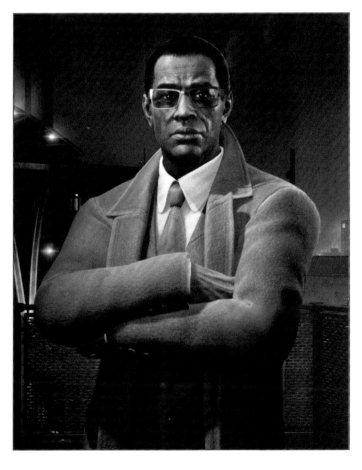

RENEE MONTOYA

- **First Appearance:** Available while Completing Leads in Case File 2.1

Renee Montoya has a hate/love relationship with vigilantes, but she is a good police officer. She assists the Batman Family throughout the game. After the second visit to see The Penguin, Renee Montoya can be found next to the Gordon Memorial on the far east side of the city. At this point, her challenges are available. Save officers, stop crimes, and interrogate criminals to earn rewards.

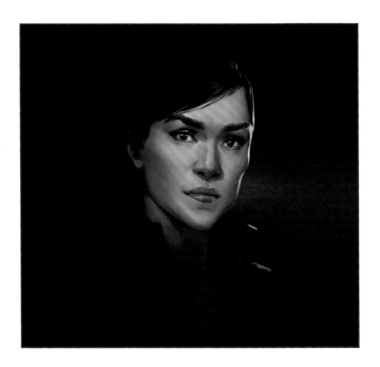

DOCTOR JADA THOMPKINS

- **First Appearance:** Complete an Organ Trafficking Activity after Case File 02 and Start a New Night Patrol

The daughter of Leslie Thompkins, founder of the Thompkins Clinic, Jada took over running the clinic when her mother retired. A woman of color who grew up in the Cauldron, Jada has on-the-ground experience with Gotham City's poorest citizens, and knows what they need to survive. Under her guidance, the clinic began championing efforts such as drug rehabilitation and safe-injection sites. The city objected, but Jada persisted. The result was the city making sure Jada lost her permits to the building that housed the clinic. Jada was not dissuaded, and turned the organization into a clinic-on-wheels.

Now she serves as a guerilla healthcare provider, using vans that can be found around the city. The city still hates the operation, but the beat cops turn a blind eye to the vans because letting her do her job helps them.

Jada and her people have been helped by Batman on more than one occasion—whether in getting them out of dangerous situations, or dropping by with cash donations. They will always help the Vigilantes when they can—and the Vigilantes help them in return. Find her in Otisburg, New Gotham.

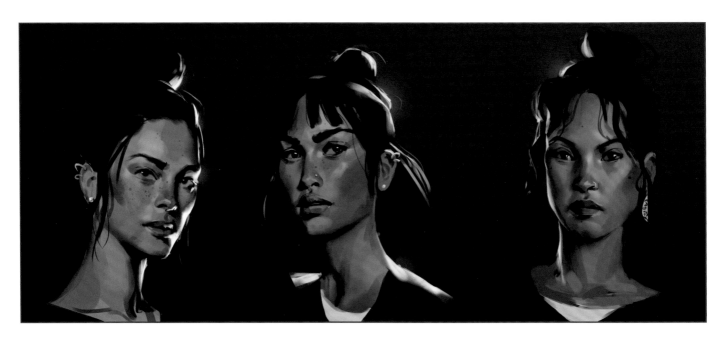

THE WATCH

- **First Appearance:** Find Mme. Palomares on the West Side of North Gotham After Case File 2.1

Mme. Palomares introduces the player to the Watch, a group of citizens concerned with crimes in their neighborhoods. The other four citizens are found in the other neighborhoods of Gotham; look for their circular icons on the map. Each person has challenges based on their neighborhood. Complete the challenges to earn rewards from each Watch member.

MME. PALOMARES, NORTH GOTHAM

- **Occupation:** Ringleader

"Mme. Palomares" is a code name—a necessary precaution undertaken years ago when she became an informant for the Batman. She is a spy movie enthusiast and proud grandmother to seven teenagers who would be simply *blown away* if they knew she worked with the Dark Knight—not that she would ever tell them, of course. She's had it up to here with the crooked GCPD, and thinks it's about time there was some real change in the neighborhood.

CHARLOTTE, HISTORIC GOTHAM

- **Occupation:** Artist

Charlotte wasn't born into money, she married into it. And while she loves her wife, she feels completely out of place in the world of Gotham's snobby elite. Moreover, she sees the kinds of petty, innocuous things her fellow wealthy citizens frequently report as crimes—and the far more sinister activities they themselves can get away with.

OSCAR, LOWER GOTHAM

- **Occupation:** Dock Worker

After years of working on the docks, Oscar feels like he's seen it all: shootouts, knife fights, illegal smuggling, that guy with a ketchup gun . . . He's also seen his fair share of suspicious containers, but he can't open them for fear of losing his job, and his bosses turn a blind eye whenever he tries to alert them. He's a little suspicious of the vigilantes, but he's willing to assist them if it will help clean up Gotham's streets.

TOSHIO, NEW GOTHAM

- **Occupation:** Teacher

Working as a teacher at the local high school, Toshio is privy to all kinds of disturbing rumblings. He cares deeply for his neighborhood and his students, and believes that they deserve a safe place to learn and grow up. The Batman showed him there was more than one way that he could help make that happen. Being a teacher doesn't pay well, so he also moonlights as a security guard. He is the newest recruit of Mme. Palomares' Watch.

DAVID, DOWNTOWN GOTHAM

- **Occupation:** Bartender

David loves his job at the Vesuvius. It's a cool joint, and there's always something fun going on—too bad Gotham's worst also like to use it as a hangout. David overhears all kinds of horrific plots while serving members of Gotham's various gangs, but unfortunately the corrupt police department refuses to take him seriously.

CRIMINALS

With Batman out of the picture, criminals in and around Gotham City move to take advantage of the situation. These individuals align with one of the local factions. The tech-savvy Regulators use state-of-the-art weaponry, typically stolen from Gotham City's tech industries. The Freaks are all about destruction and vandalism, and thanks to Harley Quinn, many Blackgate prisoners have flocked to this faction. The Mob are loyal to their families, guarding their bosses with their lives. Other factions you face in *Gotham Knights* include the GCPD, the Court of Owls, and the League of Shadows—all dangerous in their own right.

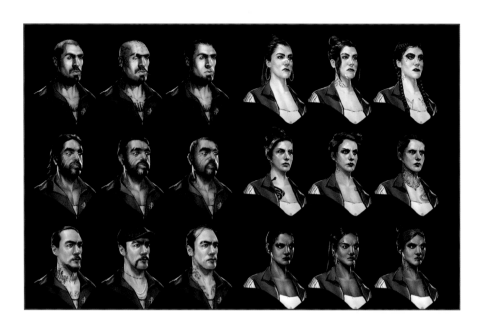

HOSTILES IN GOTHAM CITY

The hostiles in Gotham City provide a variety of challenges for our vigilante heroes. Some enemies, with labels such as veterans and champions, are tougher than others. Champions are often too powerful to finish with a single stealth takedown.

Informants are scattered throughout Gotham City, revealing crime locations when interrogated. Scan the hostiles at the scene to find out if someone has a secret to tell; informants must be grabbed to be interrogated. Revealed crimes from interrogations will appear in the Activity View.

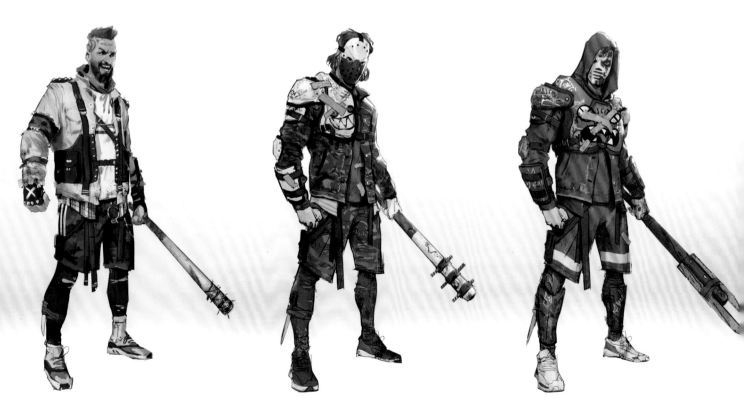

VILLAIN SHOWDOWNS

After a villain is defeated, replay them by interacting with the villain trophy on the shelves near the stairs. The bosses get tougher with every subsequent fight, so come equipped and prepared.

THE FACTIONS

The factions each have a variety of enemies in their ranks. Some enemy types are found in multiple factions, such as the following:

Brawlers are the most common hostiles and usually the simplest to take down. Whether equipped with a melee weapon or their fists and legs, these enemies almost exclusively fight in close combat, although they may also throw rocks. They can become dangerous in large numbers.

Shooters fire from a distance with their automatic rifles. **Snipers** have longer range and typically stick to rooftops. Keep them in view or watch for their aiming lasers, and time an evade just after a shot is fired. If possible, put an enemy or obstacle between the shooter and the player character.

Bulldozers are big and powerful, requiring a more tactical approach. Use a heavy attack to break their blocking stance, opening them up to other attacks.

Blackgate prisoners have a powerful attack that cannot be interrupted until piercing attacks become available.

Some enemies are unique to a specific faction. Freaks, Regulators, and the Mob are the main street gangs in Gotham City. Many Freaks are loyal to Harley Quinn, and many Regulators follow Mr. Freeze. But not all are aligned with these bosses. When you scan a hostile, any affiliation is shown.

GCPD

■ **Boss:** Commissioner Catherine Kane

For the most part, the GCPD does not trust the Batman Family and attempts to apprehend or kill vigilantes on sight. GCPD are extremely powerful and make for challenging fights, though you earn no XP or loot for defeating them. Use stealth to avoid fighting officers. When fighting alongside the GCPD, be careful not to engage them, or they may turn on you.

If the GCPD is involved in a crime or an alarm has sounded, it's best to flee the scene after completing the crime. If the GCPD finds a vigilante at the scene, they attack on sight.

Sometimes, they do so from a helicopter. Jump on the Batcycle and get far away to avoid a confrontation.

GCPD officers and **SWAT** are present in the police station and at some crime scenes. Avoid them whenever possible.

GCPD detectives are found working with enemy factions. These hostiles are an exception to the rule and should be taken down along with the criminals. Tougher than they look, GCPD detectives are master brawlers and carry handguns.

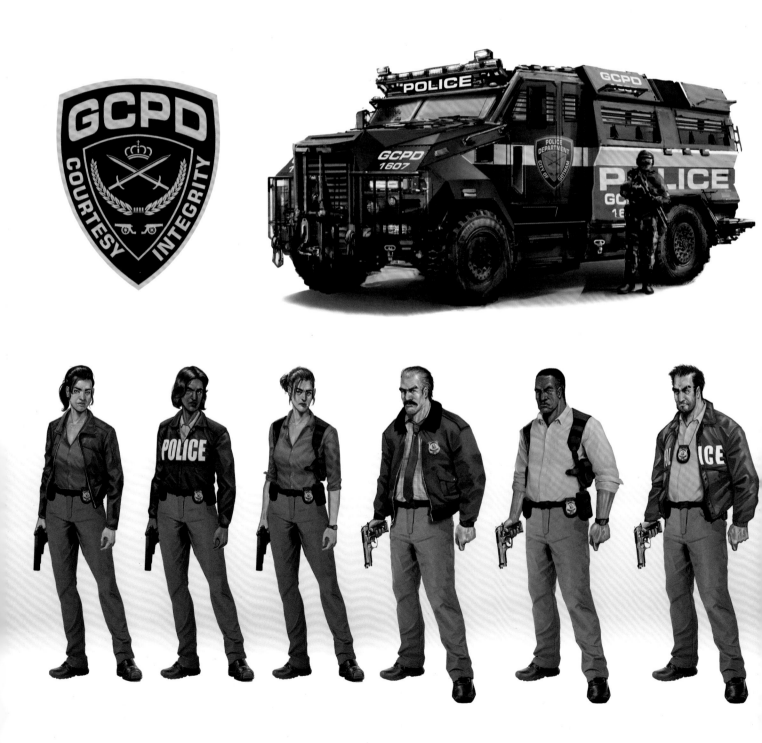

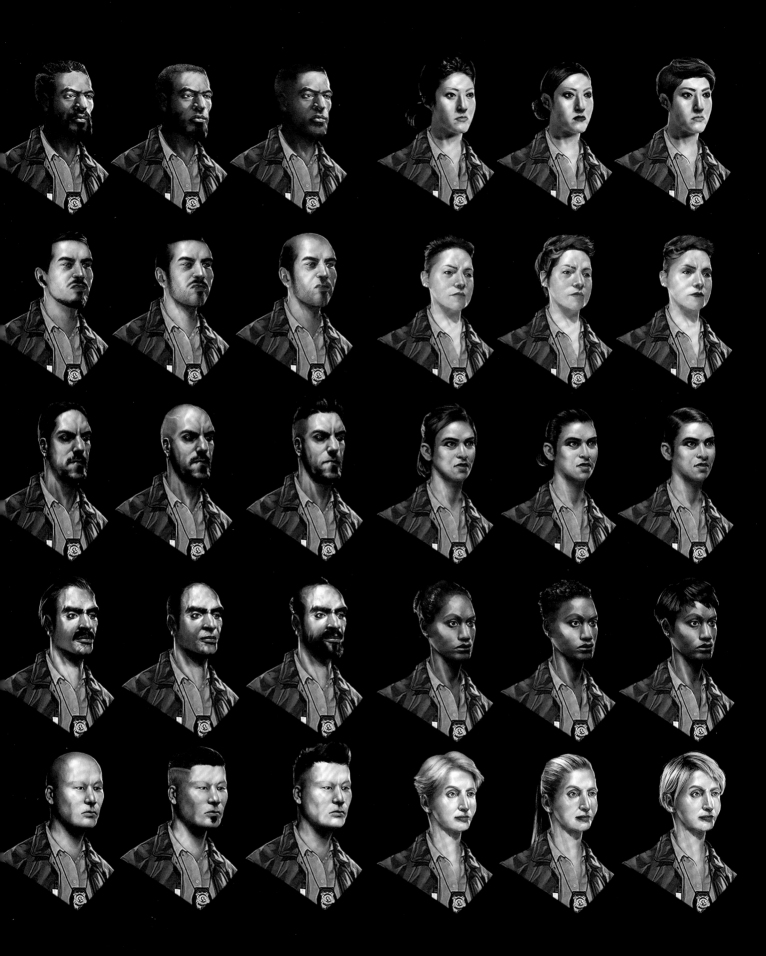

FREAKS

- **Primary Element:** Fire
- **Villain:** Harley Quinn
- **Location:** New Gotham, Tricorner Island

The Freaks are a chaotic and unpredictable faction, and they delight in destroying property. As the first faction the player fights in *Gotham Knights*, the Freaks want everyone to know they are in control. These hostiles are often found where rioting takes place, which seems to be much of Gotham these days. Due to their destructive nature, fire is their element of choice.

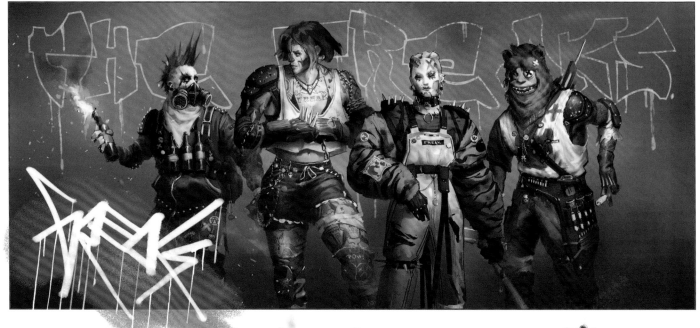

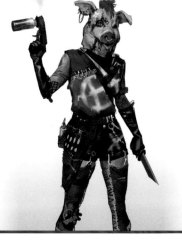

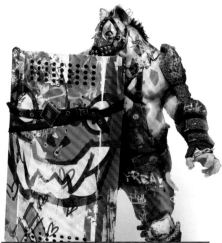

Firestarters, who lob Molotov cocktails, fit the Freaks to a T. Like shooters, they don't get too close to the player, choosing to fight from a distance. Watch for the targeting circle on the ground that indicates a bomb is incoming. This can be interrupted with a ranged attack.

Not seen until later in the game, **Freak juicers** can be a handful. They possess the ability to heal or enrage other hostiles. If allowed to remain in a fight, they make everyone around them more powerful. Keep them from spraying others; interrupt them when the can goes up. Their only weapon is a knife.

The **hyenas** are Harley's pet project. Similar to bulldozers, one carries a shield while the other wields a ball and chain. They never fight alone; a crew of Freaks always helps out, including juicers. Find them at Monarch Theatre during the Harley Quinn Case File.

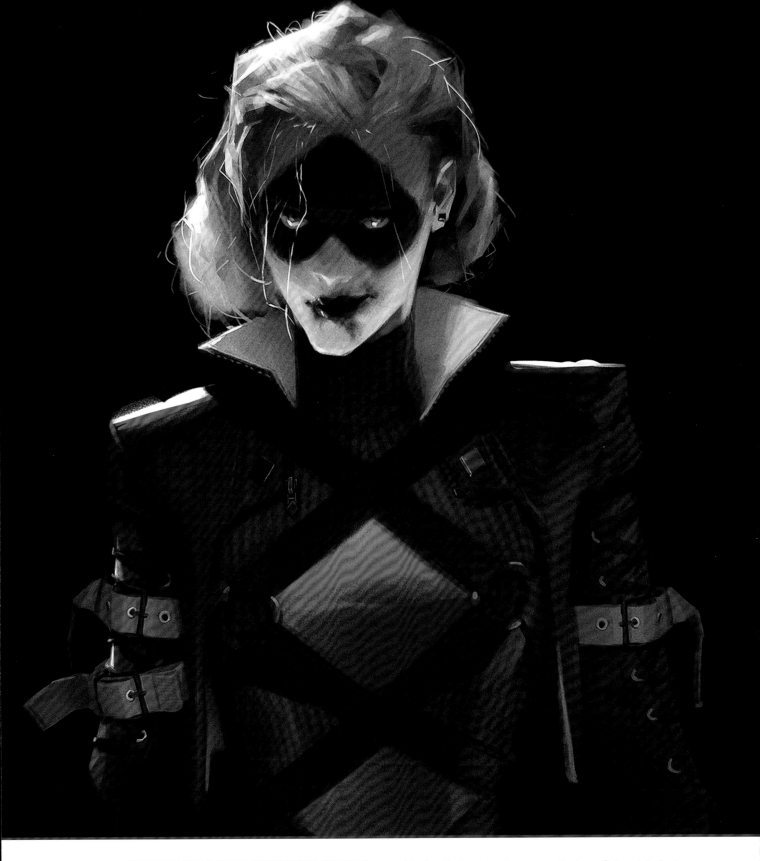

GEOFF ELLENOR
GAME DIRECTOR

Bosses had to feel like they were threatening Gotham City, so players had a real sense of the stakes if they didn't stop the villain.

Harley Quinn, also known as Harleen Quinzel, is first encountered in Blackgate Prison. After assisting the Batman Family, she creates a riot that provides the opening she needs to make her escape. She's the final boss fight of her Epic Villain Crime. Her weapon of choice is a large sledgehammer, which she swings wildly but with great effect. Don't let your guard down.

THE MOB

- **Primary Element:** None
- **Location:** New Gotham, Tricorner Island

The Mob has a long history in Gotham City, with multiple families presiding throughout the boroughs. You don't face too many mobsters in the Case Files, but they're busy criminals in Gotham.

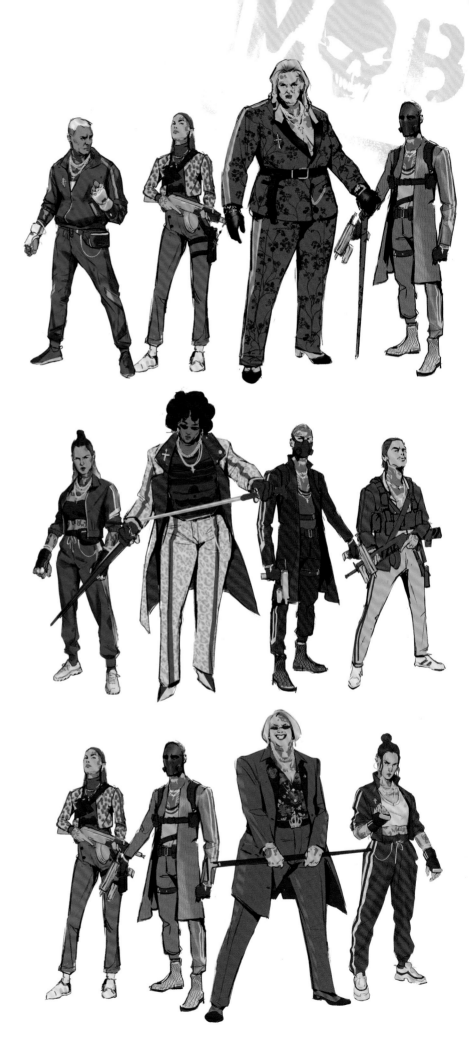

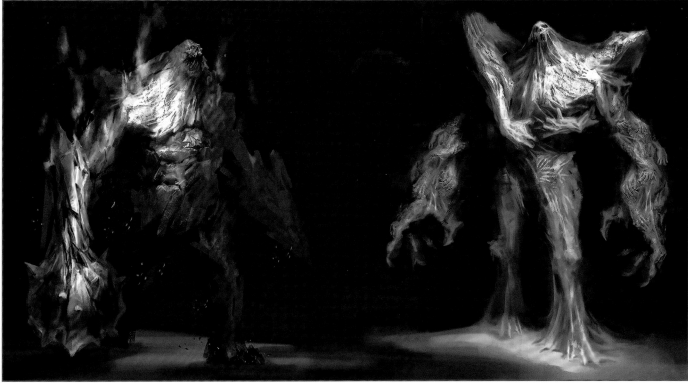

GEOFF ELLENOR
GAME DIRECTOR

We didn't want our boss-wins to be scripted. Players in *Gotham Knights* take time to unlock powerful abilities, and to craft their armor and weapons, so we wanted our normal fight mechanics to really matter in the boss fight. People who invested time to prepare for a boss should be more powerful, not just "and now you do the same quicktime event as everybody else because you hit the crane with your batarang three times."

Clayface, or Basil Karlo, has shapeshifting abilities due to his claylike body. This allows him to take any form and create multiple clay homunculi that do his bidding. Because of his plasticity, fighting Clayface can be a challenge. Keep an eye out for puddles of clay, which can form deadly traps underfoot.

THE REGULATORS

- **Primary Elements:** Shock and Cryo
- **Villain:** Mr. Freeze
- **Location:** Financial District, Southside, Tricorner Island

The Regulators are tech-savvy fighters with state-of-the-art weaponry, equipped with cryo or shock elements. During Freeze crimes, Regulator brawlers and shooters are loyal to Mr. Freeze and inflict cryo damage. Receiving enough of this element causes the player character to freeze in place.

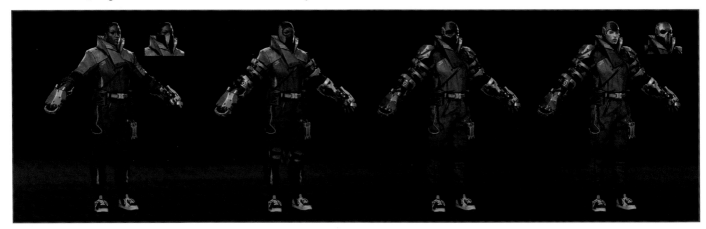

Shockers are big and powerful and wield shock weaponry. Watch for them to charge their cannons before firing a powerful blast that does massive damage and adds shock status effect with successful hits. Shockers also come equipped with shock grenades and are capable of a devastating area of effect. They leap into the air before striking the ground, causing the local area to become energized.

Drone masters are uncommon, but they can be troublesome. Although they can put up a fight, their drones are what make them dangerous. Interrupt them with projectiles to keep them from launching the drones.

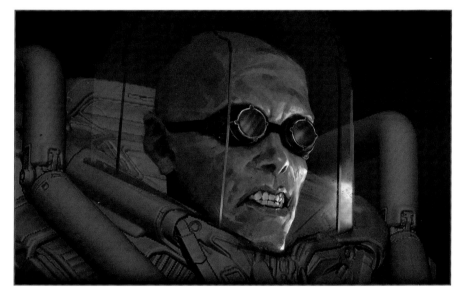

Victor Fries, now known as **Mr. Freeze**, is forced to wear a cryogenic suit due to a laboratory accident. This suit keeps his body temperature at subzero levels. In his Villain Case Files, he abandons his regular suit for a mechanical spider suit. His freeze gun and suit feed off the cryo-energy, producing devastating ice attacks. Mr. Freeze is not necessarily affiliated with the Regulators, but they assist the boss in his crimes.

THE COURT OF OWLS

- **Leader:** *Voice of the Court*

The Court of Owls is a secret society of elite and wealthy Gothamites whose corruption has infiltrated every part of Gotham, including political offices and the GCPD. Because of this, they believe they can get away with anything.

BEN GELINAS
WRITER

The Court of Owls are the old ways of Gotham City made incarnate: a secret society that represents everything rotten in the city's leadership and its elite, oppressive core. By doing battle with the Court, you're waging a war on the system itself—a difficult fight to win. If anyone's up to it, though, it's Batman. Except Batman's dead. Where does that leave Gotham?

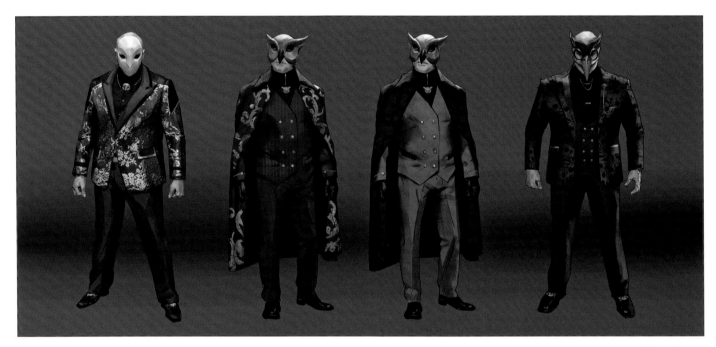

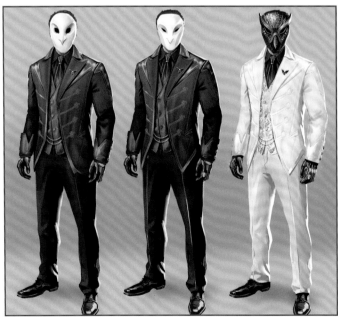

Court brawlers and **Court shooters** protect the Court.

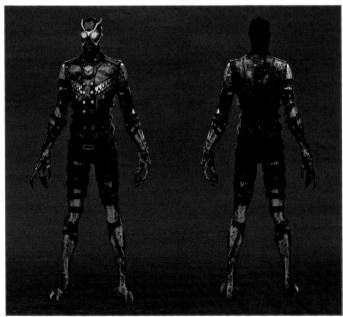

The Court created **feral Talons** to protect their interests. The Talons' quick movements and poisonous strikes make them a menace, especially in large groups.

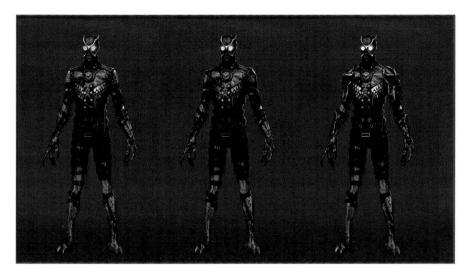

The **gladiator Talon** is a powerful foe equipped with a spiked mace and shield. Watch for them to leap toward the player character as they slam their shield into the ground, causing huge damage to anything caught underneath. Gladiators may be slow, but they hit hard, so be sure to move out of the way of their melee strikes.

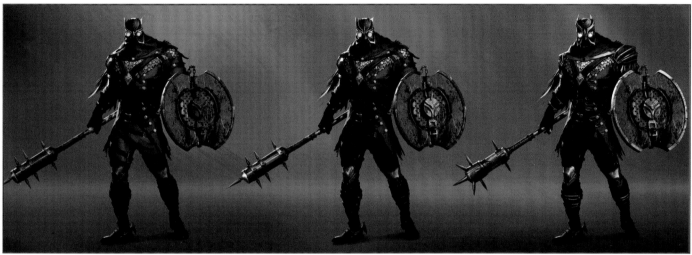

Though extremely rare, **hunter Talons** are possibly the most dangerous of the Talons. Equipped with dual blades, hunters keep their distance before leaping at their target with an uninterruptible attack. They also inflict poison with a quick projectile.

THE LEAGUE OF SHADOWS

- **Leader:** Ra's al Ghul

The League of Shadows is a secret society focused on ridding the world of corruption—by any means necessary. Longtime leader Ra's al Ghul has plans for Gotham City but ultimately dies attempting to bring Batman in as their new leader. Who will lead them now?

JAY EVANS
ART DIRECTOR (CHARACTERS)

The villains of the DC universe are iconic. Designing new interpretations of the Rogues Gallery is always a bit daunting. I think it's important to respect the many artists that worked on these characters before us and add a new layer to the fiction without trying to completely reinvent the characters. I believe players appreciate a visually fresh take while still being able to recognize their favorite villains.

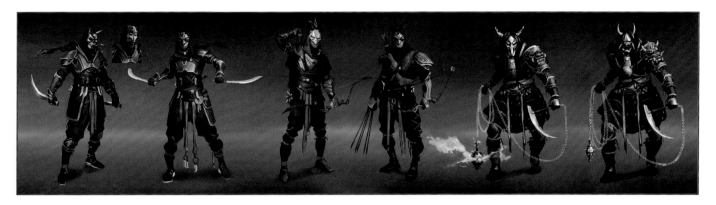

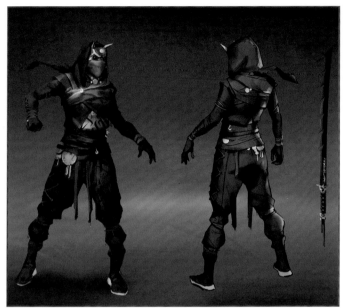

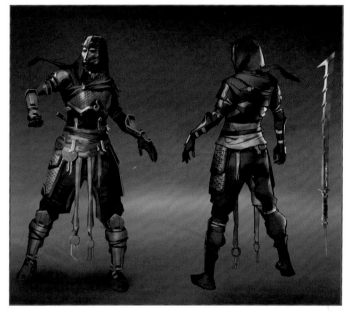

League assassins wield dual, serrated swords and are extremely fast. With the ability to disappear in a shroud of smoke and reappear next to their target, these ninja-like fighters can be tough to keep track of. Therefore, it's best to remain on the move and be quick with a counterattack. Abilities that deal damage over time, like Robin's Fireworks, can prevent these villains from vanishing in combat.

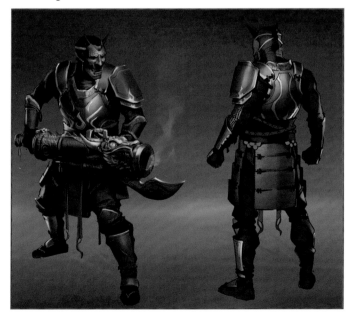

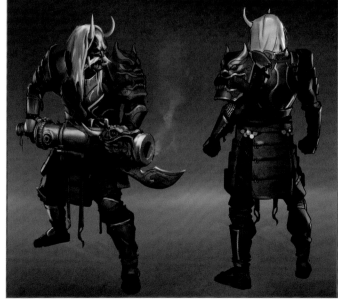

League rocketeers carry large rocket launchers that can either fire a projectile directly at a target or lob a rocket in the air that follows a trajectory back down to the ground. A white circle indicates where the explosive will land. The weapon is equipped with a blade on the front, so rocketeers can participate in melee combat when up close.

CASE FILES

The game's primary missions are split into numerous Case Files that tell the main story of *Gotham Knights*.
All Case File Leads and side activities are unlocked as you progress through the game.

THE PROLOGUE

- **Requirement:** Start a New Game

Main Objective: Defeat Ra's al Ghul

LOCATION: BATCAVE

The game begins deep inside the Batcave. Batman fends off an aggressive Ra's al Ghul, who demands Batman take his position as the leader of the League of Shadows.

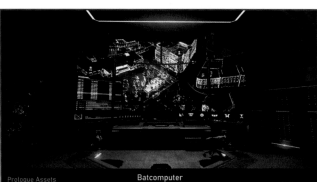

Prologue Assets · Batcomputer

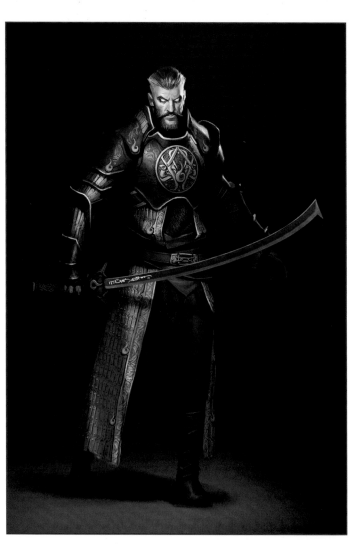

JAY EVANS
ART DIRECTOR (CHARACTERS)

The goal of Ra's was really to create an equal to Batman. From his abilities to his custom outfit. They were designed together to create a contrast between the old and the new.

Batman manages to activate his contingency plan, collapsing the Batcave around himself and Ra's and sending out messages to the Batman Family.

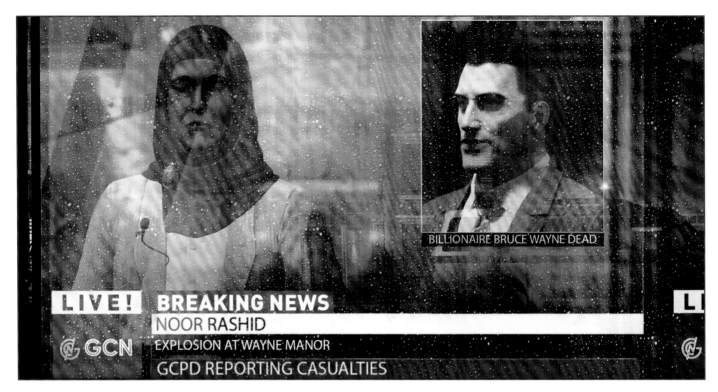

LIVE! BREAKING NEWS
NOOR RASHID
EXPLOSION AT WAYNE MANOR
GCN GCN
GCPD REPORTING CASUALTIES

BILLIONAIRE BRUCE WAYNE DEAD

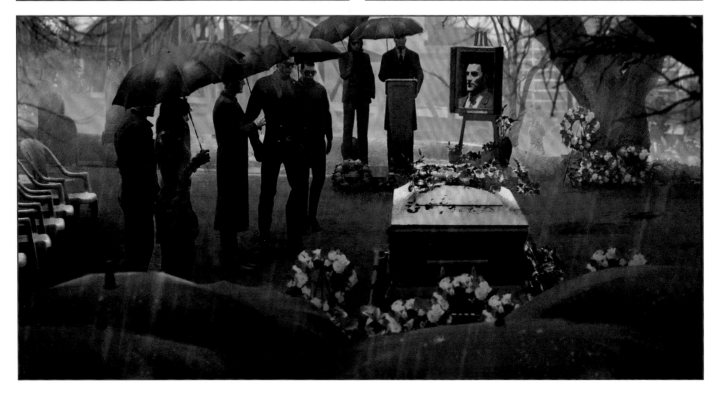

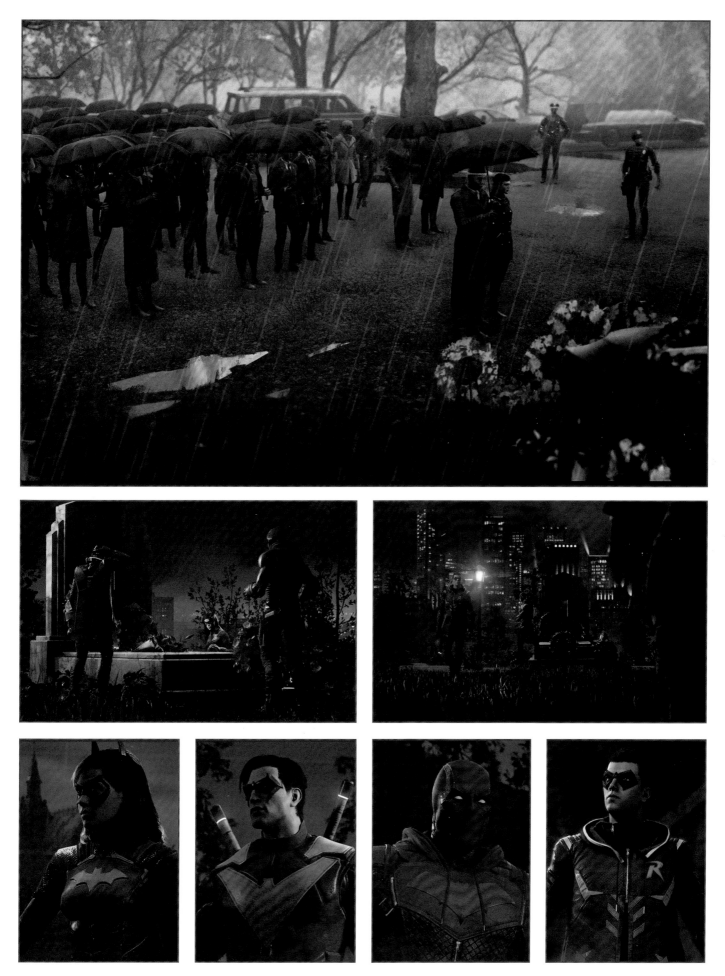

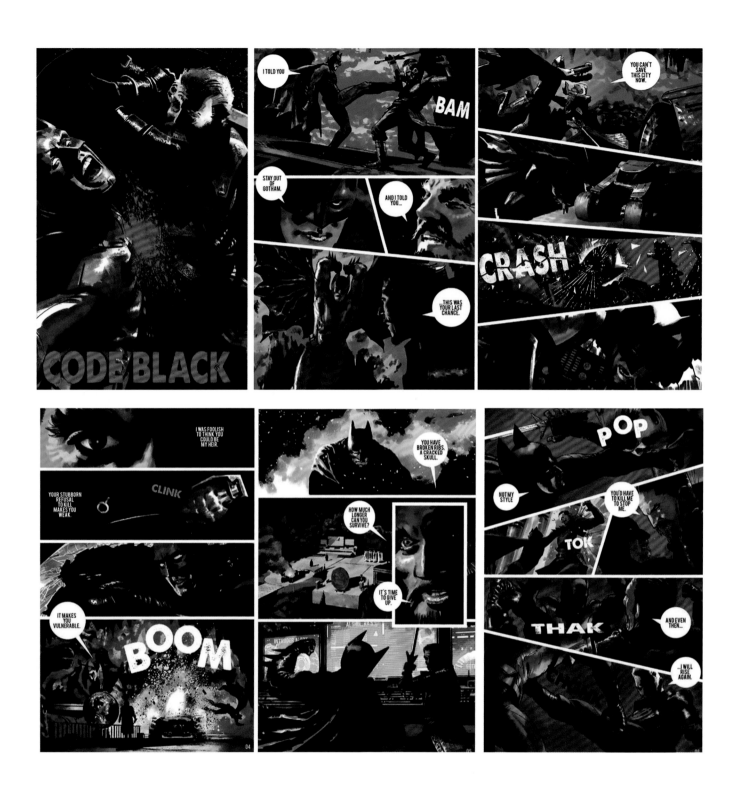

To prove out the tragic introduction to *Gotham Knights*, concept artist Manuel Vallelunga and creative director Patrick Redding created a dramatic 12-page comic entitled "Code Black." The story detailed an epic, ultimately fatal battle between Batman and Ra's al Ghul that ended with the Batcave collapsing on top of them.

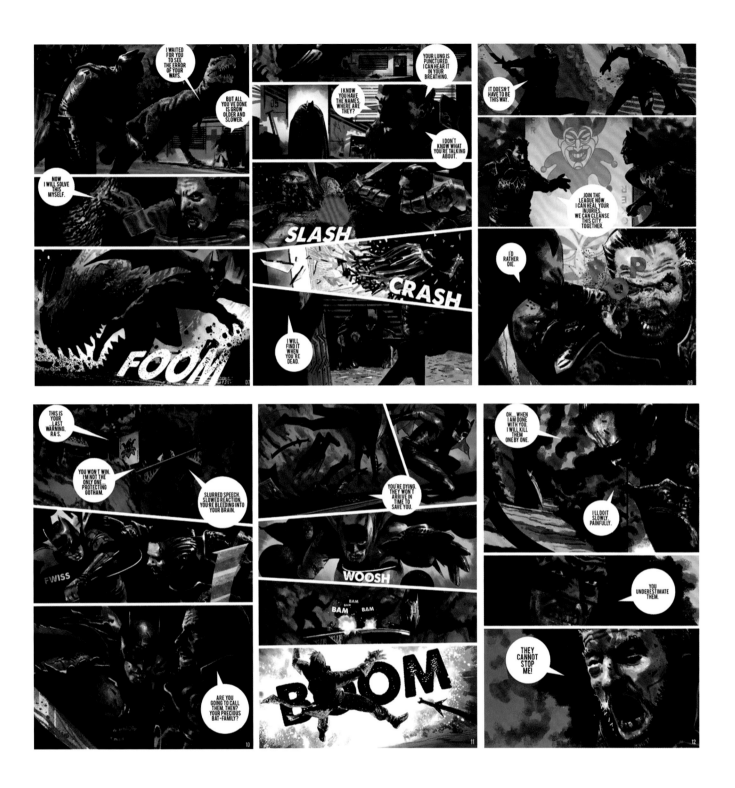

The comic was shared with the development and publishing teams early in the game's production as an internal pitch piece meant to set the tone for the game and convince the broader team that killing Batman at the start of a video game was something that might actually work.

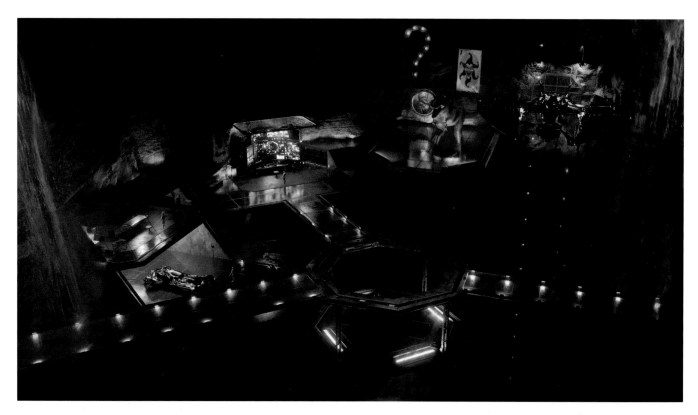

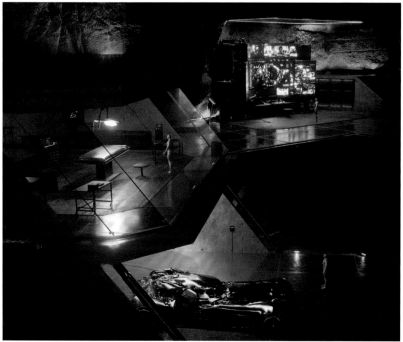

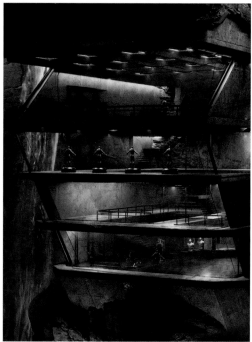

Before the *Gotham Knights* team could destroy the Batcave, they had to build it. Concept and level artists mapped out what the cave layout would look like. The Batwing, T-Rex, Joker card, giant penny, and Riddler question mark have all appeared in past comic book depictions of the Batcave, and they all reference previous cases that Batman had worked on. Including them in the game gave the space a sense of history.

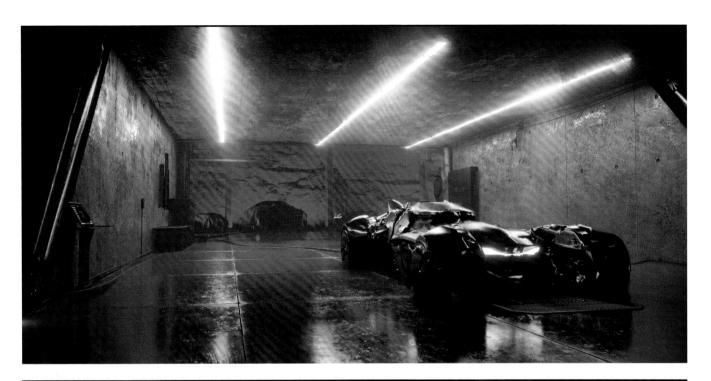

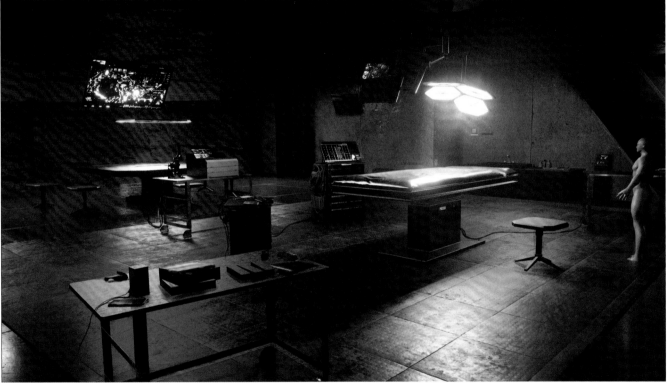

The garage that housed the Batmobile also included other vehicles not pictured, and in the center was an elevator that was used to move the vehicles between levels. The artists also included a multistory training gym, a medical bay, and plenty of bats. The whole thing was suspended above a giant pit into which it could eventually all come crashing down.

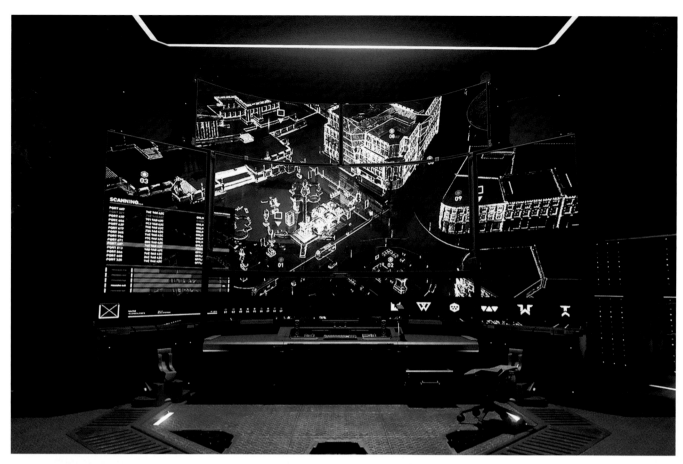

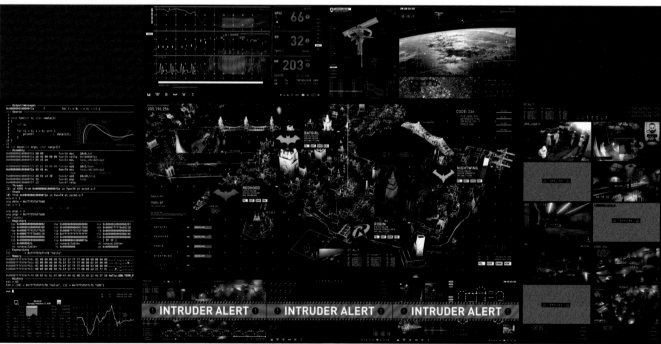

The Batcomputer in the Batcave was overloaded with screens and stacked with servers. It was designed to be significantly more advanced than the tech the heroes would have to use in the outdated, neglected Belfry. Screen mock-ups included the location of Gotham's heroes at any given time, various monitoring data feeds, and, if you look closely, the Justice League satellite.

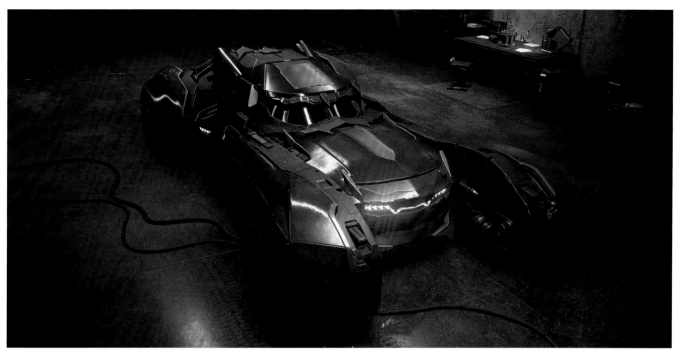

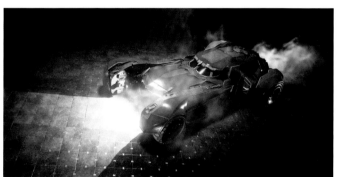

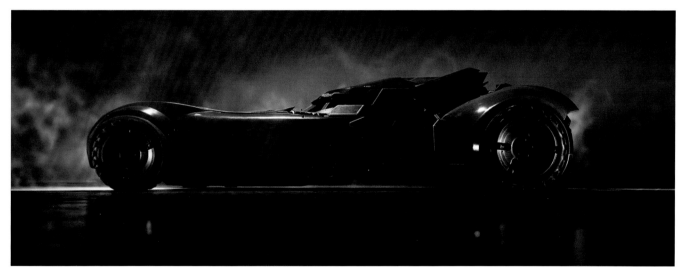

In the game, both the Batmobile and the Batwing were built around an armored cab that could be swapped into the core of either vehicle—a modular system based on some of the more recent comic book interpretations of Batman's small but mighty fleet. The cab could accommodate multiple heroes instead of just Batman, and features a reinforced windscreen designed to withstand anything Gotham City could literally throw at it. "It was built to go fast and take a hit," says character art director Jay Evans.

FRONT

BACK

So much of Batman's history is larger than life, and these Batcave mementos are no exception: a Joker Card from one of the Clown Prince of Crime's lairs; an illuminated Riddler question mark; an animatronic Tyrannosaurus Rex from Dinosaur Island; and the giant penny that came into Batman's possession after he thwarted a heist by the villain Penny Plunderer.

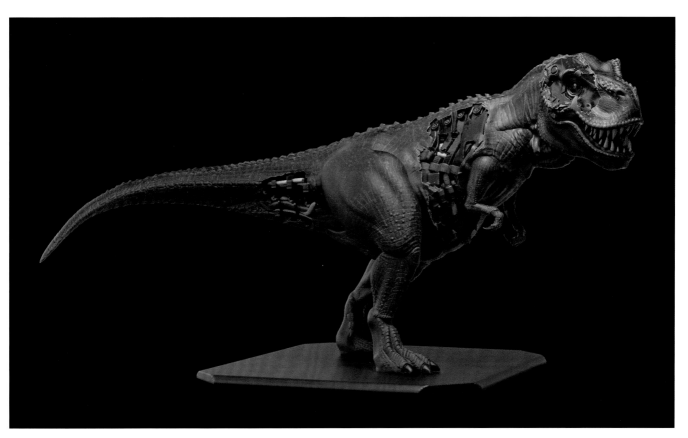

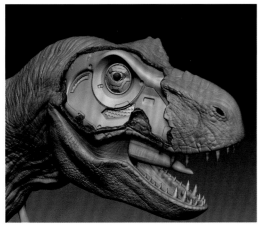

A great deal of care was taken to ensure that each iconic prop felt at home in the art style of *Gotham Knights* while at the same time maintaining its unique status as a relic of Batman's earlier adventures in print and beyond. When the heroes return to the ruins of the Batcave at the end of the game, they find that these items have all survived, albeit somewhat worse for wear.

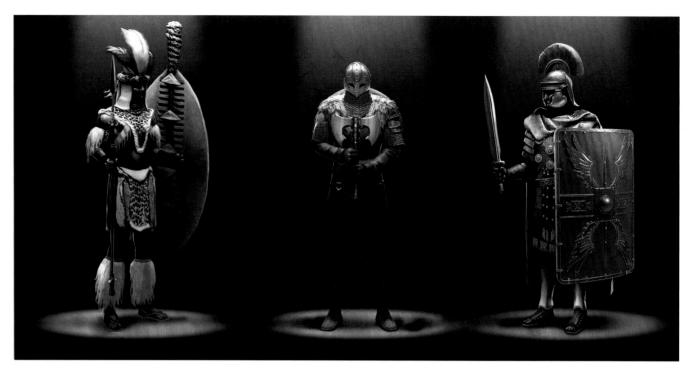

Much like his uncle Jacob Kane, Bruce Wayne was an avid collector of cultural and military artifacts from around the world and throughout history. Many of these museum-quality pieces were displayed in the Batcave's training gym, including objects inspired by the weapons and armor of Zulu warriors, Vikings, and ancient Romans.

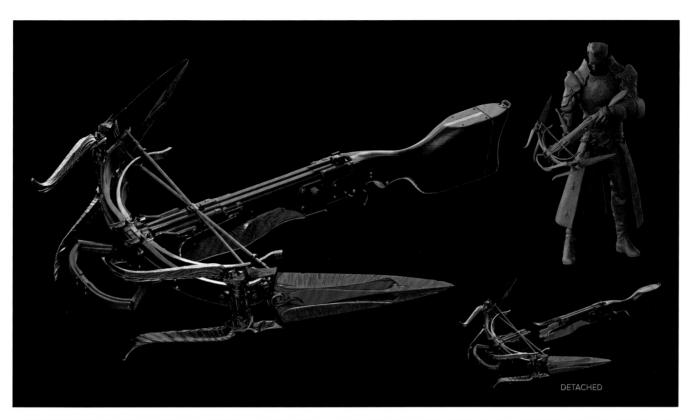

DETACHED

Ra's al Ghul's personal arsenal of weapons were all punctuated by a glowing green hue inspired by the color of the Lazarus Pit. Although their designs were centuries old, these lethal instruments were built using modern techniques to be as deadly as they were decorative.

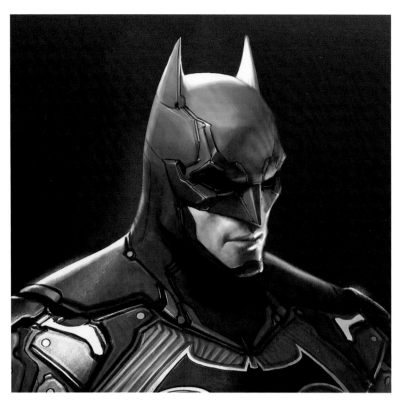

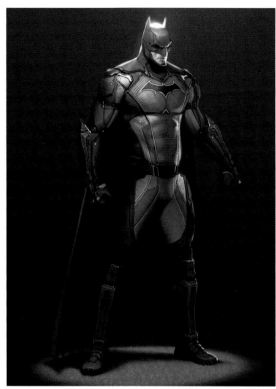

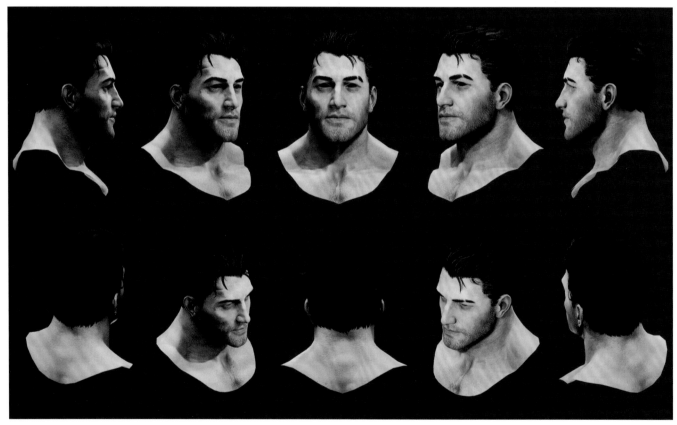

"The big thing about these two is contrast," says character art director
Jay Evans. Batman's costume design is slick, ultra-modern, and low-detail.
Made with matte plastics and high-tech composites, his suit feels almost
manufactured.

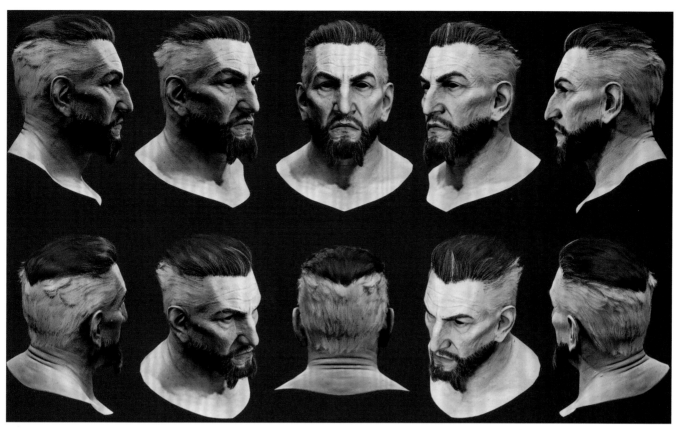

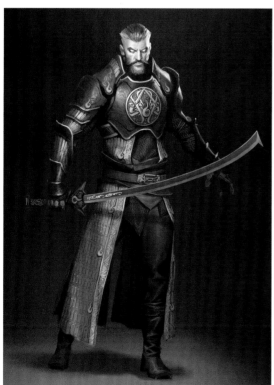

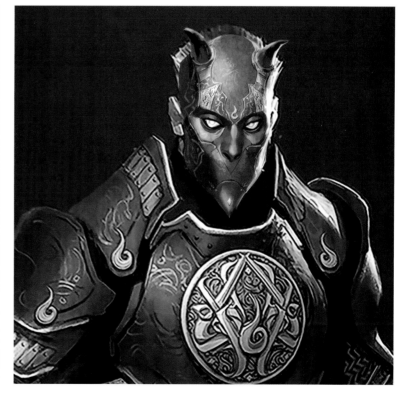

Ra's al Ghul's costume is much more decorative and detailed. It incorporates shiny metals and filigreed details. Seen side by side, the differing looks of these two costumes were meant show the rivals' competing priorities and techniques in battle: the old versus the new; the tested versus the technical.

CASE FILE 01:
BATMAN'S LAST CASE

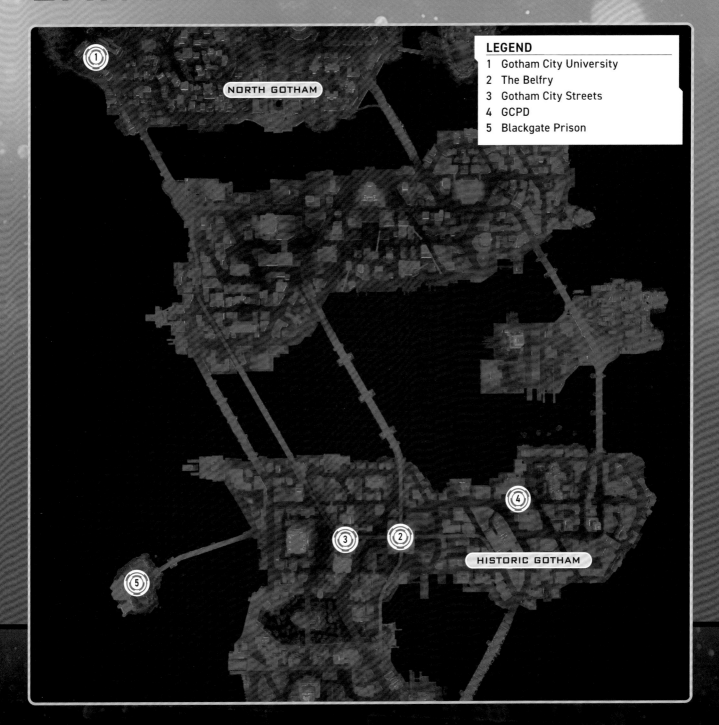

LEGEND
1 Gotham City University
2 The Belfry
3 Gotham City Streets
4 GCPD
5 Blackgate Prison

NORTH GOTHAM

HISTORIC GOTHAM

■ **Requirement:** Complete the Prologue

Main Objective: Continue Batman's Investigation

Batman has sent out a Code Black message to the four heroes in hopes of them coming together to protect Gotham City. Included in the message is information on Batman's final case, with mentions of a Dr. Langstrom. This points the team towards Gotham City University.

At this point the player must choose one of the Gotham Knights to begin: Batgirl, Nightwing, Red Hood, or Robin.

CHOOSE YOUR HERO

You're not stuck with this Knight for the entire game. Whenever you visit the Belfry, interact with one of the suits located to the left of the Batcomputer to switch heroes. All characters level up at the same time so you swap and have another hero at the same level. No need to worry about being underpowered, as enemy levels are based on the selected hero's level.

AUGMENTED REALITY

The cutting-edge augmented reality (AR) system built into the heroes' suits allows the player to acquire pertinent information from any scene. Simply toggle AR on and look around to find clues that assist the Knights in their investigations. AR can also be used to learn more about nearby criminals, allowing for weaknesses to be exploited.

CASE FILE 1.1: KIRK LANGSTROM

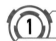

OBJECTIVE:
1 INVESTIGATE DR. LANGSTROM

- **Location:** Gotham City University
- **Faction:** Freaks

The university provides the perfect location for a quick tutorial. Learn how to get around and fight criminals in Gotham City. Drop through the skylight ahead and follow the path until the hero pauses on a rooftop. Below, a body is loaded into an ambulance.

Grapple onto the perch on the side of the building across the street, and then grapple onto the third-floor balcony of Moulton Hall. Enter Dr. Kirk Langstrom's office on the left side of the hallway. Turn on AR to find clues missed by others (like mysterious marks in the office) and pick up a trail.

INVESTIGATIONS

Investigations in *Gotham Knights* involve scanning through pieces of evidence for clues. Questions pertinent to the investigation appear in the upper corner of the screen. Move the cursor around the items laid out before the hero for helpful descriptions. Use this information to mark the items that answer the questions. Once all questions have been satisfied, press the Solve Crime button. The correct solution moves the investigation forward. If failed, select a different combination of clues.

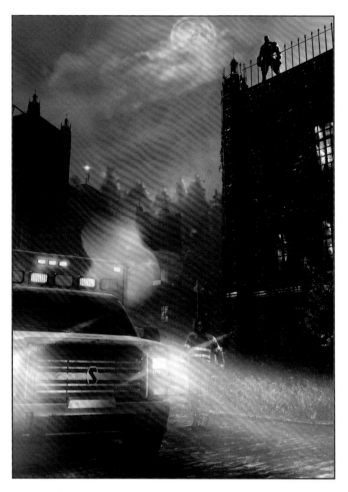

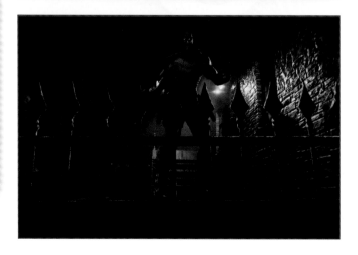

Follow the marks across the hall, down the stairwell, and into the open workshop. Drop through the broken window into Langstrom's lab. Scan the sliding rails behind the right cabinets to find out a passcode is needed to proceed. Interact with the far workbench to begin an investigation. By scanning items around the bench, numbers are found as potential codes. Pick up Langstrom's Notebook and turn it over to find it. Next, mark the microwave as a clue and solve the crime. This provides a path down to a hidden laboratory. Interact with a Hard Drive on the far desk before backtracking upstairs and following the waypoints out of the building.

ANN LEMAY
NARRATIVE DIRECTOR

It's difficult to convey four character arcs within the scope of a single game—we had to really pick and choose how we were going to do this while not making four games' worth of cinematics. Finding ways to convey individuality of voice and character development for all four of our Knights while still finding some narrative depth was a heck of a challenge.

One way we found to solve this was with the Belfry scenes. There was a lot of back and forth on whether the Belfry would have the other heroes present at all times for example, but that was one of the things the narrative team was always very set on having—that yes, the Batman Family would be there nearly at all times and yes, we would work specifically to showcase the progression of their comfort levels with each other and their gradual acceptance of what had happened to Bruce while they are settling into their new roles as protectors of the city. At the start of the game you can see how tense they are, and that they do snap at each other and are more aware of their personal space.

We worked with Wilson and the cinematics team specifically and used the Belfry Scenes involving all four Knights (and Alfred!) to showcase the gradual shift in their relationships in a very visual, intuitive way. They aren't a cohesive unit at first—there are tensions and unease, and this is easily discernable in how they interact with each other. For example, at the start, Babs points out to the others that they are crowding her at what used to be her space during her time as Oracle. Later on, however, we see them being closer to each other, literally, in how they touch more and are more casual in their interactions—and decidedly so in how they tease each other, with shifting alliances to boot! When stress gets to them again in the aftermath of the Labyrinth, Alfred steps in to remind them of what matters—and they listen. Because they know he's right, and all they need is a reminder of this to refocus on the task at hand. And because, of course, they don't actually want to be upset at each other.

The only Belfry scenes where just one hero is featured occur for a specific reason. To highlight, near the end of the game, the rise of the new Dark Knight. But even so— we still end the game on a Batman Family group moment (don't miss the easter egg cinematic!) because at the end of the day, found family should absolutely be a part of any Batman story.

- **Location:** Gotham City University
- **Faction:** Freaks

A Freak brawler occupies the courtyard, providing an opportunity for the hero to brush up on basic fighting skills with light attacks and evasion. Once clear, enter Hummel Hall ahead, where an unsuspecting Freak is an easy target for an Ambush Strike.

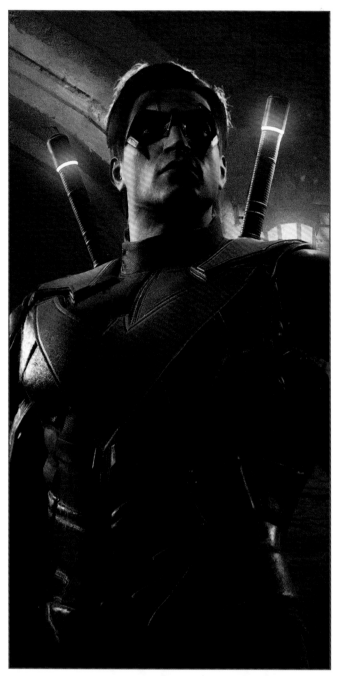

AMBUSH STRIKES AND SILENT TAKEDOWNS

Whenever an enemy faces away, approach in a slow-moving, crouched position to remain undetected. Once close enough, the player can perform an Ambush Strike or Silent Takedown. An Ambush Strike is quick but attracts attention. The Silent Takedown leaves the player vulnerable but a successful takedown leaves the hero undetected. When multiple foes are around, observe their patrol routes and pick them off one at a time without alerting the others. If a criminal finds a body, they switch to an alert mode that makes them aware of the hero's presence. Flee to a safe position and wait until they return to normal, or fight it out in a big brawl.

Climb the left stairwell to the second floor and perform successive Silent Takedowns on more unaware Freaks. Exit through the open window to find a small group of criminals back at the courtyard. Use AR to scan the three hostiles, grapple to the statue, and then use the perches to defeat the hostiles with Silent Takedowns. Enter Woolfolk Hall.

STRIKE FROM ABOVE

When a hero is perched directly above an enemy who is unaware of the vigilante's presence, Silent Takedown and Ambush Strike become available. This is a great opportunity to remove an enemy without being detected. Take a look around the area for gargoyles, balconies, statues, vents, or anything that can be grappled to. The AR system highlights these locations. If you're detected, grappling between these perches may disorient the enemy, causing them to lose your location—especially effective with lower-level criminals.

 OBJECTIVE:
DEFEAT THE FREAK FIRESTARTERS AND BULLDOZER

- **Location:** Gotham City University
- **Faction:** Freaks

A lone Freak makes great target practice for your ranged attack. Head up the right steps and observe the scene from the balcony, where a group of firestarters has trapped a few civilians behind the counter. It's possible to get a Silent Takedown on one of the foes, but an Ambush Strike is quicker. The rest immediately attack no matter how you start the fight. These guys add an extra element of danger—Molotov cocktails. Quickly move between the hostiles, keeping them on their toes. Look out for a circle on the floor signaling an incoming projectile. A quick ranged attack can prevent the strike from following through. Otherwise, evade the fireball.

BASE VETERAN CHAMPION

With the firestarters out of the way, free the hostages before a Freak bulldozer bursts into the room. This guy carries a shield and mace. Use a heavy attack to break the enemy's blocking stance, then follow up with a series of light attacks. When the big guy recovers, be ready to evade his shield bash. Once he goes down, the hero exits the building.

OBJECTIVE:
② GO TO THE BELFRY

■ **Location:** Gotham City

Walk to the nearby street and call the Batcycle. Arrows on the road lead back to the Belfry. Along the way, learn the ins and outs of the bike. Wheelies provide short bursts of speed and allow the bike to drive over objects in the way, but they do affect control. Tapping the brake while steering around a turn causes the bike to drift, allowing for a quicker turn. This takes some getting used to but is worth the effort.

AVOID GCPD OFFICERS

Feel free to fight crime as you travel through Gotham City, but avoid engaging GCPD officers. No XP or loot is earned for their defeat. Use stealth to avoid fighting them.

Follow the arrows all the way to the Belfry. This automatically takes you up to the new Batman Family headquarters. Boot up the Batcomputer to investigate the new evidence.

LEVEL UP

At this point, the player character used through the tutorial levels up. Take this opportunity to check out their Ability Tree and use available Ability Points to unlock new abilities. Abilities make each character unique and extremely useful in specific situations. How you approach a crime scene may differ greatly depending on the abilities unlocked. Later, and often better, abilities require a set amount of points to be spent before becoming available.

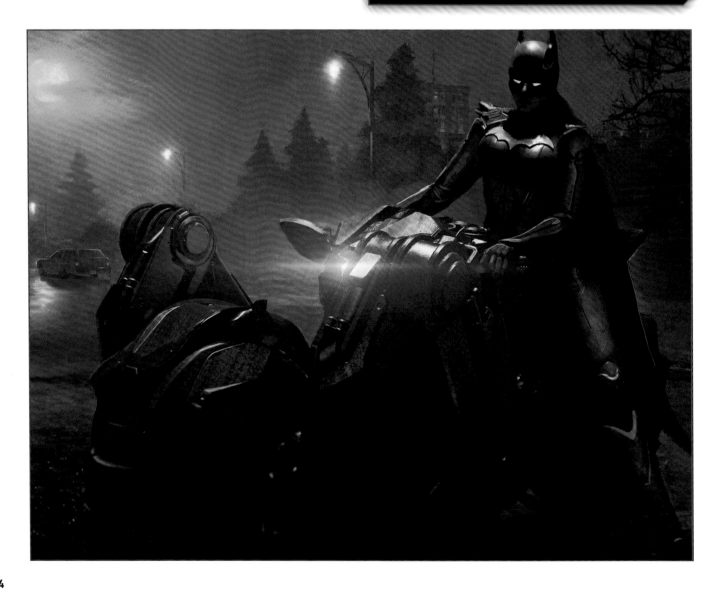

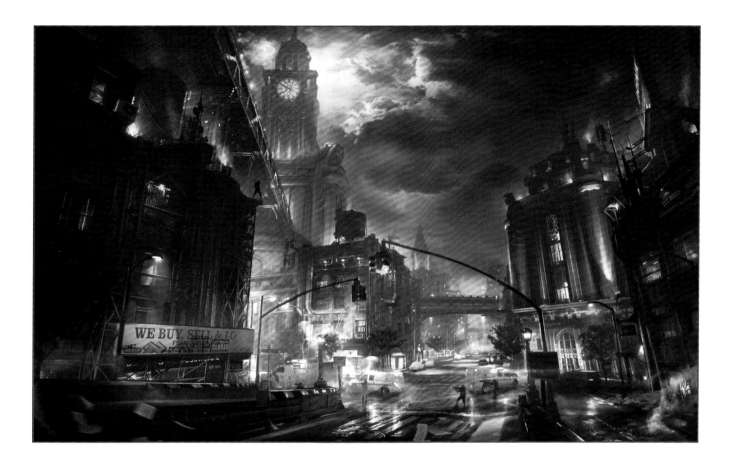

SPECIAL ABILITIES

Special abilities, unlocked as you level up, provide unique combat maneuvers for each hero. During a fight, the momentum meter fills when certain actions are performed: successfully attacking enemies, evading their attacks, and performing stealth takedowns. When a full momentum segment is achieved, press the Ability toggle along with the assigned face button to perform the special ability on a targeted enemy.

CO-OP PLAY

Upon arrival at the Belfry, co-op play becomes available. This allows you to play through the game with another player or participate in Showdown boss fights with up to four players. Press the com-wheel button and select Social Menu or Co-op to begin.

 OBJECTIVE:
3 PATROL THE STREETS OF GOTHAM CITY

- **Location:** Gotham City
- **Faction:** Any

Exit the Belfry to head out on night patrol. Find active crimes and defeat the criminals before they get away. Clues collected from criminals can be processed at the Belfry.

NIGHT PATROL

Each time you exit the Belfry, you begin a new night patrol. Explore Gotham City to find active crimes. Premeditated crimes are marked on the map, as well as the compass if nearby. Active crimes are marked with a red X, while premeditated crimes are marked with a specific icon, depending on the type. Use AR to scan the criminals to find informants. An informant can be grabbed and interrogated for clues. Highlight a crime on the map, and you can place a manual marker to help you find them. Defeat the criminals at these locations, and they may drop clues, which can then be returned to the Belfry. There, access the Batcomputer and use the clues to reveal upcoming premeditated crimes. Follow these crimes on your next night patrol.

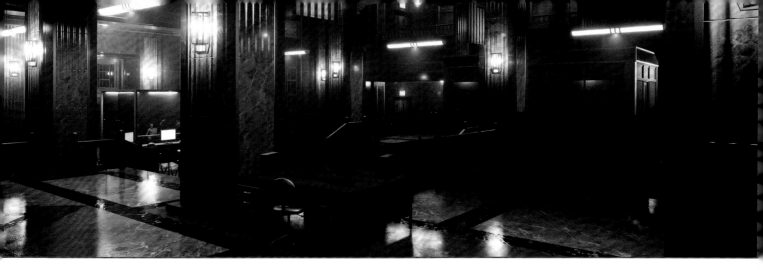

CASE FILE 1.2: THE LANGSTROM DRIVE

OBJECTIVE:
4 COLLECT BIODECRYPTION KEY AT GCPD MORGUE

- **Location:** GCPD, Financial District
- **Faction:** GCPD

Exit the Belfry to head out on night patrol. Find active crimes and defeat the criminals before they get away. Clues collected from criminals can be processed at the Belfry. After you complete a couple of crimes, Alfred informs the hero that a biodecryption key is required to access files on the hard drive. This key can be found on Dr. Langstrom at the GCPD morgue. Follow the arrows to a rendezvous point on the rooftop across from the station.

Next, head around the police station and through the rear entrance. At the bottom of the ramp, duck under the open garage door on the left and enter GCPD through the nearby double doors.

CHESTS

Chests are hidden around Gotham City, as well as inside buildings visited throughout the game. These chests contain valuable resources and are typically found inside rooms off the beaten path. Use the AR system to spot nearby chests, even through walls. Get in the habit of scanning every new room to score free resources and blueprints.

It's best to avoid detection throughout the GCPD; the officers don't reward the player with XP or loot. Move ahead cautiously and use AR often to spot nearby hostiles. Criminals are held throughout the station, but they're not a threat.

Cut through the gym into an open vent and follow it to an observation room. Follow the waypoints out to the main hallway, and then right into the detention block. Held criminals are not a threat, but officers patrolling the room are. Use the AR system to mark GCPD officers so they're easier to track. Sneak past the lone officer and then climb through the opening on the right to reach the evidence room.

DETECTION METER

Enemy awareness is represented by a meter filling up. When it turns yellow, the hostiles are searching; when red, they attack. Be aware that this doesn't just pertain to sight. Enemies react to sound, so move slowly to avoid detection.

Though not necessary, there are several pieces of evidence along the surrounding shelves that can be scanned and interacted with. There are a few chests inside GCPD, starting with one in the evidence rooms. Use AR frequently to find them in side corridors and rooms. Follow the path to reach the bullpen.

Climb onto the rail and scan the room to find numerous GCPD officers and security cameras. Nearby enemies are alerted with reinforcements possibly triggered if the hero remains in a camera's field of view for too long, so note their locations. Officers and cameras are located along the lower floor; grapple points above allow the player to move around undetected.

The main objective is to reach the opposite corner of the bullpen, but you must also find and collect files on the detectives' desks below. Note their locations and observe the movements of officers and cameras. At the other side, climb onto the balcony and check the door to find it locked. Return to the bullpen and swipe the keycard off the Desk Sergeant's desk. Enter the Forensics Wing.

Interact with the injured medical examiner before entering the next room, where Talia al Ghul takes care of some loose ends. Once she disappears, enter the morgue and investigate Langstrom's body. Mark the Blood Glucometer and the blood vial, then finish the investigation. Return to the bullpen, as SWAT enter the room.

Observe the GCPD SWAT movements, and move through the bullpen to reach the exit at the far corner. Follow the objective markers out of the building and call the Batcycle for a speedy escape. The GCPD continue their pursuit, so stay on the move and return to the Belfry.

CRAFTING

The workbench is now available at the Belfry, allowing the player to craft new weapons and armor from collected blueprints and salvage. These materials are acquired from chests, crimes, leads, and challenges. Blueprints provide stats and properties so use this information to craft gear best suited for your play style. Access your gear at the storage station next to the workbench, or at any time by remotely accessing the Batcomputer.

Craft a new melee weapon, then interact with the Batsuit near the elevator to unlock Knighthood challenges and progress the story.

TRAINING AREA

The training area lets you practice combat moves and abilities with Training challenges unlocking as you complete certain objectives. Get in training often to brush up on skills.

KNIGHTHOOD CHALLENGES

Once a hero interacts with the Batsuit, Knighthood challenges become available for all four characters. Track progress on the challenge tab. Completing the Knighthood challenges unlocks a unique Knighthood ability and access to the Knighthood Ability Tree.

BATCYCLE TIME TRIAL

The Batcycle Time Trial side activity is now available. Every night, a Batcycle Time Trial is available in Gotham City. Race the Batcycle through a series of waypoints to the finish line to earn rewards.

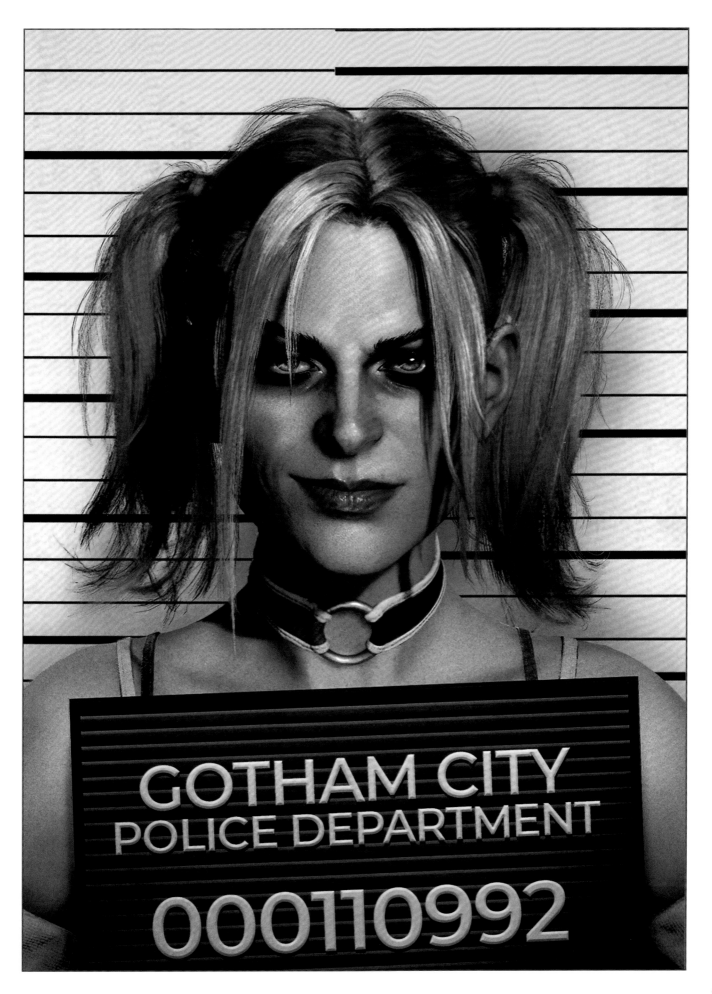

GOTHAM CITY
POLICE DEPARTMENT

000110992

CASE FILE 1.3: WEIRD SCIENCE

OBJECTIVE:
COMPLETE CASE FILE LEADS

■ **Location:** Gotham City

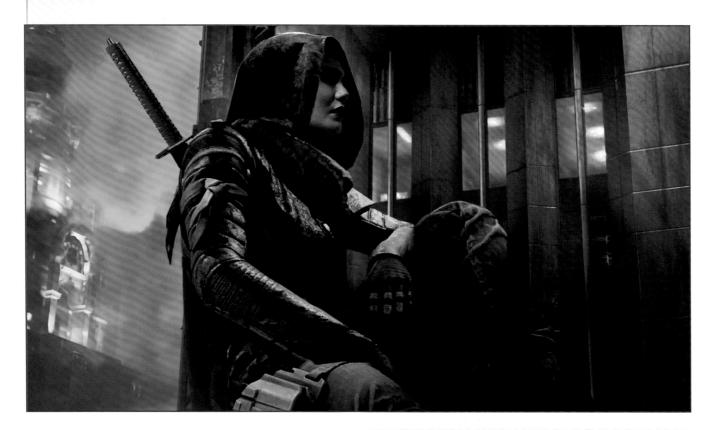

During night patrol, use AR to scan criminals, keeping an eye out for informants. During combat, grab and interrogate gang members about Langstrom's experiments. Successfully interrogate three criminals to complete the lead.

Seek out Talia at the top of a Stagg Enterprises tower. Then, return to the Belfry. Fast travel is now available on the map.

CASE FILE LEADS

Occasionally, you must complete certain Case File Leads to progress the story. Return to the Belfry once leads are complete to resume the story. Track leads progress on the Batcomputer's Challenge tab.

CASE FILE 1.4: BLACKGATE BLUES

OBJECTIVE:

(5) TALK TO HARLEY QUINN AT BLACKGATE PRISON

- **Location:** Blackgate Prison, Blackgate Island
- **Faction:** Freaks

Drive west to Blackgate Island. Dismount during the approach to avoid attracting attention from the guards ahead. Quietly descend the left steps and take the path across the underside of the bridge, following the prison wall to the left. Enter the prison grounds through the old entrance.

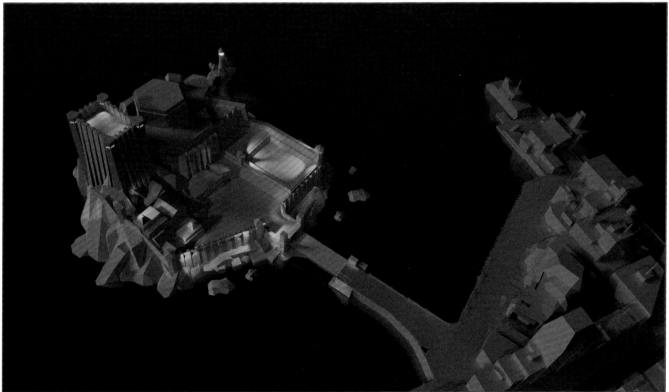

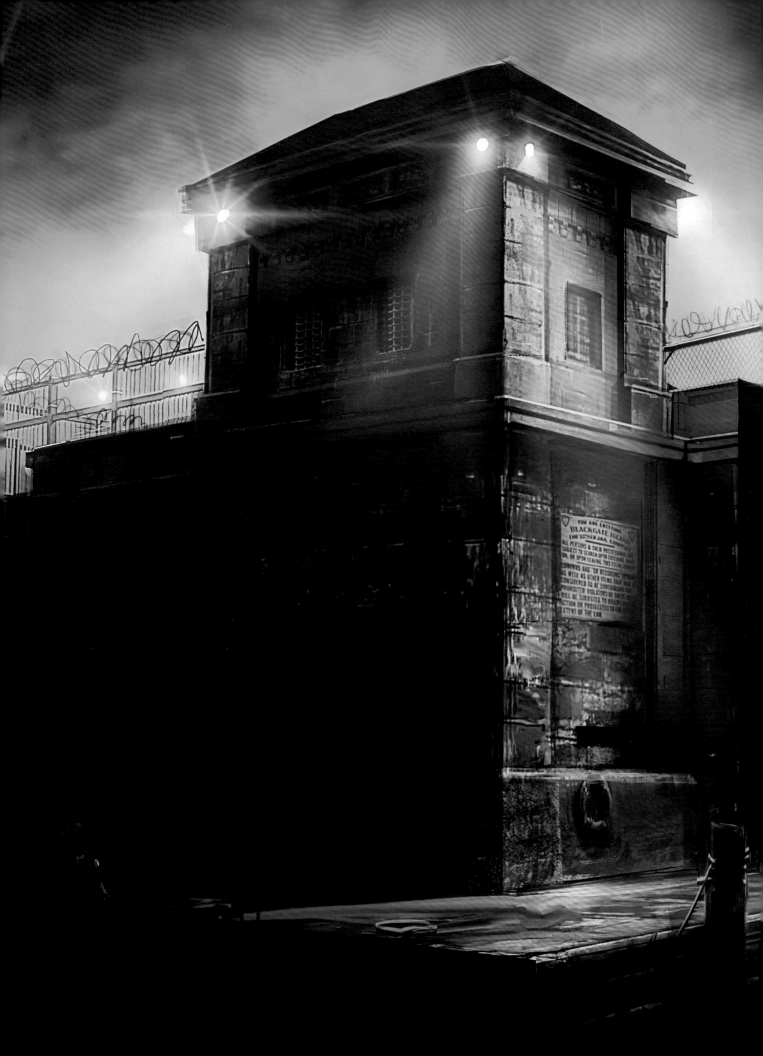

YOU ARE ENTERING
BLACKGATE ISLAND
THE GOTHAM JAIL COMPLEX

ALL PERSONS & THEIR POSSESSIONS ARE
SUBJECT TO SEARCH UPON ENTERING, WITH-
IN, OR UPON LEAVING THIS FACILITY

FIREARMS AND/OR RECORDING DEVICES
AS WELL AS OTHER ITEMS THAT ARE
CONSIDERED TO BE CONTRABAND ARE
PROHIBITED. VIOLATORS OF THIS RULE
WILL BE SUBJECTED TO DISCIPLINARY
ACTION OR PROSECUTED TO THE
FULLEST EXTENT OF THE LAW

WILSON MUI
CINEMATIC DIRECTOR

When our heroes arrive at Blackgate, they find a more mature and controlled Harley Quinn at first glance. Confirming her suspicions that Batman is dead, Harley Quinn sizes up the Batman Family and sends them on a wild goose chase through a chaotic riot that she has meticulously planned. As a preliminary test, Harley sees in her own twisted way the potential for the Batman Family to become their own version of Batman and ultimately a new nemesis for herself.

Squeeze through a narrow opening on the right to find the first chest. There are several more hidden throughout the prison, so use AR often to find them. Now, follow the path into the prison via the ductwork. This leads into processing, a large, open area with Blackgate guards and connections to cell blocks around the perimeter. Scan the area to mark the guards.

Sneak around the perimeter, avoiding the gaze of nearby guards. Pass through the open doorway and eliminate the prisoners in the corridor before exiting out the far side to reach Cell Block 3.

A large group of inmates riot in the large open area. Quickly move between the inmates, keeping an eye out for incoming attacks. Once all hostiles are defeated, find Harley Quinn in her second floor cell, near the balloons.

② COLLECT SCRAPBOOK FROM HARLEY QUINN

- **Location:** Blackgate Prison, Blackgate Island
- **Faction:** Freaks

Harley has compiled a book of criminal profiles, but before handing it over, she needs some missing information. Harley sends the hero down to records to acquire it. Follow waypoints into the next corridor to find more inmates. Use the high platforms to get Silent Takedowns on them.

This leads to Central Yard, where more guards patrol with the help of a few security cameras. It is not worth the time to take any officers on directly, but if an unsuspecting guard is in the way, perform a takedown maneuver on them. Sneak around the left or right perimeter into Nexus Processing.

Ahead, a guard releases the Godmother into the corridor and it's up to you to subdue the inmate. She has a powerful attack that cannot be interrupted. Evade this maneuver until she pauses, then hit her with a series of attacks. Repeat this process until she's defeated, at which point a GCPD containment force enters the processing area. The guards are a challenge, so if possible, avoid them.

ARMORED ATTACKS

Watch out for enemy attacks with a red glow, because they cannot be interrupted. Evade the attack until a pause allows you to retaliate with attacks of your own. As you progress through the game, abilities with a piercing property become available. These allow you to stop attack chains or unique attacks.

You're back in the large processing room from before, but now inmates have taken it over. Defeat them, grapple into the small opening on the far side, and drop down the elevator shaft. Follow the waypoints through the basement, past a few Freaks, and enter the records room.

Search the card catalog first and then find The Penguin's old incarceration files in the filing cabinets in the old cells above. Return to Cell Block 3 and fight off a new group of inmates before returning the letter to Harley in her cell. Unable to do anything the easy way, she ties the book to a big balloon and sends it out to the yard, as the prison uprising continues. Follow the balloon out to Central Yard and clear out the inmates. Blackgate Guards are also involved, so be careful. Once the scrapbook drops to the ground, grab it. Return to the Belfry to complete the first Case File.

ANN LEMAY
NARRATIVE DIRECTOR

Thanks to a really firm commitment on the part of the cinematics team, we were also able to add specific character arcs for each of our Knights. Each of them got a topic we felt made sense for them and which allowed us to explore different aspects of our story within their character arc:

- Barbara: here we explored trauma and how it affects memory, with her father's death being revisited along with his old cases, while layering the context of her knowledge of the existence of the Court of Owls atop it all.

- Tim: the newest Robin, the one closest to Bruce right before his death, having framed his entire existence as Robin around being Batman's sidekick . . . but also the one with the last history with the villains of Gotham, now having to figure out how to be Robin without a Batman.

- Dick: having struck to find his own way as Nightwing during a time of strife, now having to figure out how to

cope with his adoptive father's death and whether he even wants to step into a new role or not.

- Jason: having died, been brought back to life in a particularly traumatic way and not entirely remembering how that even occurred, going off the deep end and having just reconciled with Bruce only to lose him . . . now trying to fit back in with the others while doubting his own humanity. His story is absolutely about finding his way back to his family, and the kitchen scenes are symbolic of this in so many ways.

These scenes allowed us to showcase interactions between the heroes in really interesting ways, which we never would have been able to do so well within the framework of the main path or mission only scenes. As expensive as they were and as technically non-essential to the mission path as they are, it was the team's belief that these scenes remained vital to the game in terms of doing justice to such iconic characters within DC lore.

HARLEY'S SCRAPBOOK

Harley Quinn has a . . . *unique* . . . interior monologue.
Her scrapbook is the perfect example of her boisterous
personality, and the shrewd mind of the trained
psychologist behind it.

HQ + BERNIE

Hi Hi

BUD & LOU

#1 GENIUS

LOU

BUD

GENIUS

ARKHAM ASYLUM

GRRRR

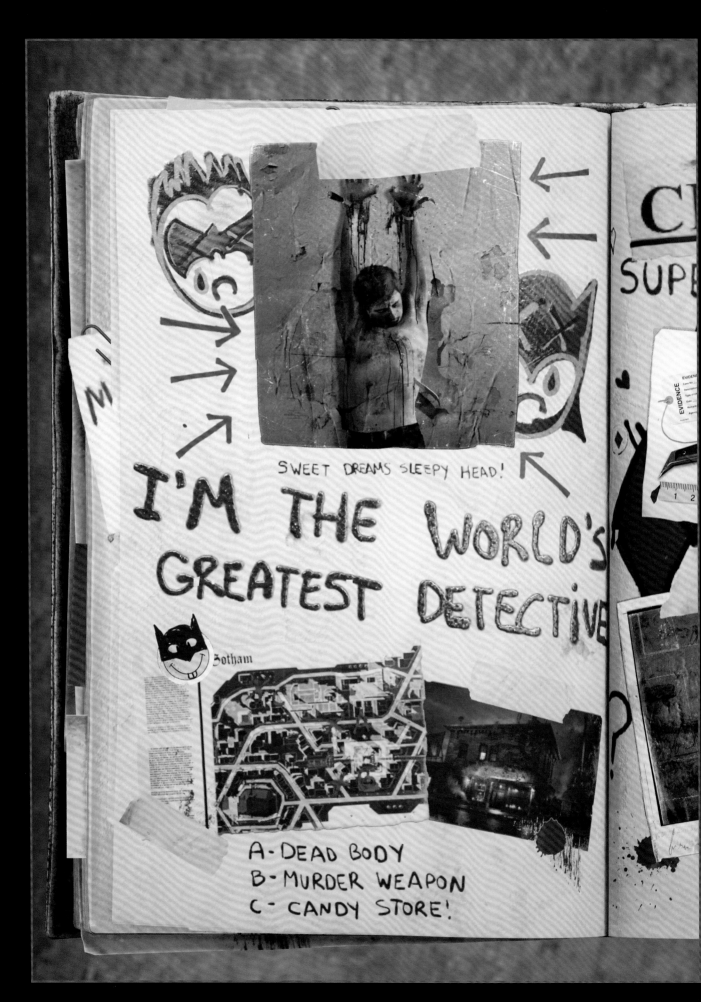

CLASSIFIED!

SUPER SECRET ♥

CRIME WEAPON

EVIDENCE/CHAIN OF POSSESSION

POLICE DEPARTMENT
CITY OF GOTHAM

EVIDENCE

1 2 3 4 5 6 7 8 9 10 11 12 13 14 15 16 17 18

R.i.P

SUPER iMPORTANT

TRICORNER ISLAND, GOTHAM
APRIL 1936

SUPER SECRET

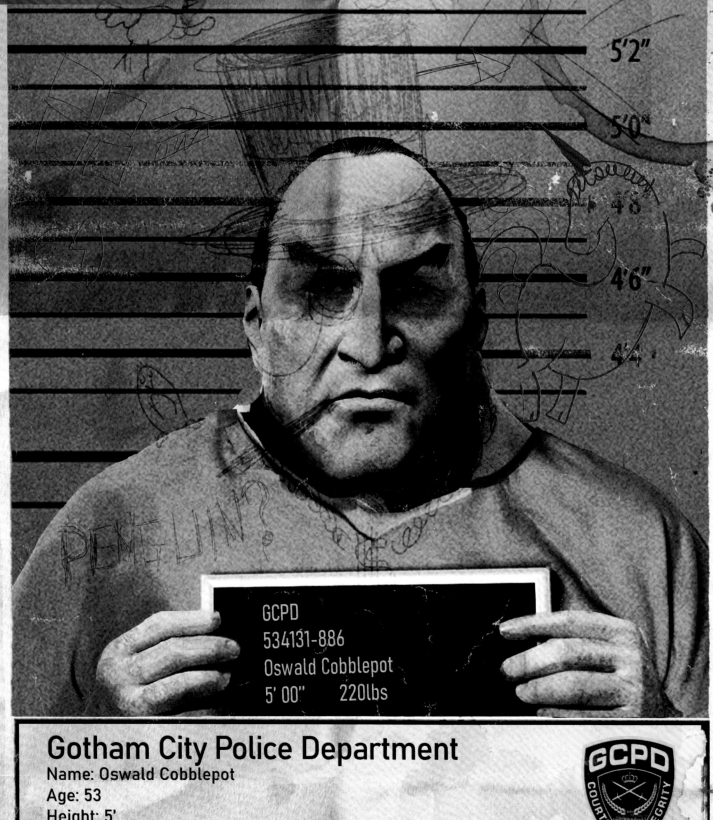

GCPD
534131-886
Oswald Cobblepot
5' 00" 220lbs

Gotham City Police Department

Name: Oswald Cobblepot
Age: 53
Height: 5'
Weight: 220lbs
Previous convictions:

File no: 53431-886 Date: Mar 3. 2012

CASE FILE 02:
THE RABBIT HOLE

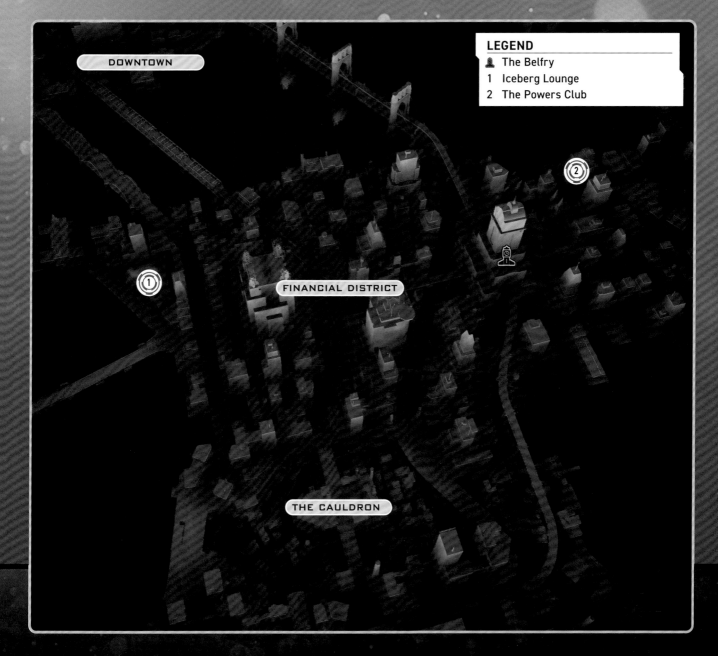

LEGEND

🪦 The Belfry
1 Iceberg Lounge
2 The Powers Club

DOWNTOWN

FINANCIAL DISTRICT

THE CAULDRON

- **Requirement:** Complete Case File 01—Return to the Belfry after Blackgate Prison
- **Main Objective:** Continue Batman's Investigation

With Harley Quinn's notes, the Knights discover a pattern of early release at Blackgate Prison, but not for The Penguin. Take a trip to see Penguin at the Iceberg Lounge to continue Batman's investigation.

HERO ARCS & HARLEY QUINN VILLAIN ARC

Also available inside the Belfry, character arcs provide a unique narrative for each hero. Interact with the right side of the Batsuit display as Nightwing or Red Hood. Head up to the mezzanine to access Robin's and Batgirl's narratives at the game table. Visit other locations in and out of the Belfry to continue the story arc. At this point, players can continue the Harley Quinn villain arc. See the Villain Case Files section for more information.

CASE FILE 2.1: AKA OSWALD COBBLEPOT

OBJECTIVE:
TALK TO THE PENGUIN

■ **Location:** The Iceberg Lounge, Financial District

TOP VIEW EXTERIOR — ORIGINAL BUILDING LAYOUT — BENGUIN LAYOUT

The Iceberg Lounge is located west of the Belfry, near the prison, on the west side of the Financial District. Enter through the skylight on the south side of the roof. Mob brawlers and shooters patrol the club, a few are above on the mezzanine and the others are down on the main floor. To proceed, all guards must be defeated. Their patrols are distant from one another, allowing for stealth takedowns.

TOP VIEW
ENTERIOR 3RD FLOOR

PATRICK REDDING
CREATIVE DIRECTOR

Once we settled on the major themes and narrative arcs for *Gotham Knights*, we had a filter we could apply to the huge potential cast of supporting characters and foes. The Penguin is a perfect example. He didn't make sense tonally as a major adversary for the Knights, but because the Cobblepot family is so heavily implicated in Gotham City's history, we saw a huge opportunity to include Oswald and start to dig into the complicated relationship he has with the rest of the family. It became more interesting to have him as this untrustworthy contact. Because the heroes are cut off from their usual support structures, it made sense for them to reach out to characters like Lucius Fox and Renee Montoya.

With the guards defeated, it's time to speak to The Penguin. But first, find the duct opposite your entry point on the main floor. Follow it back to a storage room and loot the chest inside. Head up to the mezzanine and bust through the double doors to interrupt The Penguin. After a brief conversation, head downstairs and exit through the security room. Return to the Belfry and continue the investigation by completing the given objectives.

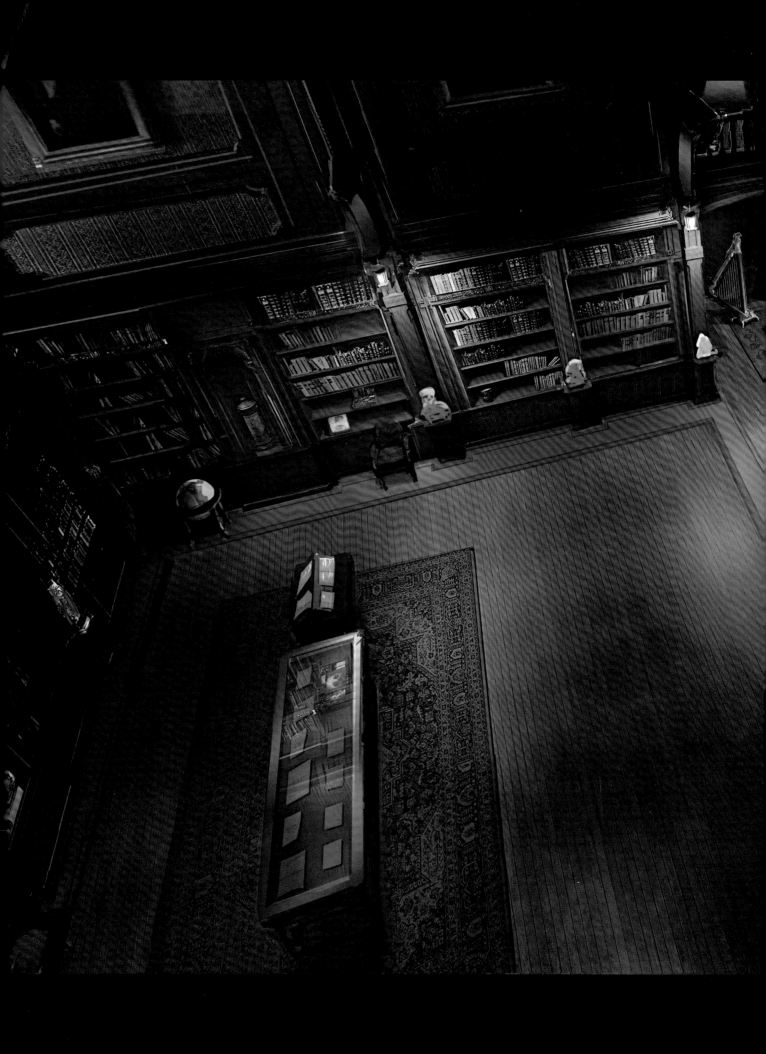

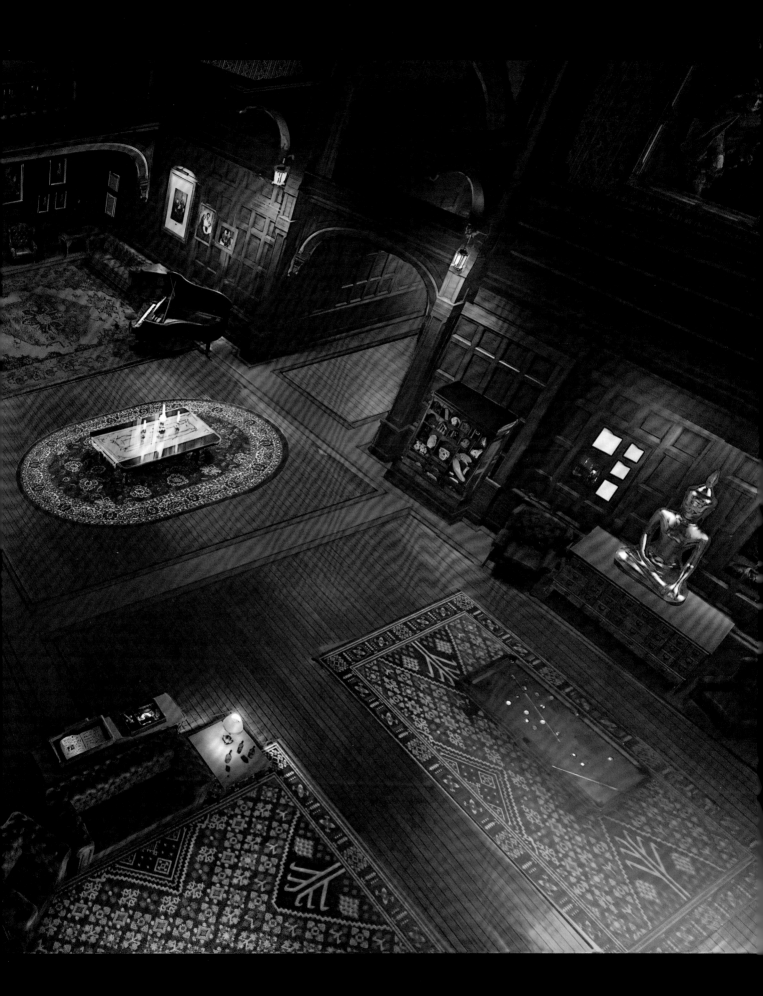

OBJECTIVE:
COMPLETE CASE FILE LEADS

- **Location:** Gotham City

Process leads at the Belfry or find evidence in Gotham City to find Penguin's crimes. Patrol the streets until the Case File Leads have been satisfied to proceed in the story.

SIDE ACTIVITIES NOW AVAILABLE

As part of the Case File Leads, the player can meet up with two contacts and begin a Villain Case File. Speak to Lucius Fox to the north and Montoya to the east. See the Villain Case Files section for more information on the villain story arcs.

OBJECTIVE:
① RETURN TO THE ICEBERG LOUNGE

- **Location:** The Iceberg Lounge, Financial District

Return to The Penguin's Iceberg Lounge and, again, drop through the skylight to gain access. This time a large inmate has been called in with several brawlers. Attempt to pick off surrounding foes with Silent Takedowns before everyone converges on the hero. Watch for the red glow that signals an uninterruptible attack, and counter with a piercing attack or evade the attack altogether.

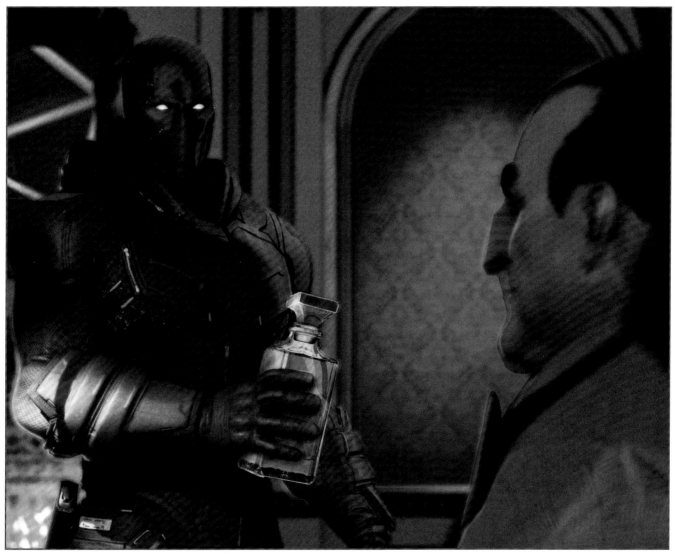

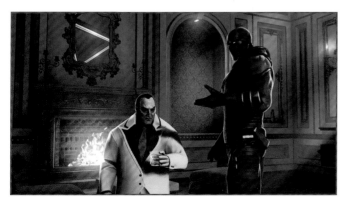

Once the guards are defeated, join The Penguin in his office. After he expresses concerns that others are listening, scan the room for hidden devices. You find several on the display cases, bust, flowerpot, and fireplace. Disable them all, then retrieve the bottle of whiskey from The Penguin's liquor shelf. With the ability to speak freely, he directs you to the Powers Club.

CASE FILE 2.2: THE POWERS CLUB

① OBJECTIVE:
INVESTIGATE THE POWERS CLUB

- **Location:** The Powers Club, Financial District
- **Faction:** Court of Owls

Head over to the Powers Club, located northeast of the Belfry. Drop through an opening in the western rooftop and enter the club.

To proceed, the club must be investigated, but several security guards stand in the way. Defeat them all; you earn a bonus if you go undetected. The guards are located on the first floor: two patrol in and out of the atrium, while the others are split into pairs in the library wings opposite the entry point. Use AR to mark all six and then observe their routes. Take advantage of the mezzanine and vantage points to isolate the guards. Take two out at a time; don't let a guard find his unconscious partner, or the bonus becomes unattainable.

Return to the aviary and use AR to investigate the blood on the floor, though the blood trail shortly comes to an end. Investigate further, following connections between a nearby lamp, a bust in the left library, and a book in the right. Activate all three devices to reveal a secret entrance next to the tree.

 OBJECTIVE:
1 REACH THE END OF THE CAVE

- **Location:** The Powers Club, Financial District
- **Faction:** Court of Owls

Continue following the blood trail down into an underground cave. Four sculptures sit on the table with switches that rotate them 90 degrees at a time. By interacting with the spotlight, a light is cast through these sculptures creating a shadow on the door ahead. Move these around until the shadow appears as an owl hunting prey, providing access farther into the hideout. You can use AR to see the gears underneath the sculptures. These will give clues on how to solve the puzzle. Court brawlers and shooters are scattered throughout the rooms. Use the perches when available to perform Silent Takedowns while clearing them out of the way.

As you approach a prisoner, both of you are dropped into a pit, where you must survive a series of death traps in order to escape the cave.

Once the wall opens, sprint down the corridor. Weave between blade and fire traps to prevent taking damage. Slow down to avoid the rotating traps, and sprint as openings are revealed. If available, use a Health Pack when your health gets low. At the end, the hero tumbles down the hill, finding a key at the bottom.

Follow the marks to escape the cave and return to the Belfry.

CASE FILE 03:
IN THE SHADOWS

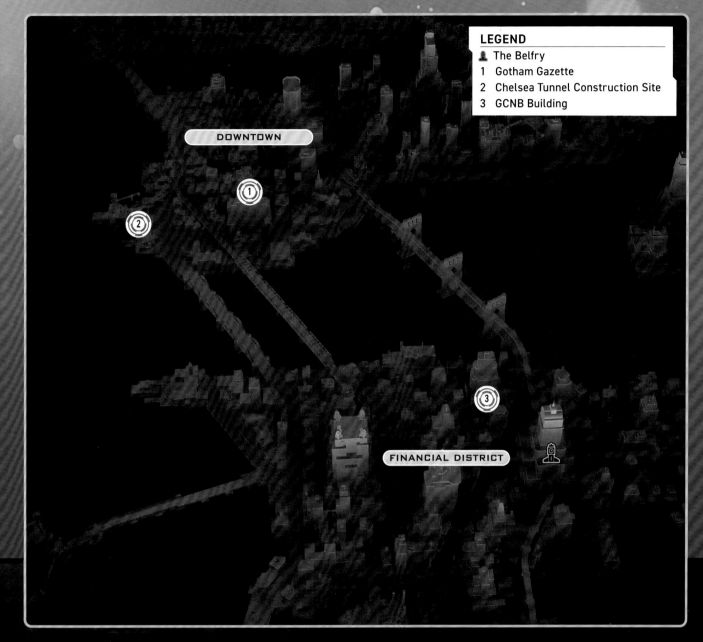

LEGEND

🦉 The Belfry
1 Gotham Gazette
2 Chelsea Tunnel Construction Site
3 GCNB Building

DOWNTOWN

FINANCIAL DISTRICT

- ■ **Requirement:** Complete Case File 02—Return to the Belfry with the Key

Main Objective:
Investigate the Court of Owls

The Court of Owls is real, and they tried to kill the Knights after they crashed their party at the Powers Club. A key found in the death pit beneath the club has an owl on it. But what does it open?

DANIEL KVASZNICZA
ART DIRECTOR (ENVIRONMENT)

For our major landmarks we've drawn inspiration from a remix of the most interesting historic East Coast buildings.

CASE FILE 3.1: THE KEY

OBJECTIVE:
① INVESTIGATE GOTHAM GAZETTE

- **Location:** Gotham Gazette, Downtown
- **Faction:** Court of Owls

The key found at the club leads the Batman Family to Gotham Gazette, located in Downtown Gotham—just across the bridge to the north. The large building sits on Dillon Avenue. Grapple to the rooftop and find the hidden door to the Talon's Nest on the west side, near the top.

Scan the document on the box, and then begin an investigation on the Court order by interacting with the wooden table on the left. Select the order to Purge a location for the Court's instructions and the Brass Peg that points west toward the Gotham River as the location.

Return outside and go west to find the Chelsea Tunnel Construction Site. Chelsea Tunnel is closed but you can follow the road down and enter through a derelict ventilation fan. Descend further to reach the site of a cave-in and a makeshift memorial for a lost construction worker.

CASE FILE 3.2: CHELSEA TUNNELS

OBJECTIVE:
② INVESTIGATE THE CHELSEA TUNNELS

- **Location:** Chelsea Tunnel Construction Site, Downtown
- **Faction:** Court of Owls

Follow the marks down the waterfall and through the tunnels until you're ambushed by a feral Talon. Defeat Talons while exploring the caves.

The next cavern contains several wooden decks and walkways, separated by large, open space. Search the various decks for chests before climbing up the far side.

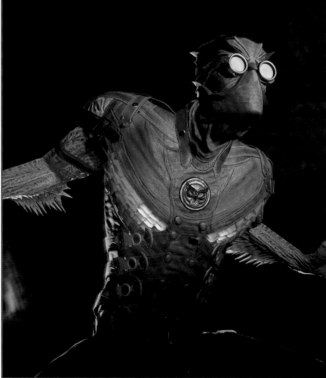

Continue through the mine, following Talons down to a lower level, where a group of feral Talons ambush you. Talons inflict poison with successful attacks, so be ready to evade at all times. Stay on the move to avoid their strikes, bouncing between foes until you defeat them. Area-of-effect abilities are best against Talons. The path leads back out to the large cavern.

Grapple to the platform above, and then drop down to the rock surface on the right. Investigate the surface, return to the platform, and then investigate the notes on the desk.

Interact with the keypad to proceed along the path. Follow the path to reach the Extraction Room and investigate the desk. Scan the samples and equipment. Mark the Composite Ore to be placed in the extractor and Sulfuric Acid as the chemical that will extract material from it. This extracts Dionesium. Return to the walkway and interact with another keypad to proceed.

Step onto the elevator at the end of the walkway and interact with the console. This sparks interest from the Court of Owls, and after a conversation with the Voice of the Court, a group of Talons ambushes the hero. Fend them off as the elevator rises.

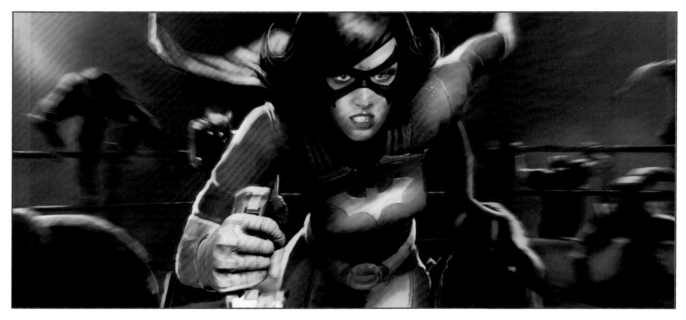

Follow the path up a series of platforms until the hero escapes through a hatch. Grapple up another walkway and proceed along the path, following the waypoints to the exit.

OBJECTIVE:
(3) TALK TO TALIA

■ **Location:** GCNB Building, Financial District

Before returning to Belfry, you must find and talk to Talia. Follow the bridge south, then grapple to the top of the Gotham City National Bank building on the right. After talking to Talia, return to Belfry to complete this Case File.

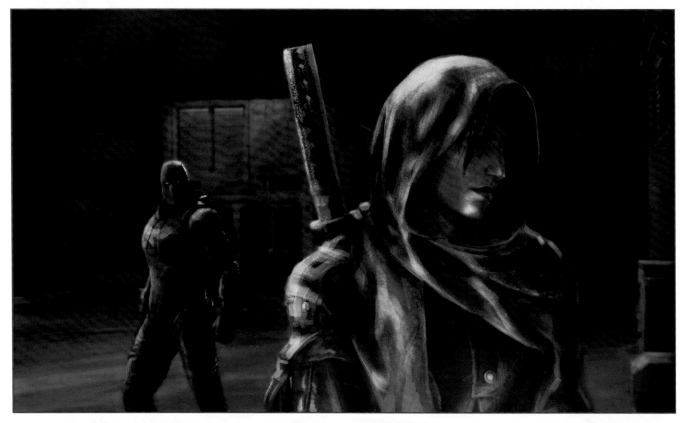

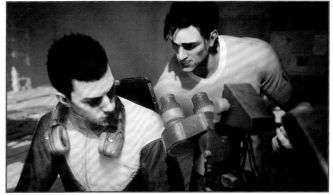

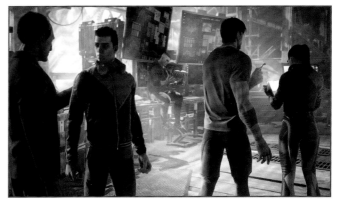

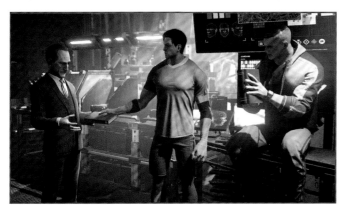

WILSON MUI
CINEMATIC DIRECTOR

Another personal favorite is Talia al Ghul. Her dynamic scenes with the hero throughout the game were fun and challenging to realize as it was important to keep the player constantly guessing whose side she was on. Talia was always cryptic with her messages but we were able to see different shades of her that told the hero otherwise: calm and deceptive, yet deadly when necessary. She takes it to a whole new level at the end of the game as her true diabolical plans come to fruition for our Batman Family.

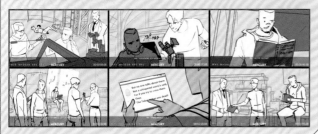

CASE FILE 04:
THE MASQUERADE

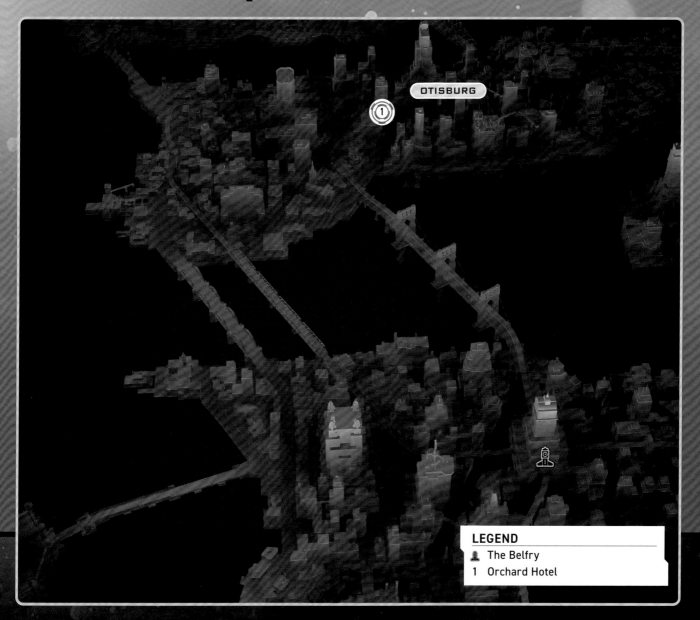

OTISBURG

LEGEND

🏯 The Belfry
1 Orchard Hotel

- **Requirement:** Complete Case File 03—Return to Belfry after Talking to Talia

Main Objective:
Find Members of the Court of Owls

Evidence gathered at the Powers Club links wealthy families of Gotham to the Court of Owls. Fortunately, the Orchard Hotel is hosting a masquerade ball, which may be a great location to gather more information and possibly find a member of the court.

CASE FILE 4.1: MARK HENDRICKS

OBJECTIVE:
COMPLETE CASE FILE LEAD

- **Location:** Gotham City

Before heading to the Orchard Hotel, complete the Case File Lead by finding and protecting an employee of the Orchard Hotel. Complete a Witness Under Attack activity on the west side of Tricorner Island. At this point, an Owl's Nest is revealed in North Gotham. Complete it to reveal the Orchard Hotel on the map.

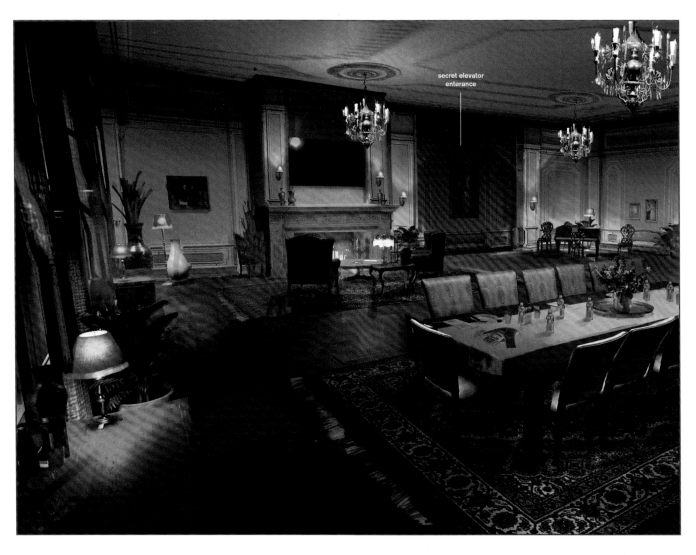

secret elevator enterance

CASE FILE 4.2: THE ORCHARD HOTEL

① OBJECTIVE:
INFILTRATE THE MASQUERADE BALL

- **Location:** Orchard Hotel, Otisburg District
- **Faction:** Court of Owls

Travel to the Orchard Hotel in New Gotham on the west side of Otisburg, and find an entry point between the two spires on the terrace. Move into the foyer, where sentries surround hotel guests gathering for the ball. Security cameras installed throughout the hallways continually scan for intruders. The first objectives require you to sneak around these hostiles. If you're spotted, the objective is failed, and the game resets to the previous checkpoint.

Sneak along the outer wall, using furniture as cover. Wait for hostiles to move away from the path, or perform Silent Takedowns on them, but be careful not to be spotted.

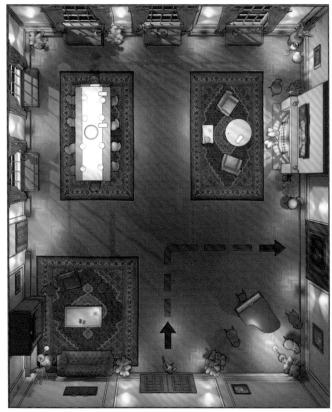

Drop out the other side to find a way into the ballroom, though the security cameras must be disabled first. Continue around the outside, slip into the open security room, and take out the sentry. Use the console to disable the cameras. Eliminate the guards that guard the lounge area and then grapple into an opening above. This leads the hero onto a perch above the ball.

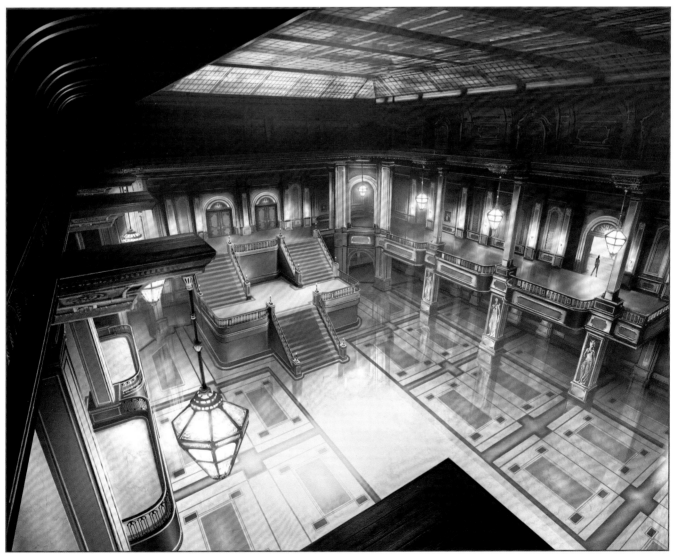

① OBJECTIVE: FOLLOW THE VOICE

- **Location:** Orchard Hotel, Otisburg District
- **Faction:** Court of Owls

From the perch, eavesdrop on the attendees below by listening in on group conversations. Eventually, the Voice shows up and gives a speech. Utilize AR to follow the Voice through the hallways of the hotel.

PATRICK REDDING
CREATIVE DIRECTOR

A central theme in *Gotham Knights* is "family," and how families of all types produce a tension with the ambitions and dreams of their individual members. That theme is so pervasive in the game that we realized early on that Gotham City itself would have to be a living testament to it. We could answer the question of how Gotham got so messed up by pointing to the way its founding families shaped it, and exploited its people, and built it up to be a kind of twisted monument to their desires. This connects in a direct, physical way to the Court of Owls, who famously "live inside the walls" of Gotham, and we wanted that to be a literal thing in our city.

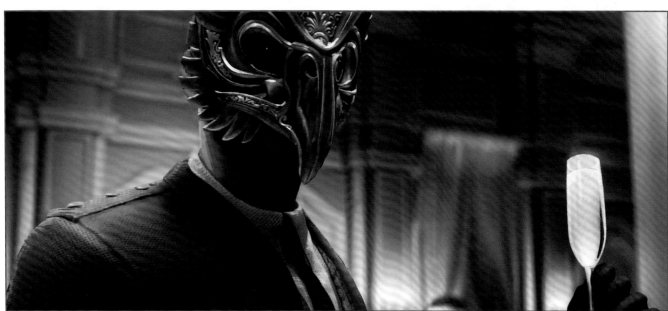

Scanning with AR highlights usable doorways. Take advantage of these alternate routes to avoid more hostiles and remain undetected.

Continue down the hallway and enter the stairwell. Descend the steps to the final landing, floor 13, and scan the wall to find the Talon's Nest hidden door, leading to a secret hideout of the Court of Owls.

OBJECTIVE:
(1) SEARCH THE SECRET HIDEOUT FOR EVIDENCE

- **Location:** Orchard Hotel, Otisburg District
- **Faction:** Court of Owls

Inside the first room on the left, interact with the owl statue to find the Court meeting room. Defeat the court members inside before interacting with the computer.

A group of Court Members emerges from the adjacent room. Defeat them before entering the room. Models of four Gotham power structures on the floor are surrounded by wall displays that showcase a history of Gotham architecture. Examine the display to infer a chronological order for the four structures on the floor and activate them in order by stepping on the pressure plates next to each one. Once solved, interact with another owl sculpture to reveal a corridor that leads into another meeting room. Step up to the left wall to find the Voice of the Court.

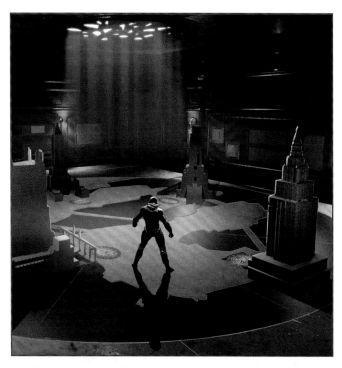

① RETURN TO THE BALLROOM

- **Location:** Orchard Hotel, Otisburg District
- **Faction:** Court of Owls, League of Shadows

After a conversation with the Voice, a small group of feral Talons and Court Members enter the room. Once the hostiles are defeated, head back toward the ballroom by grappling up the secret elevator and prying open the doors. Assassins from the League of Shadows have infiltrated the hotel to confront the Court. They attack the player character at a couple locations on the way back to the ballroom. League assassins are very quick with the ability to disappear between attacks. They reappear next to their target before unleashing an attack. Be ready to make a quick evasive maneuver and immediately counter as they miss their target. Quick projectiles and special abilities are extremely helpful in these fights. Continue into the ballroom.

Drop down to face a small group of enemies, including a League rocketeer. This hostile has a ranged weapon that launches both an explosive, similar to that of the firestarters seen at the University, and a bullet projectile. Watch for incoming projectiles while fighting the League. Once the fight is over, the hero returns to the Belfry.

WILSON MUI
CINEMATIC DIRECTOR

As the Voice of the Court openly reveals himself to be Jacob Kane to the Batman Family, a strong sense of betrayal and injustice is evident as each hero struggles to comprehend what they now know. Discovering that Jacob had known Bruce's true identity all along and proposing to join sides is too much for the Batman Family to bear. Jacob Kane knows he is untouchable as the Voice of the Court and husband to the GCPD Police Commissioner, and this causes a major complication for the Batman Family in bringing him to justice. Adding even more insult to injury, Jacob Kane had given the eulogy at Bruce's funeral, knowing well their alter egos at the time.

ANN LEMAY
NARRATIVE DIRECTOR

At the end of the day, even though we're talking about a high stakes superhero story depicting the endless corruption that permeates Gotham and society in general, we really wanted to tell a story about . . . people. Yes, the backdrop of our game is fantastic in a lot of ways, but we're still hitting very relatable beats, both in the extraordinary and the mundane. Institutional corruption is something people understand and can relate to. Navigating through grief and the loss of a loved one is something everyone can understand. Even one of our antagonists is going through their own grieving process!

Dealing with family dynamics and strengthening bonds of friendship through thick and thin, teasing your friend, caring about what happens to others . . . these are all things we show in the Belfry and also with how the Batman Family interacts with key precious people in the open world, and all of that is at the very core something deeply relatable for players. We wanted to give them Knights with different personalities and hopes and worries that they could deeply invest in emotionally.

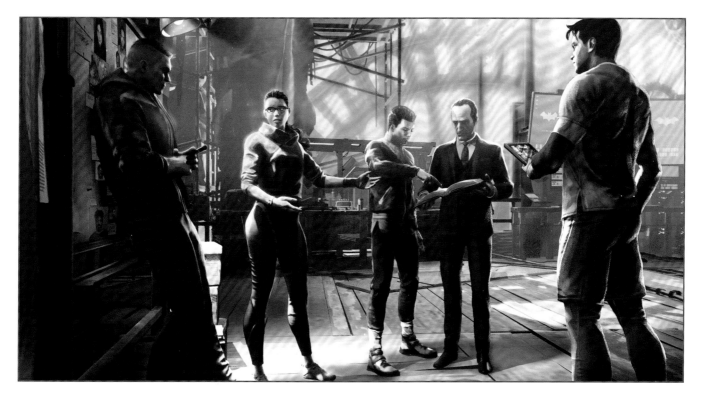

LIVE! NEWS
Kane | GCPD director
GCN ference
COMMISSIONER COMMENTS ON ORC... EL INCIDENT

CASE FILE 05:
THE COURT OF OWLS

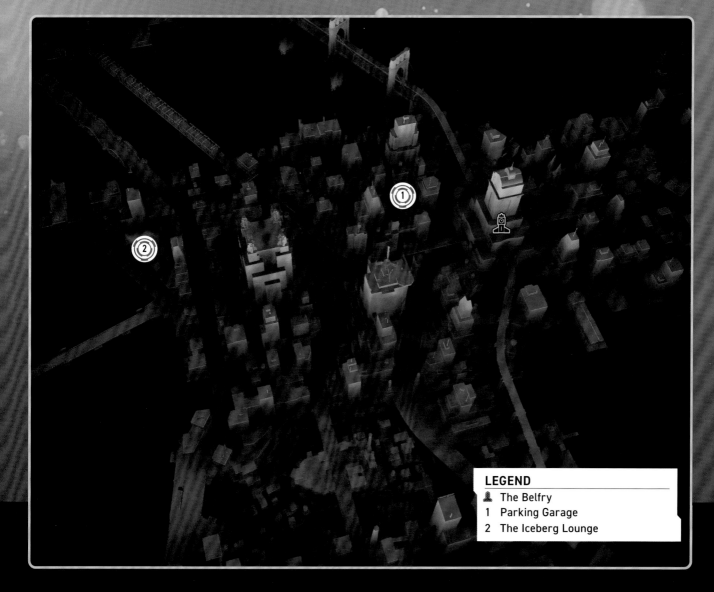

LEGEND

🦇	The Belfry
1	Parking Garage
2	The Iceberg Lounge

- **Requirement:** Complete Case File 04—Return to the Belfry after the Orchard Hotel

Main Objective:
Escape from the Labyrinth

With new evidence against the Voice of the Court and a list of names, the Batman Family is ready to pass this information along to Detective Montoya.

CASE FILE 5.1: LITTLE BIRDS

 OBJECTIVE:
COMPLETE CASE FILE LEADS

- **Location:** Gotham City

Hit the streets of Gotham City and complete the Case File Leads to proceed. This requires checking in with Montoya and stopping five corrupt detectives. Those corrupt detectives will be near GCPD in Old Gotham and the Major

Crimes Unit in The West End. Use AR to find all the clues and then select the one that points to the culprits' locations. Head to the given locations and defeat the enemies. After completing all of the leads, the next objective is revealed.

 OBJECTIVE:
TALK TO TALIA

- **Location:** Parking Garage, Financial District
- **Faction:** N/A

Just northwest of the Belfry, grapple to the top floor (L3) of the parking garage on Grand. Descend to L1 and approach the objective marker to speak with Talia.

OBJECTIVE:
2 TALK TO THE PENGUIN

- **Location:** The Iceberg Lounge, Financial District

Respond to The Penguin's urgent call by returning to the Iceberg Lounge. Drop through the same skylight, visit The Penguin in his office, and help him down. It turns out to be a trap, and the hero passes out.

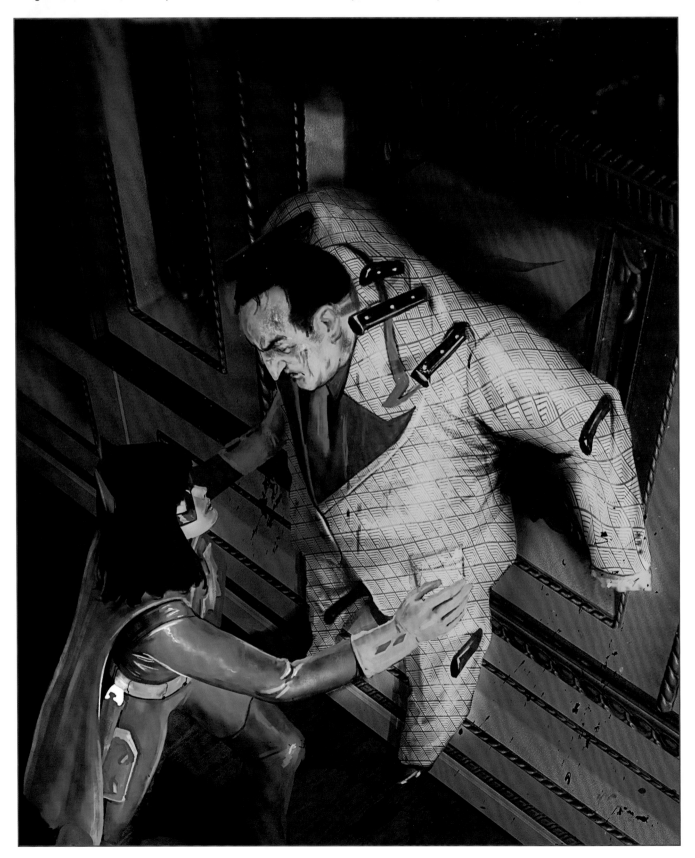

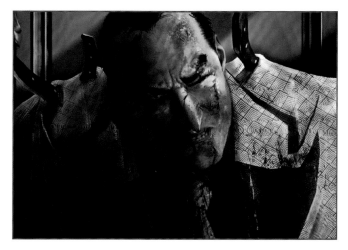

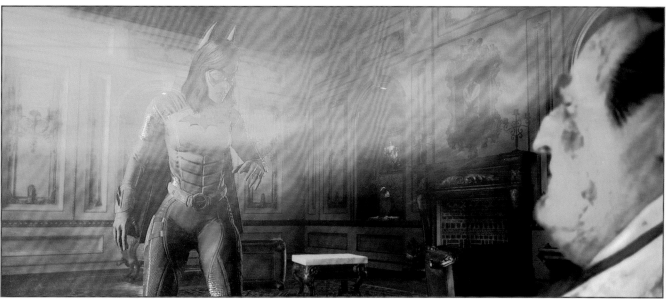

CASE FILE 5.2: INSIDE GOTHAM'S WALLS

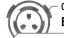 OBJECTIVE:
ESCAPE FROM THE LABYRINTH

■ **Location:** Mysterious Labyrinth
■ **Faction:** Court of Owls

THE LABYRINTH BEGINS

The hero wakes up in a mysterious underground facility. AR is useless at the moment, and it becomes apparent that a hallucinogenic gas is being pumped into the corridors. The procedurally generated labyrinth is random, so there's no specific route out. There are, however, certain situations each hero may face, as well as character-specific moments, that are triggered by the hallucinatory effects of the gas.

During the first portion of the labyrinth, the only threats to the hero's health are traps. Sprint across floor spikes, and crouch underneath wall spikes. Keep away from burn marks on the floor, while carefully maneuvering between rotating blades inside the trap room—reminiscent of those found inside the hideout in Case File 04. Follow the blades as they rotate around an axis, crouching to avoid the midlevel blade.

A variety of scenes play off memories. These scenes require you to investigate or simply interact with an object. Some scenes do not require your participation. Do as instructed, and once a new path is available, continue through the labyrinth.

If the maze appears to dead-end, shifting the camera around eventually exposes an exit. An otherwise empty-looking room may reveal feral Talons when scanned with AR. They finally split, and a new hallway appears.

DANIEL KVASZNICZA
ART DIRECTOR (ENVIRONMENT)

Aside from the comic book references, the Court of Owls labyrinth was heavily inspired by a marble mine in Vermont. I've always imagined, "What if Gotham was built on top of such a marble deposit and the Court of Owls have been excavating for decades desperately in search of the Lazarus pit?" All the while building their ominous ceremonial spaces underground by carving into the marble bedrock.

OWL SYMBOLISM

No matter which hero is in play, an exit is eventually located. It leads to a room with a spherical owl sculpture in the middle. There are four owl symbols in the room, two on the floor and two above the room. You must step on all four of them in the correct order to open the secret door. The sphere will rotate and indicate which symbol needs to be activated next. A lone feral Talon knocks on the left door; defeat it at any time. Three symbols display above the exit.

One of the floor plates and two of the perches cause the sculpture to line up in such a way that a smaller sphere is revealed through the owl's mouth. To solve the puzzle, stand at these three locations and fire a projectile at the inner sphere in the order that matches what is displayed above the exit.

NIERWEP

TAKE THEM PRISONER

DÍEDE

KILL THE ENEMY

OFÁSÍEÐE

PURGE ALL WHO TRESPASS

HWŌP

MAKE THEM FEAR US

THE GAUNTLET

As you progress through the labyrinth, Talons emerge from the sewer and attack. Defeat the small groups of feral Talons in the first two rooms.

In the next room, a single gladiator Talon drops from above. This large gladiator possesses extremely powerful but telegraphed moves. Evade the attacks and counter until the gladiator's health gets close to zero. This triggers a cutscene that reveals the path forward. Clear out when the gladiator comes down next to the statue. The impact topples the statue, which takes out the enemy and the wall segment, exposing the labyrinth's backstage area.

BACKSTAGE

Enter the backstage area by grappling to the platform ahead, and loot a chest to the left. From there, jump and grapple across the platforms up to the right to find a control room with four operators. Grapple to the beams above them and eliminate the Court Members and Talons. Interact with the console to activate the next platform. From the next platform, break open the marked thermal valves by hitting each one with a projectile, using the side platforms to get a better view. Drop into the new hole.

THE LAB

The underground path runs beneath a laboratory, where Court Members and shooters are present. Loudly running through the water draws the attention of nearby hostiles, who begin searching. You can wait them out, but it's better to walk quietly when within range of the foes before grappling up to a walkway at the far end. This leads into the lab.

Several surgeons work the lab with the head surgeon marked by an objective mark. Defeat all of the surgeons, and interrogate the head surgeon.

ANN LEMAY
NARRATIVE DIRECTOR

Having the chance to create what is essentially our own Elseworlds of the Court of Owls gave us a lot of room in weaving some of our thematics in interesting ways throughout the game. Family for example is an important narrative pillar—and we injected that theme through many aspects of our story, from the heroes' relationships with each other, or with Alfred and Bruce, to how our antagonists view family (and what matters to them or not), to how the ruling families of Gotham have shaped the city itself.

At a higher level, getting to target aspects of character, story and lore in specific ways really just gave us the room to create a story and a world that has a tight weave. The amount of lore at our fingertips was limitless, as well, and there was no way we could put all of it in a single game. Getting to pick and choose what worked on our canvas, always with DC oversight, made it much easier for us to create a compelling world.

COFFIN ROOM

At the back of the lab, use the keypad to open the cage and take the elevator to the upper level, where a message from the Voice of the Court greets the hero, along with a group of Court shooters and brawlers. Stay on the move to avoid gunfire, and dodge behind machinery to break up the group.

With the Court Members out of the way, override the coffin hibernation controls by turning the wheels on the two control panels. After you successfully activate each control, a group of feral Talons attacks, so remain alert.

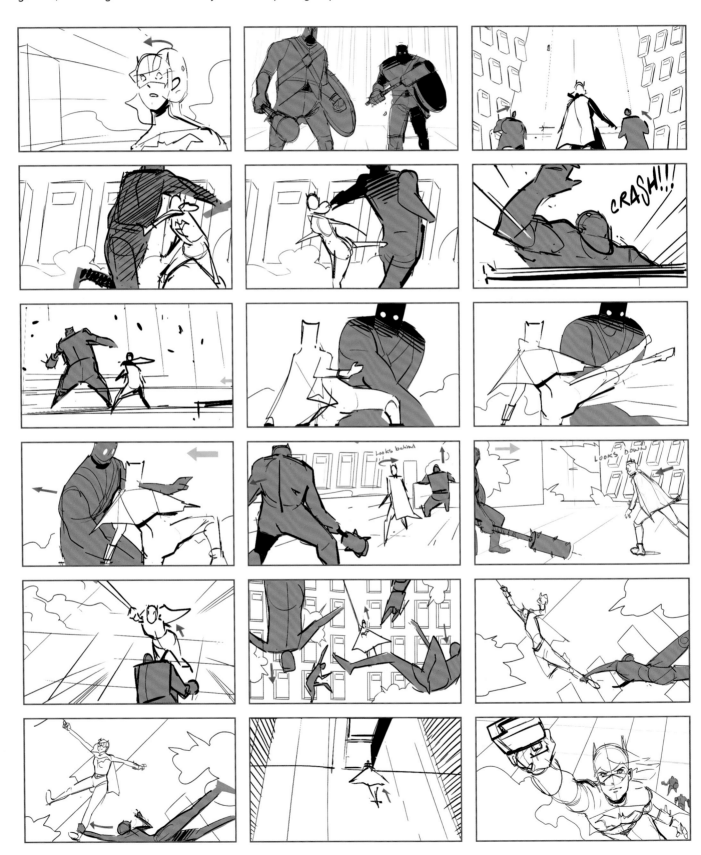

Next, step up to the main console and turn the final control. This time, a group of Talons, including a pair of gladiator Talons, drops in. Run around the consoles to keep the gladiators from teaming up, and use special abilities when available to get an upper hand.

Once outside, return to the Belfry to continue the story. Feral Talons are released into the city, so they become part of your patrol night crime fighting.

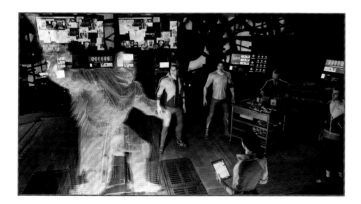

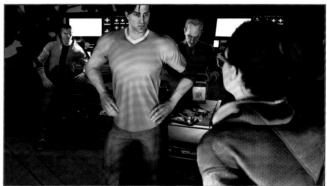

CASE FILE 06:
JACOB KANE

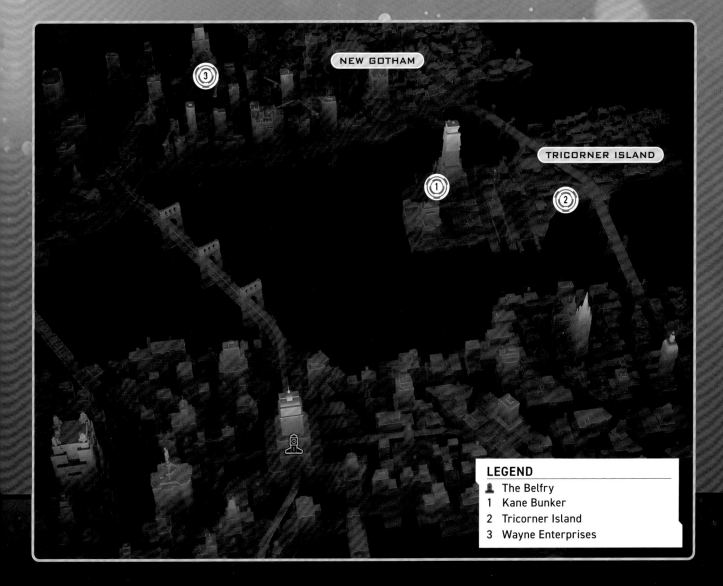

NEW GOTHAM

TRICORNER ISLAND

LEGEND
- ♙ The Belfry
- 1 Kane Bunker
- 2 Tricorner Island
- 3 Wayne Enterprises

- **Requirement:** Complete Case File 05—Return to the Belfry after Escaping the Labyrinth

Main Objective: Apprehend Jacob Kane

The Knights discuss everything that has occurred and conclude that the only way to stop the League of Shadows and the Court of Owls from turning Gotham City into a battlefield is to take aim at a specific target: Jacob Kane.

CASE FILE 6.1: COURT JUDGMENT

 OBJECTIVE:
COMPLETE CASE FILE LEADS

- **Location:** Gotham City

To continue, you must check in with Montoya and complete the given Case File Leads. Hit the streets of Gotham and interrogate three Mob informants, followed by three Regulators, and finally, three Freaks. This reveals a murder scene in North Gotham. Scan the clues and select the one that points to the Judge's location. A Witness Protection becomes available in eastern North Gotham. Defeat the enemies to save Judge Moreno. Then return to the Belfry to meet up with Alfred and Detective Montoya.

CASE FILE 6.2: THE VOICE OF THE COURT

① OBJECTIVE:
INFILTRATE KANE BUNKER

- **Location:** Kane Bunker, Tricorner Island
- **Faction:** Kane's Private Security

With violence erupting around the city, the Batman Family decides it's time to bring Kane in. Interact with the drone at the Belfry, located in the corner near the Batcycle. This sends the player to the Kane Bunker.

Grapple up the side of the high rise, as friendly drones are deployed to take out anti-aircraft weaponry on the rooftop. Grapple around the outside of the building until new platforms become available. Climb all the way up to the rooftop, where Kane Private Security stand guard. Defeat them before using the computer to enter Kane Building.

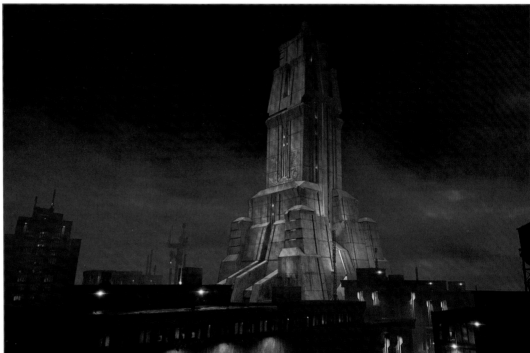

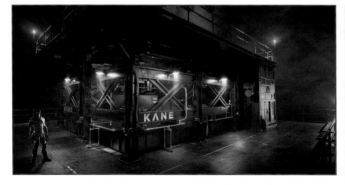

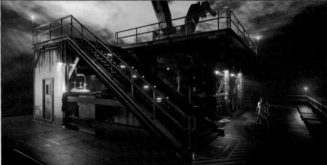

DANIEL KVASZNICZA
ART DIRECTOR (ENVIRONMENT)

It was important to us to emphasize the "Oligarchs" of Gotham and how they shaped the city by erecting monumental family buildings. For example, the Cobblepot family have influence on the industrial-themed south side of Gotham, while the Kane family has ties to the corrupt police force in the historic part of Gotham. As a weapons manufacturer they also have a major presence on the adjacent Tricorner Island with a whole naval yard. You'll notice some remnants of colonial forts on the east side towards the Atlantic that tie into the same theme of their history in naval warfare.

OBJECTIVE:
1 INFILTRATE JACOB KANE'S OFFICE

- **Location:** Kane Bunker, Financial District
- **Faction:** Kane's Private Security

Before the hero can track down Jacob Kane, something must be found that can cut through armor. Fortunately, an experimental laser cutter is available in munitions storage. Descend into the storage room and scan the crates on the shelves. Find the laser drill on a workbench in the back-right corner of the room. After you collect the equipment, a group of guards enters. Defeat them and collect an access card off one of the bodies.

CONCUSSION BARREL

During combat, keep an eye out for concussion barrels. These can be turned into explosive traps by shooting them with a projectile. Wait for hostiles to move near a barrel before igniting it, though be careful not to get caught yourself.

Follow the path to the security station and rewrite the Access Card at the console. This allows the player to move freely through the building. Accessible doors will automatically open when approached.

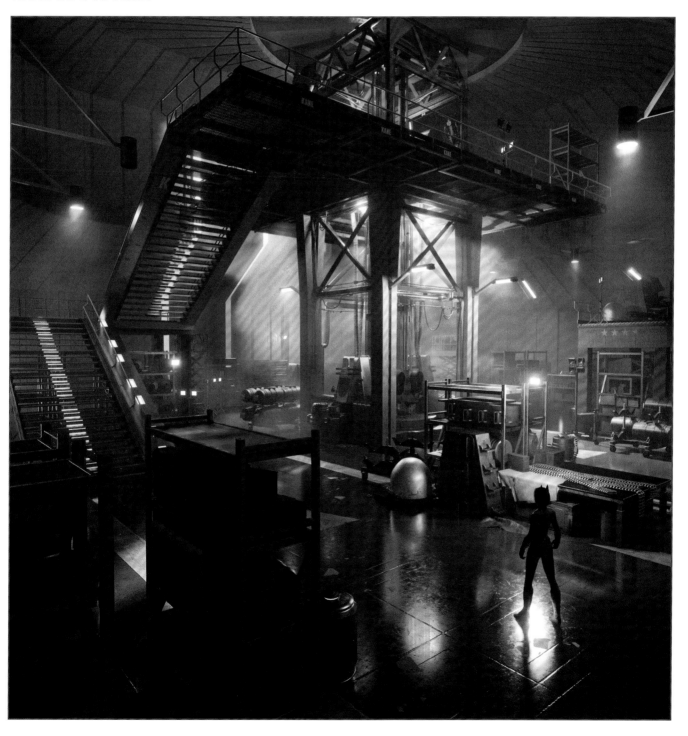

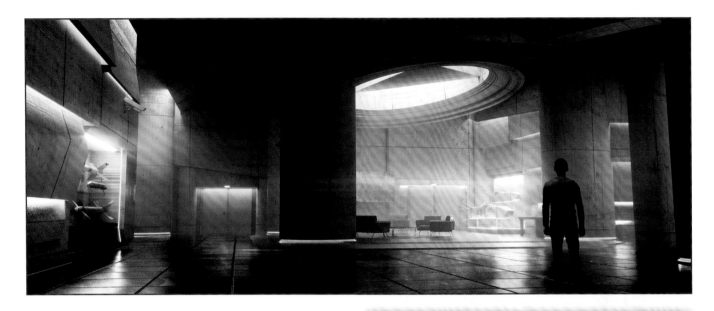

Return to the hallway and enter the locker room ahead to find a chest. Next, head through the remaining door in the hall and descend the staircase to the seventy-eighth floor. Enter the red door and loot another chest.

Continue down to the seventy-fifth floor to reach the lobby for Jacob Kane's office. A group of Kane Private Security huddles inside, including veterans, so be ready for a brawl. Step into Kane's office in the far corner and loot another chest. Carefully move through the hallway, avoiding the lasers and security cameras. If the alarm is tripped, the player must return to the office and disable it. Reinforcements show up, so deal with them before proceeding. A panel on the wall in the hallway can be used to deactivate the lasers, making the next trip less difficult.

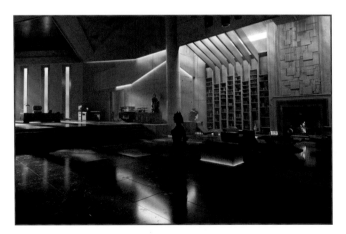

Enter the president's office and loot another chest to the left. To find the private elevator, a puzzle door must first be solved. This sudoku-style puzzle uses four different owl symbols in a four-by-four grid. Each row and column must contain one of each symbol, while the four corners must also hold all four symbols. Symbols already present in the puzzle cannot be changed. Investigate the symbols to start, then rotate each white square until the correct symbol is displayed. Once the puzzle is solved, the door opens.

HACK KANE'S LAPTOPS

Search laptops and filing cabinets inside Kane's office for secret information from Jacob Kane.

At the Suspicious Painting in the far corner, scan and manipulate the Strange Globe nearby. Next, place the cutting device on the revealed door, but it will take time to get through the armor. The cutting device draws the attention of Kane Private Security guards, as they storm the room. The player must defend the device until the armor has been cut. When the device malfunctions, run over to the door and reset the tool. The private elevator opens once the cutter completes its job. Ride the elevator down to the foundation.

OBJECTIVE:
1 FIND JACOB KANE

- **Location:** Kane Bunker, Tricorner Island
- **Faction:** Kane's Private Security

Scan the security personnel inside the war room ahead. Sneak through the outer hallway and quietly take down a couple guards along the way. Enter the room and defeat the remaining hostiles.

Beyond the next door, a smaller group of hostiles are accompanied by a Light Turret, as they guard the Inclinator. Defeat them before stepping onto and activating the Inclinator. As the elevator descends, multiple groups of guards join the vigilante. Quickly defeat them as they arrive. They are followed by a group of feral Talons. Defeat them before arriving at the bottom.

A few more Talons greet the hero as the cargo door opens, including a gladiator Talon. Eliminate them before exploring the sublevel. The corridor leads to a large room where the building's power is controlled. Guards patrol the center, while others man the controls. Several perches above provide vantage points, where you can scan the room and plan an attack. Take out as many guards with Silent Takedowns as possible, then finish off the remaining hostiles.

TURRETS

Turrets are stationary weapons that fire bullets at a high rate of speed, though they must spot their target before firing up the gun. They can be hacked with the appropriate ability, and their weapon fire can be dodged with quick evasive maneuvers. Exploit their biggest weakness by disabling them when standing next to them. Despite these advantages, don't lose track of them, or they can eat through the player character's health.

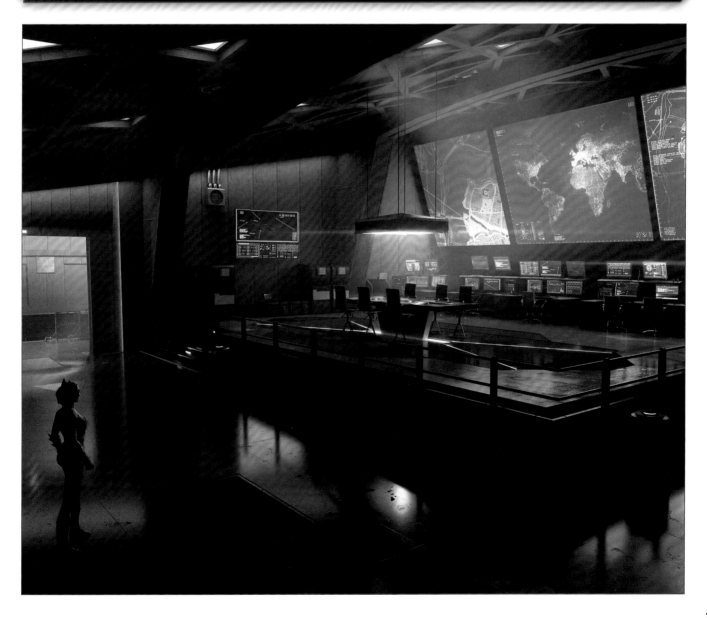

Inside the hangar, Court shooters and brawlers are scattered throughout the room. Some patrol the walkway, while others guard the room below. Observe their patrol routes and perform Silent Takedowns on lone Court Members when backs are turned. Perches on the outer walls are available to escape the walkway. Continue around the room until all hostiles have been defeated.

The player must find a way to open Jacob's blast door. Follow the steps below to do so. More of Kane's security team enter the room during this process so deal with them while completing the steps.

1 Approach the old blast door, located opposite the entrance on the main floor.
2 Interact with the switch next to the rotatable platform to turn the vehicle 90 degrees. Repeat this twice more until it faces the blast door.
3 Find a pair of switches on the upper walkway across from the vehicle that manipulate a Military Mounted Turret. One switch moves it up and down, while the other moves laterally. Interact with them to raise the turret, move it left, and then lower it.
4 Lastly, interact with another switch on the same console that rotates the platform. This activates the APC cannon, which proceeds to destroy the blast door.

CONFIDENTIAL DOCUMENTS

Keep an eye out for confidential documents sitting around the hangar. Scanning these papers gains you extra insight into Jacob Kane.

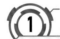 OBJECTIVE:
1 APPREHEND JACOB KANE

- **Location:** Kane Bunker, Tricorner Island
- **Faction:** Court of Owls

Destroying the blast door grants the hero access to the research facility where Kane hides out. Chase after him as he escapes down the stairwell. Watch out for thermal mines, lasers, and turrets in the corridor. Disable them if possible before busting into the facility, where Kane introduces the hero to a new Talon archetype, the hunter Talon. A pair of hunters team up with quick, poisonous strikes and projectiles. They retreat after each strike, making counterattacks more challenging. Defeat both hunter Talons before pursuing and capturing Jacob Kane.

Use the console on the right to open the door to the reactor room, and proceed inside. The reactor fills the left side of the room with toxic gas, while fire forbids passage on the right. Wait for openings before ducking or evading past the leaks. The next corridor leads to Kane's.

OBJECTIVE:
② PURSUE AND TALK TO TALIA

- **Location:** Tricorner Island

Talia spoils the day and escapes. Follow the checkpoints north across the Robert Kane Memorial Bridge into New Gotham and immediately turn west. Grapple and climb the rooftops northeast, defeating enemies along the way, until Talia is located on the rooftop of the Wayne Enterprises skyscraper.

Talia splits, leaving behind a group of League assassins. Stay on the move to avoid their surprise attacks, and defeat the ambushers. Return to the Belfry to wrap up Case File 06.

CASE FILE 07:
THE LEAGUE OF SHADOWS

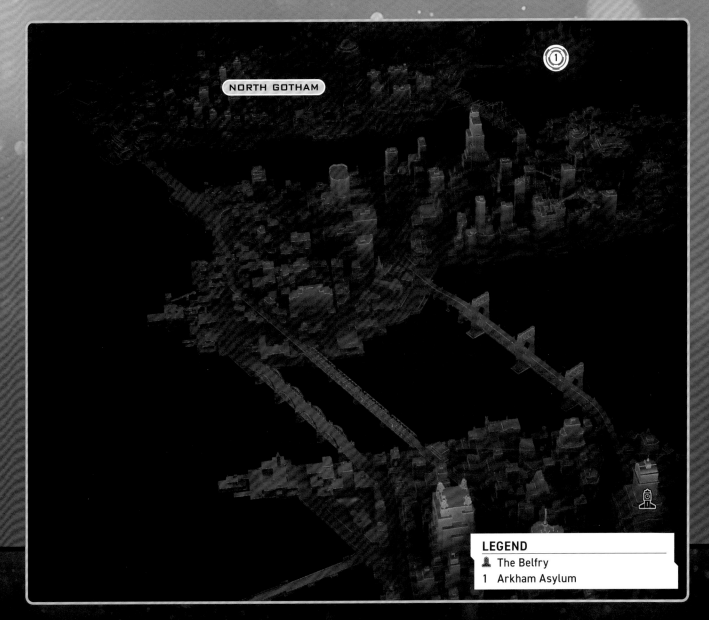

NORTH GOTHAM

①

LEGEND

⚑ The Belfry

1 Arkham Asylum

- **Requirement:** Complete Case File 06—Return to the Belfry after Apprehending the Voice of the Court

Main Objective:
Find Talia

Talia remains the leader of the League of Shadows and has big plans for Gotham. The heroes discover some of Langstrom's research took place at a secondary lab. They must find Talia soon and put an end to her plans.

CASE FILE 7.1: FRIENDS IN NEED

 ── OBJECTIVE:
COMPLETE CASE FILE LEADS

- **Location:** Gotham City

To continue, complete the given Case File Leads: rescue Lucius Fox by completing an Illegal Hack activity at Foxteca, rescue Jada Thompkins by completing a Witness Under Attack activity in New Gotham, rescue Montoya by completing an Officer Under Attack activity in New Gotham, and stop the League of Shadows by completing an Illegal Hack activity in the Cauldron. Then return to the Belfry to search for Talia. Irregular energy usage points to old Arkham Asylum.

CASE FILE 7.2: TALIA AL GHUL

OBJECTIVE:
① DISCOVER TALIA'S PLOT AT THE ASYLUM

■ **Location:** Arkham Asylum, North Gotham

Travel to the northeast corner of Gotham City and enter the grounds of Arkham Asylum. Follow the driveway up to the manor and step inside to find an abandoned laboratory. Scan the specimen tube on the raised platform and then begin an investigation at the lab table by scanning the serums and genetic marker groups. Mark Serum v24.07 for the component and Genetic Marker Group M for what Talia is trying to achieve.

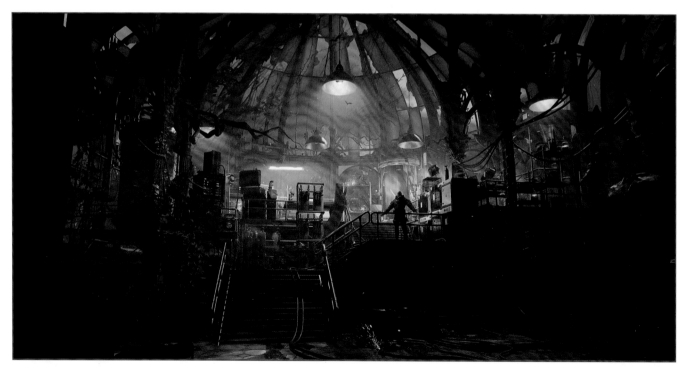

The hero must restore power to Arkham Asylum before investigating further. Use AR while exploring Arkham Asylum to find a few chests hidden off the beaten path and inside side rooms.

Follow a walkway out the back of the room that leads into a maximum security wing. Continue down the hallway and then drop into the basement. Move down the corridor and step into the booth. Interact with the console to activate backup generators and then return upstairs.

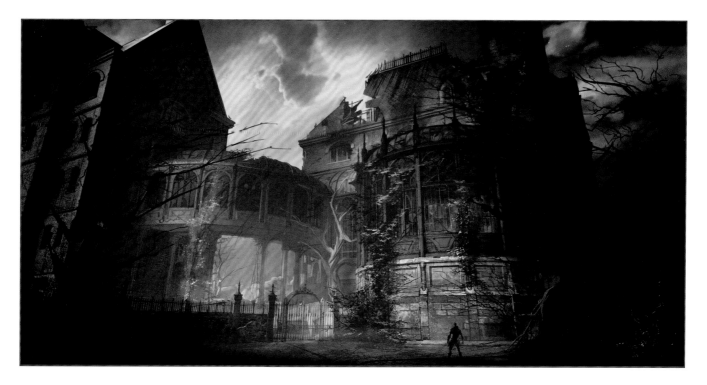

The nearby exit leads outside to the courtyard, where League rocketeers and assassins attack the hero. Re-enter the manor through the back door. Climb the stairs to the second floor, drop into the elevator shaft, and grapple to the third floor.

Follow the path past a few open rooms until the big hole in the ceiling. Grapple all the way to the top of the tower to find a main processing unit attached to four oscilloscopes and sound amplifiers. Reset the main unit to activate the oscilloscopes, which are all connected to their own amplifier; follow the cables to see which ones are connected. Interact with each oscilloscope to align the sound frequency displayed on the amp. Green light means success. Align all four by interacting with the scopes in the following order: twice on the middle-left oscilloscope, once on the far-right oscilloscope, three times on the middle-right oscilloscope, and three times on the far-left oscilloscope.

Return to the laboratory and interact with the tank. At this point, a Man-Bat prototype swoops in out of nowhere and transports the player character outside.

BOSS FIGHT: MAN-BAT

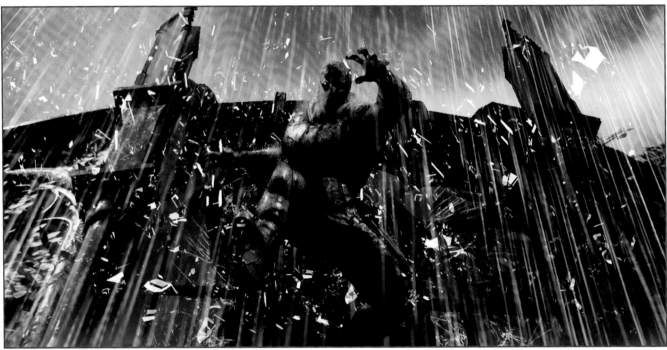

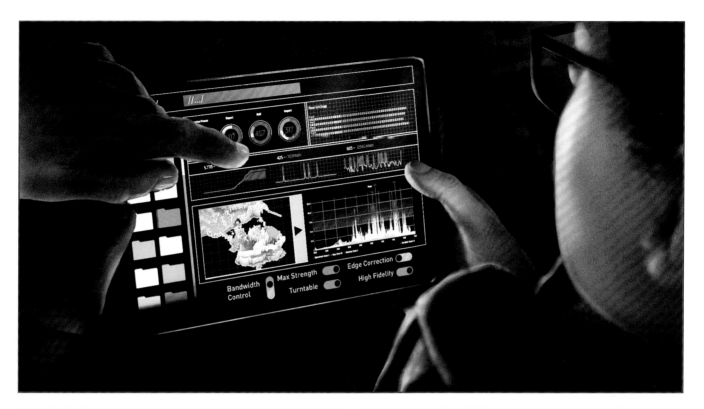

Man-Bat has powerful, uninterruptible, attacks that do high damage. Watch for the red glow and prepare to evade. Combat moves with the piercing property are helpful against the boss.

If Man-Bat takes to the air, keep an eye on him as he may circle around the courtyard, or immediately attack. When he dives, prepare to evade laterally as he rolls directly toward you. This leaves him vulnerable for a moment, so take advantage with some attacks from behind.

From distance, Man-Bat can leap and grab his target, pinning them to the ground and mauling them. Evade as the creature jumps to cause him to miss and then follow up with a counterattack.

Man-Bat has a powerful, swooping wing strike that is uninterruptible. He can strike three times finishing with a powerful two-wing swipe. On top of that, he can add a poison effect to his attacks. Evade each strike or use a piercing ability to counter.

After depleting Man-Bat's health bar, the boss smashes the hero through a gate, but falls into an underground tunnel on the other side.

The hero is brought back to the Belfry, as Man-Bats are released into the city. Once the hero is ready, these monsters must be defeated.

WILSON MUI
CINEMATIC DIRECTOR

Brought back to the Belfry from an intense fight with the Man-Bat at Arkham Asylum, our hero wakes up disoriented and recovering from their injuries. With the others out in Gotham fighting crime, their conscious decision and acceptance to go find Talia signifies that they are ready to become the next Dark Knight.

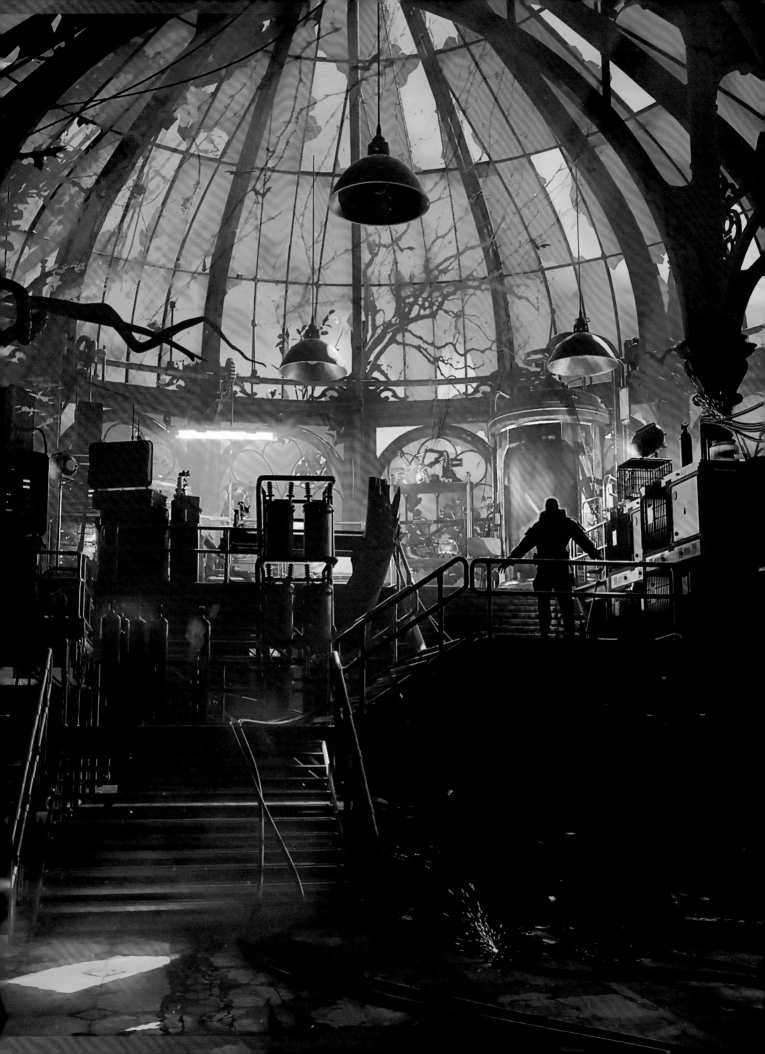

CASE FILE 08:
HEAD OF THE DEMON

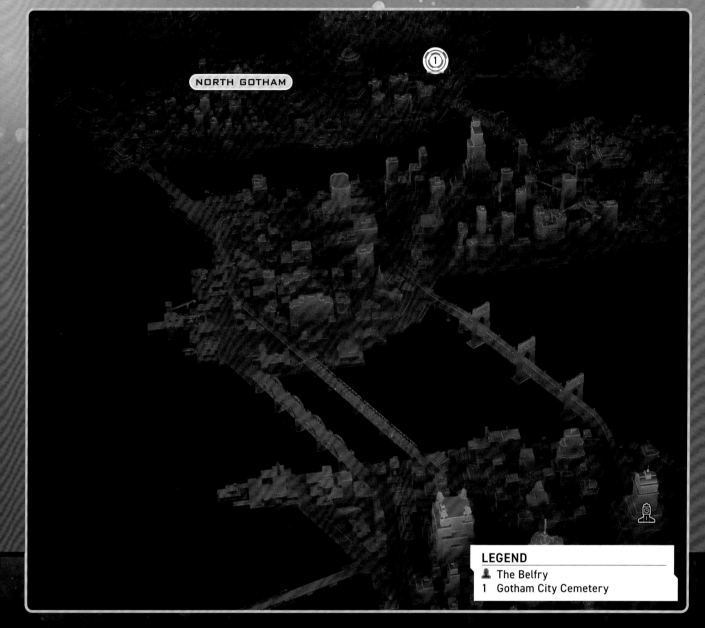

NORTH GOTHAM

1

LEGEND

🛡 The Belfry
1 Gotham City Cemetery

- **Requirement:** Complete Case File 07

Main Objective:
Locate the League of Shadows and the Lazarus Pit

Following the signals that control the Man-Bats, the Batman Family tracks Talia al Ghul and charts the likely location of a Lazarus Pit. All signs point to Gotham City Cemetery, or somewhere beneath it. With Gotham City in chaos, the Knights must rush to find Talia and stop the League of Shadows before it's too late.

CASE FILE 8.1: DANGEROUS SKIES

 OBJECTIVE:
STOP THE MAN-BATS

- **Location:** Gotham City

Man-Bats have been unleashed across Gotham City, and you must defeat three of them to continue. Find them on the rooftops of Elliot Center in the Financial District, Gotham City General Hospital in The West End, and Wayne Enterprises in Southside.

CASE FILE 8.2: THE LAZARUS PIT

① OBJECTIVE: FIND TALIA AND THE LAZARUS PIT

- **Location:** North Gotham, Gotham City Cemetery
- **Faction:** League of Shadows

Return to North Gotham and head to the cemetery, northwest of the asylum. Follow the path to the top of the hill and spot the pair of small mausoleums beyond Bruce Wayne's headstone. Enter the tunnels and slide to the first landing. The long and windy path through the tunnels is full of hazards, but a series of spikey lanterns conveniently lead the way. Stay on the move to avoid explosive traps and clear out the League assassins once met. Otherwise, you may be overwhelmed by their large numbers.

At the large gaps, look for lantern posts on the side walls. If the post is propped upward, the player must hit it with a projectile to drop the lantern. This provides a grapple point for the player character. Do not leave a perch until there is another point to grapple onto.

Stay on the move as some lanterns are rigged to explode. Watch for them to lower slightly before detonation. Later, lantern posts above the large pits are rigged to explode, forcing the player to stay on the move as much as possible.

Look out when sliding down an embankment as it may just send the hero off the edge. Be ready to grapple just before dropping into the abyss.

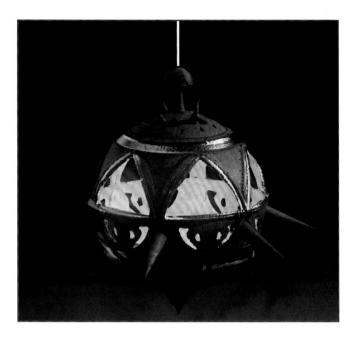

Use AR often to spot hidden chests on side paths and rooms.

League assassins ambush the hero on several occasions inside the tunnels. Watch for incoming explosives from League rocketeers and be ready to evade League attacks when a cloud of smoke appears.

Continue to follow the path through tunnels and across grapple points until Talia is spotted.

FOLLOW THE LEAGUE OF SHADOWS UNDERGROUND

- **Location:** North Gotham, Gotham City Cemetery
- **Faction:** League of Shadows

Drop off the ledge as a group of League assassins and a rocketeer ambush immediately. Defeat each group of League ninjas as they are met before leaping to the next platform or lantern post. Rocketeers may fire from distance, but only if the hero gets too close. The final ledge brings more League into the fight. Defeat the League guards before moving into the temple.

BOSS FIGHT: BRUCE WAYNE

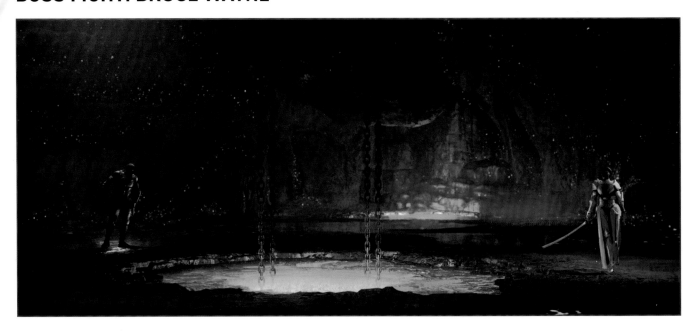

WILSON MUI
CINEMATIC DIRECTOR

Discovering a Lazarus Pit with Talia al Ghul around is never good news, as Red Hood can tell you. As the hero arrives deep below the remnants of Wayne Manor expecting to defeat Talia al Ghul, they discover a horrific revival of Bruce from the dead. Perfectly executed and according to plan, Talia al Ghul leaves our heroes in utter shock and agony only to have them face Bruce in battle.

■ **Weapons:** Proximity Mines

The League has tunneled into the lost Lazarus Pit, which Talia has used on the recovered body of Bruce Wayne.

Bruce has a lethal combo of punches and kicks that are uninterruptible. Melee and ranged attacks are useless unless used in a counterattack. Learn the timing of his moves, because counters must be performed quickly before the boss's defense is restored.

When he leads with a rotating jump kick, he strikes three times. With a flying kick, he strikes four times. Evade the strikes and then quickly hit him with a series of attacks.

When close, he may simply punch twice and attempt to grab his target. If successful, he performs a devastating character-specific throw.

Bruce will often throw down three proximity, explosive shurikens. A mine detonates after a few seconds when approached too closely. Red targeting circles signify the danger area, so clear out to avoid taking damage.

Watch for Bruce to spin around and leap into the air. This signifies an incoming ground punch that does significant damage, as well as add shock effect. This move has a large area of effect so sprint a safe distance away to avoid it.

After Bruce takes significant damage, he hunches over and a prompt appears, offering a chance to interact. Do so quickly, or he may recover a little health. Each time this opportunity pops up, hold the indicated button to appeal to Bruce. The player will have a few of these opportunities throughout the fight. After the final plea, Bruce finally comes around. Talia attacks, but Bruce takes the hit. After an attempt to leave the tunnel, the hero is forced to challenge the leader of the League.

BOSS FIGHT: TALIA AL GHUL PART 1

■ **Weapons:** Sword, Bow, Shuriken

Talia al Ghul carries a long sword and bow that she uses to deliver brutal attacks with precision. As a master assassin, she possesses the ability to move around the arena quickly, disappearing in a shroud and reappearing to deliver exacting blows against the hero.

She has spin attacks that she combos together in a series, ending with a spinning kick and 360-degree sword attack. When she sidesteps to her right, be ready to evade each spinning attack, and if close enough, immediately counter when she lands.

If her sidestep goes to her left, she begins with a ranged attack before going in for a couple sword strikes and finishing with a flying maneuver straight for her target, spinning with sword extended. Again, quickly counter with a series of attacks before she fully recovers.

One of her ranged attacks involves three throwing stars, thrown in succession. These can be avoided with quick lateral movements.

From distance, she also shoots one powerful, focused arrow with devastating effects. Because it takes a while for her to power it up, interrupt her or ready a side evasive maneuver.

Depleting her health bar is not the end of the fight, as members of the Court of Owls, including the new Voice, arrive to confront Talia. This enrages her, making her more powerful for a second fight.

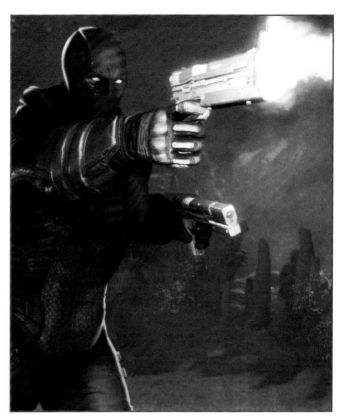

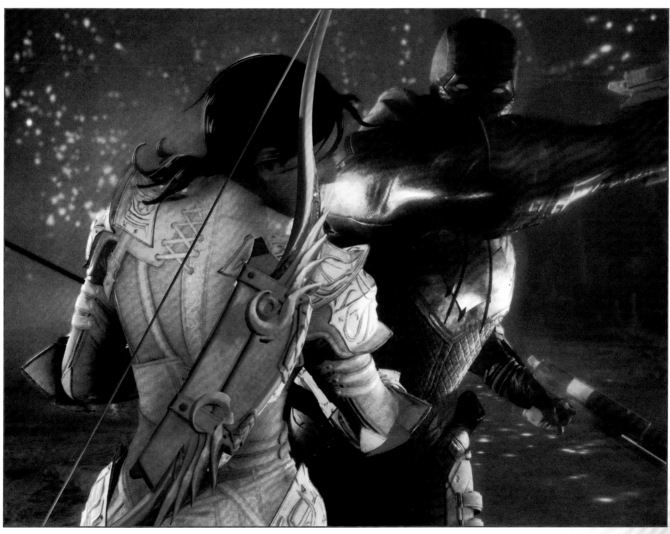

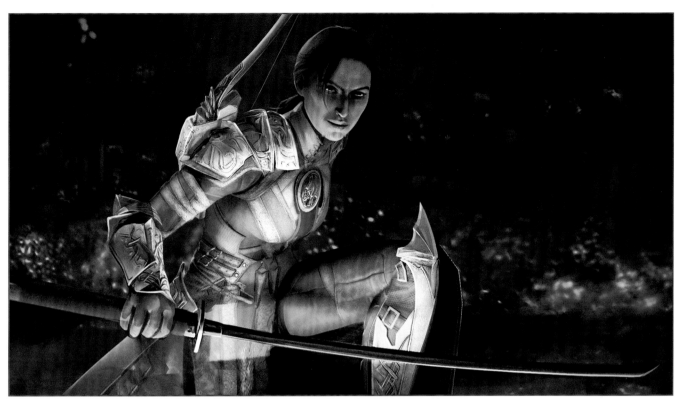

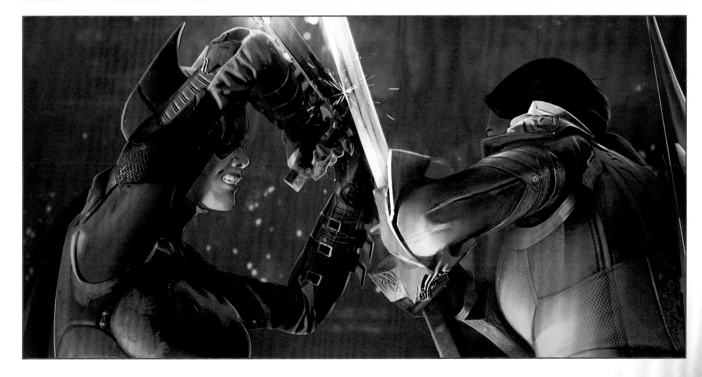

BOSS FIGHT: TALIA AL GHUL PART 2

■ **Weapons:** Spear, Bow, Shuriken

Talia al Ghul still possesses the throwing stars and bow, but her sword is now a long spear giving her greater range with her attacks. Remain alert for her previous ranged attacks, but also prepare for a new melee combo.

When she sidesteps to her left, she leaps in with a stab attack. This is followed by a couple spin attacks before launching the spear straight at her target. Be ready to evade all the way through the range attack before countering.

Her bow will also fire three explosive arrows that land on the ground, detonating on impact. Clear out of the area as soon as she prepares her bow.

She is also capable of taking flight, hovering above the arena, waiting for an opportunity to strike. Remain alert as she will dive at the hero with a devastating 720-degree spear attack.

Be patient with the boss, evading every time she attacks. Use the player character's best abilities and counter at every opportunity. Once her health bar has been depleted, the Voice of the Court attempts to intervene and take over the Lazarus Pit with an army of Talons. Talia then disappears, leaving the hero to face the Court of Owls alone.

This completes the Case Files, but there's still plenty left for the Gotham Knights to do . . .

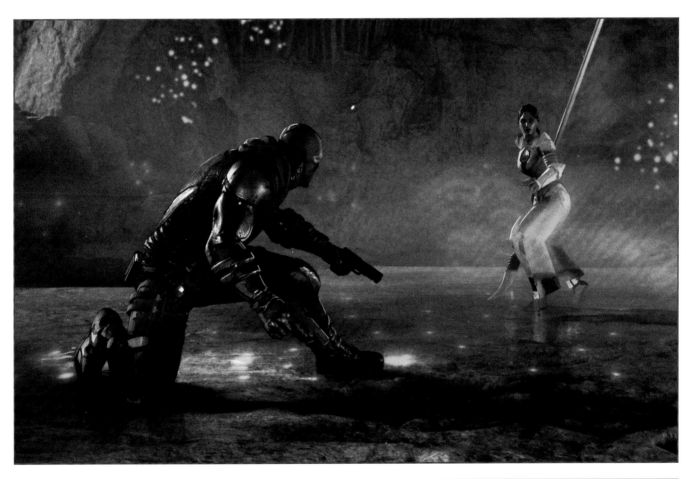

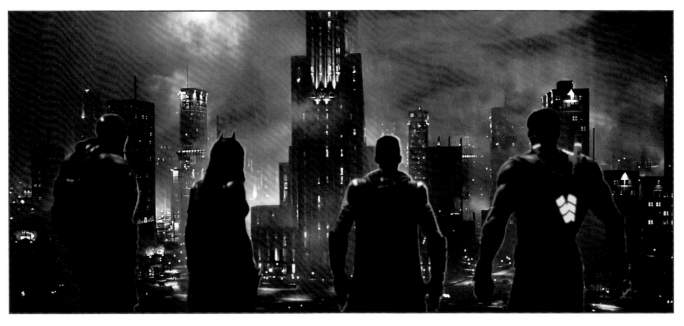

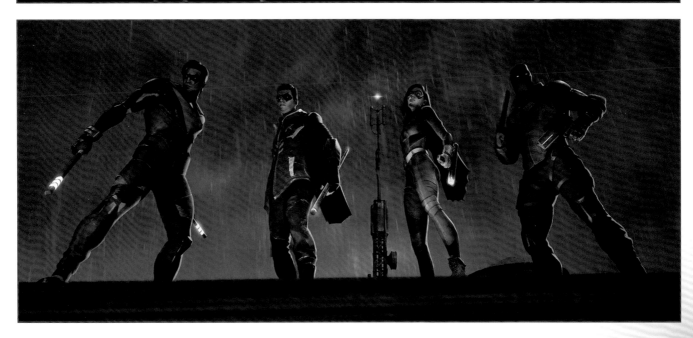

VILLAIN CASE FILES

As you progress through the Case Files, three villain story arcs become available. Once these are unlocked, complete a series of objectives to face off against the three bosses: Mr. Freeze, Harley Quinn, and Clayface. Each story arc includes multiple fights against the boss.

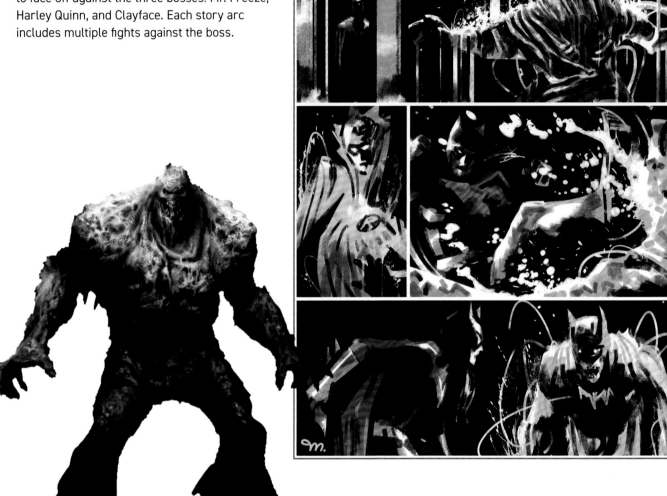

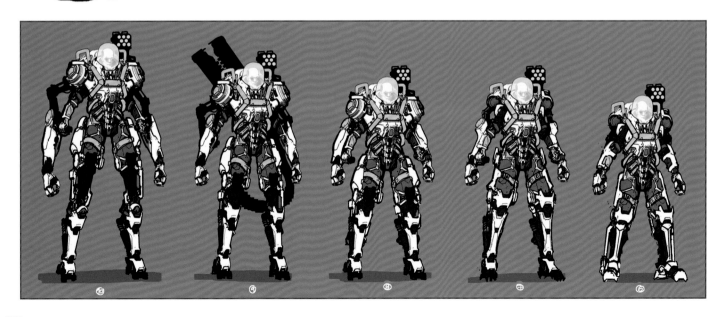

VILLAIN CHALLENGES

Each story arc is broken up into multiple parts, separated by challenges. These challenges typically involve fighting the villain's devotees and must be completed in order for the villain arc to continue.

PATRICK REDDING
CREATIVE DIRECTOR

One thing we realized quickly is that the death of Batman isn't just a blow to the heroes' world. Because of the weird dynamic he's always had with his enemies, it would be hugely disruptive to their lives as well. Sure, they might see it as an opportunity; but it would also take away some certainty. We played around with that a lot.

At the start of the game, Clayface is literally putting himself back together after his last encounter with Batman and when he discovers that he'll never get a chance at revenge, he snaps and decides to punish the whole city.

In our world, Mr. Freeze made a deal with Batman to turn himself in and do his time in return for a cure to his condition. With Batman gone, Freeze saw that possibility evaporate, and so he took on a contract that required him to terrorize Gotham City.

JAY EVANS
ART DIRECTOR (CHARACTERS)

Harley Quinn is another character who evolves throughout *Gotham Knights*. In her first appearance she is comfortable at "home." Later she's a psychopathic leader inspiring her minions, and finally we see her as a fully evolved independent super villain.

MR. FREEZE

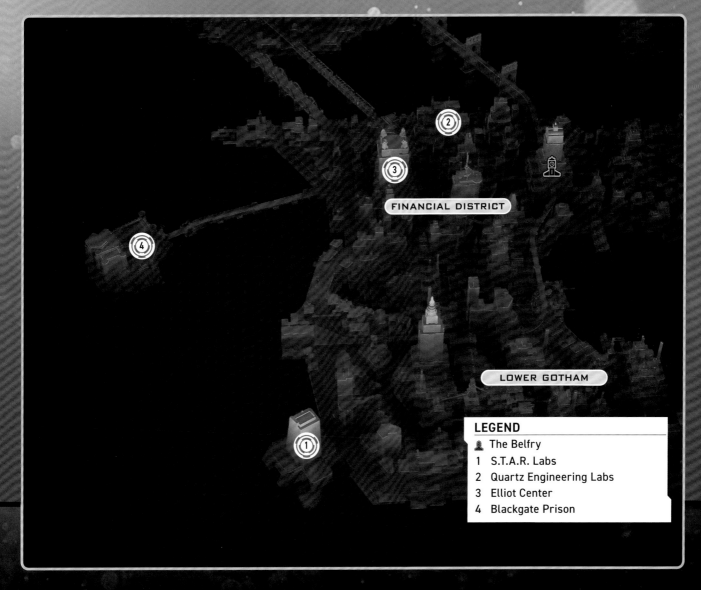

- **Requirement:** Talk to The Penguin at the Start of Case File 02 and Return to the Belfry

Main Objective:
Defeat Mr. Freeze

After visiting The Penguin, the player returns to the Belfry to complete Case File 2.1. This unlocks a few required challenges, including an objective to investigate S.T.A.R. Labs. This is the start of the Mr. Freeze Case File.

CASE FILE 1.1: HEIST AT S.T.A.R. LABS

 OBJECTIVE:
INVESTIGATE S.T.A.R. LABS

- **Location:** S.T.A.R. Labs, Lower Gotham
- **Faction:** Regulators

WILSON MUI
CINEMATIC DIRECTOR

Encountering Mr. Freeze in S.T.A.R. Labs and watching him calmly kill innocent civilians was a traumatic and impactful event for our heroes, especially Red Hood. Dangerous, unpredictable, and deadly with his mechanical suit and weapons, we start to have a glimpse of Mr. Freeze's motivations evident from his suit malfunctions. Foreshadowing his health decline, he becomes more dangerous and reckless with his rampage and destruction in Gotham.

Travel to S.T.A.R. Labs, located on Port Street in the southwest corner of Lower Gotham, to learn that Regulators have occupied the facility. Find an entry point on the front of the building; follow the maintenance access to an upper floor and duck into the left path. This leads into the corridors of S.T.A.R. Labs.

SERVER ROOMS

Take out the two guards in the hallway before entering the server room, where a group of Regulators has hacked into the system. Scan the area to find their locations, as well as a few security cameras. Avoid the cameras while eliminating the shooters and brawlers with Silent Takedowns. Use AR throughout S.T.A.R. Labs to find hidden chests like the one inside the server room. Interact with the emergency cooling controls to open the vents on the nearby wall; grapple onto the ledge and scan the next room.

A Light Turret protects the room as Regulators hack the servers. Keep equipment between the turret and hero if possible, while fighting the hostiles. Each character has their own way of dealing with turrets, but they all can disable the gun when up close. With the threat eliminated, exit the room.

ST/R LABS
Applied Physics Division

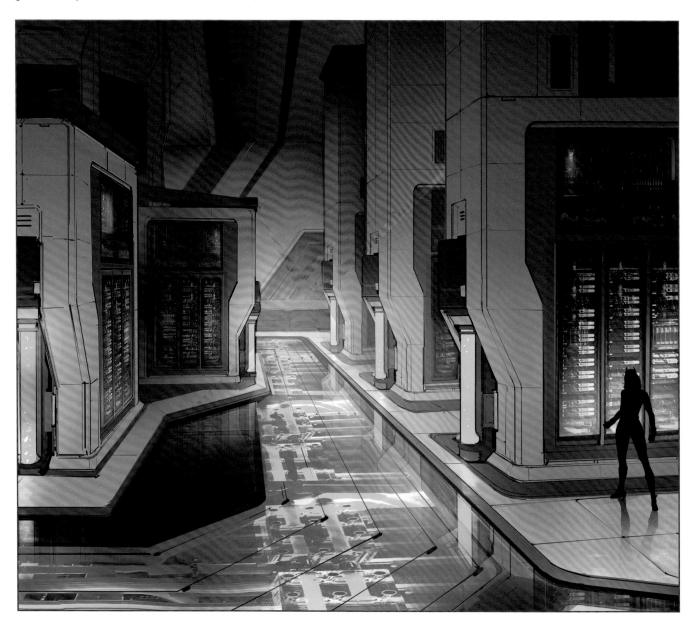

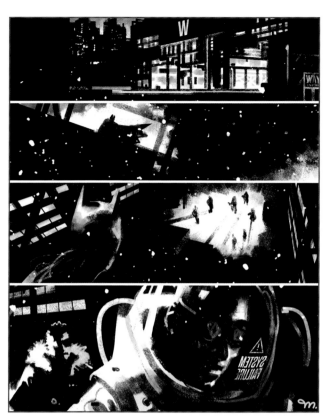

SECURITY ROOM

The security room is just upstairs and is currently occupied by more brawlers and shooters. Some patrol the outer room and walkway, while the remaining hostiles work in the center. These inner hostiles are watched by security cameras. Observe the patrols of the guards and use Silent Takedowns on them. After all Regulators have been defeated, approach the desk, and check the security terminal to find Mr. Freeze is responsible for the intrusion.

RECEPTION

Through the new exit, grapple to the accessible floor above and quietly take down a lone crew member. Hop the turnstiles and climb onto the railing that overlooks reception, where more shooters and brawlers are found. A security camera watches over the balcony below. The hostiles are fairly spread out, allowing for a stealthy approach. Start with a Silent Takedown from above, then defeat the hostiles in the area.

LABS

Use AR to follow Mr. Freeze's tracks through the door and down the corridor. Use AR again to scan the labs on the right. There are several Regulators, along with a drone master. There is one side room, allowing the player to isolate the Regulators. Be careful as some hostiles patrol through different areas, and if a body is found, everyone converges on that location.

There are numerous ways to deal with the hostiles in the labs, but a good place to start is the far-right lab. Carefully move around the perimeter of the labs, disposing of the hostiles along the way. If you are detected, flee in and out of the labs, picking the hostiles off as they follow. Light turrets guard the central area. Be sure they have been disabled, or steer clear.

TEST CHAMBER

Follow Freeze's trail through the labs to the far side and grapple to the next floor. Crouch through the HVAC corridor until able to grapple up another level. Quietly drop into the control room below and perform Silent Takedowns on the hostiles. Look back at the control room and use the grapple point to exit to the next floor.

MR. FREEZE

Mr. Freeze's trail leads into another laboratory. Approach the marked computer and interact with it to open the security blast door. Mr. Freeze traps a few doomed scientists in the adjacent room and, after a short conversation, exits the facility.

Brawlers and shooters enter from multiple points. Defeat them, then interact with another console to initiate rail gun rotation. This process takes some time as more hostiles converge on the hero's location. After everyone has been defeated, move up the steps and use the computer to arm the rail gun—freeing the scientists.

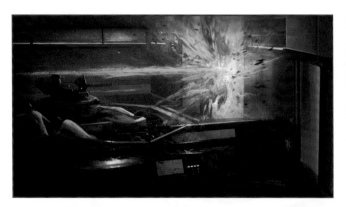

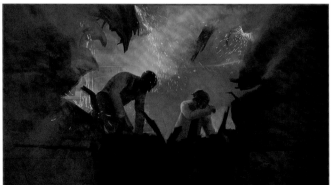

OBJECTIVE:
COMPLETE MR. FREEZE CHALLENGES

- **Location:** Gotham City

Hit the streets of Gotham City and complete five crimes involving Regulators allied with Mr. Freeze to complete the Mr. Freeze challenges. Return to the Belfry to progress through the story.

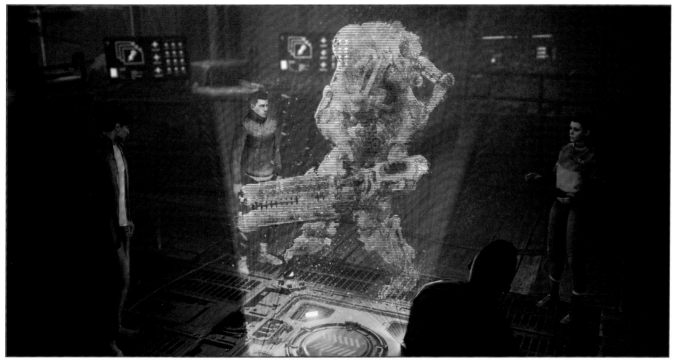

CASE FILE 1.3: QUARTZ LABS

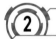

SUSPICIOUS ACTIVITY—OBJECTIVE:
INVESTIGATE QUARTZ LABS

- **Location:** Quartz Engineering Labs, Financial District
- **Faction:** Regulators

QUARTZ PARKING LOT

More suspicious activity has been discovered at Quartz Engineering, and evidence of Cryogel points to Mr. Freeze. From the Batcomputer, launch the next part of Freeze's villain arc from the Case Files tab. The rooftops are guarded by snipers, while brawlers and a shocker patrol the parking lot. Take care of the shooters with Silent Takedowns before defeating the hostiles below.

QUARTZ LABS

With the hostiles out of the way, enter the building through the Quartz garage. More Regulators, including another drone master, occupy the labs. The main hallway leads directly to the hostiles, but ductwork can be accessed from the garage. Follow it onto a railing high above the Regulators. Use Silent Takedowns from above to avoid detection. If spotted, retreat to the ductwork until the hostiles return to normal, or fight it out with the remaining Regulators.

Press the vault release on the central desk to open the vault door, attracting the attention of shockers. Defeat them before using AR to scan the Quartz scientist inside the vault. Read the notepad on the back wall to gain access to Upshot's office. Climb the stairs in the far corner and interact with the keypad on the office door.

Inside the office, scan the floor to the right to find a hidden compartment under the floor. Open the hatch to locate the disruptor. Exit the labs to return to the Belfry.

OBJECTIVE:
COMPLETE MR. FREEZE CHALLENGES

- **Location:** Gotham City

Hit the streets of Gotham and complete crimes around the city. Keep an eye out for criminals wearing Mr. Freeze colors. Collecting evidence dropped by enemies is a quick way to locate them. Complete the challenges to continue the story arc.

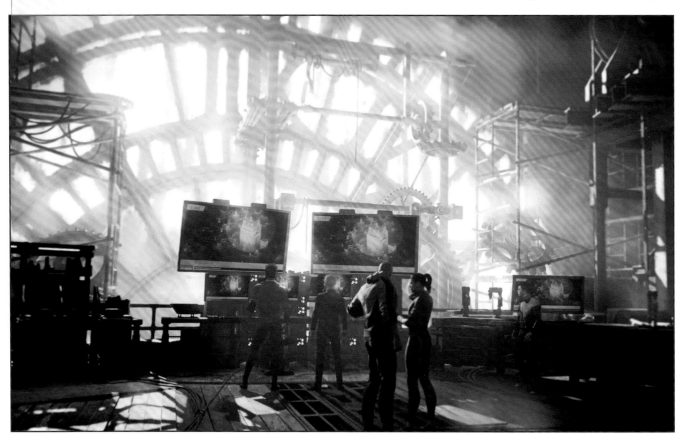

GOTHAM UNDER ICE—OBJECTIVE:
② STOP MR. FREEZE

- **Location:** Elliot Center, Financial District
- **Faction:** Regulators

New Mr. Freeze challenges must be completed before continuing the villain arc. Collect evidence from criminals allied with Freeze to find the location of their hideout. Clear out the hideout to complete the challenge.

CASE FILE 1.4: ELLIOT CENTER ON ICE

GOTHAM UNDER ICE—OBJECTIVE:
③ SHUT DOWN THE STORM ENGINE

ELLIOT CENTER

After completing the Freeze challenges, head to the Belfry for a debriefing. Extreme weather has encased Elliot Center in ice. Travel west to Elliot Center and observe the standoff from the rooftop across the street. Several Regulators shoot it out with GCPD in the plaza. Use the frozen pillars to get the drop on them while they're distracted. Defeat all of the hostiles to proceed.

ASCEND ELLIOT CENTER

After the GCPD chopper fires on the building, grapple up to the new ledge and interact with the narrow gap to get inside the ice shell. Follow the path to a drop-off. Drop down and take out the two enemies.

Grapple up the building and scan the Regulators ahead, which includes shockers. If available, use a Silent Takedown to start the fight. Return through the short opening and heal, if needed. Finish dealing with the hostiles before continuing along the path.

Continue to follow the waypoints up the building to the narrow ledge. Shimmy right around the corner and drop down. After grappling farther up the building, defeat more Regulators before proceeding. As the building becomes more unstable, chunks begin falling onto the path. Stay on the move, climbing farther up the building. After the ice bridge collapses, the hero gracefully slides inside Elliot Center.

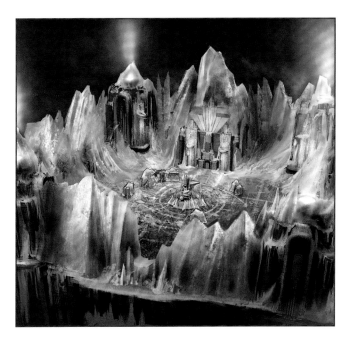

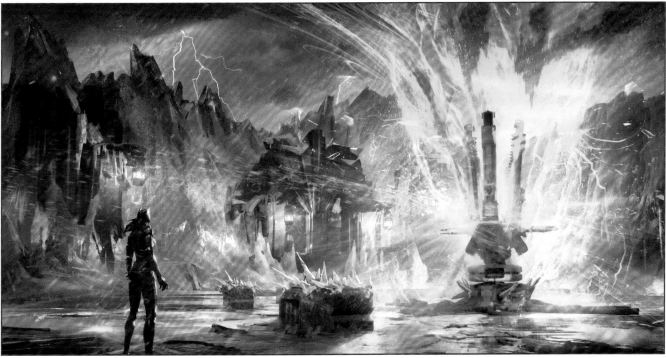

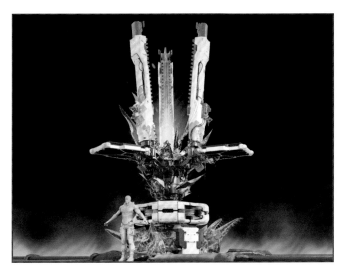

ELLIOT CENTER INTERIOR

Move into the interpretive center and duck behind the railing. Scan the area ahead to find brawlers and shooters on the same level and a floor above. Stairwells to each side provide access to the balcony. The hostiles can be defeated with Silent Takedowns but avoid takedowns within view of others. If you are detected, quickly move between the two floors to avoid being overwhelmed.

After defeating the hostiles, move through the big doors. Follow the path up the shaft, shimmy to the right, then follow the large cables up. Cut through the gift shop and exit through the narrow opening. The trail leads up another grapple point to a weather machine on top of the building. Interact with the machine to install the arc disruptor.

BOSS FIGHT: MR. FREEZE

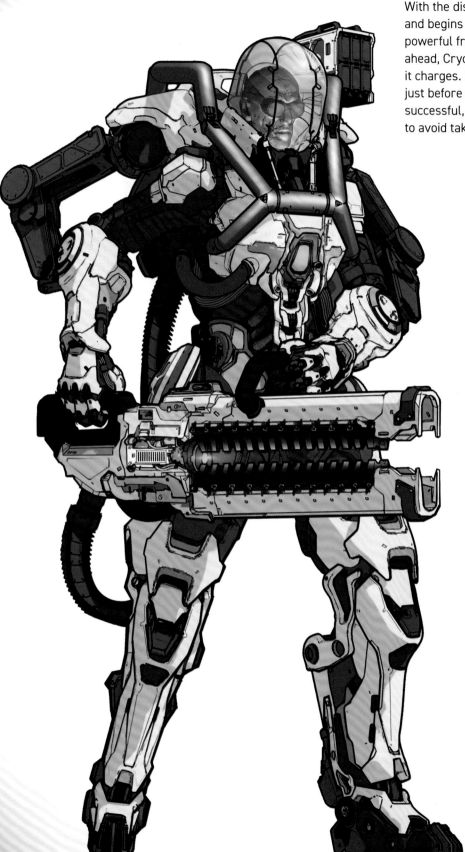

■ **Weapons:** Freeze Guns, Grenades

With the disruptor in place, Mr. Freeze takes an interest and begins a battle with the hero. The boss wields a powerful freeze gun. Freeze aims the weapon straight ahead, Cryogel swirling around the barrel of the gun as it charges. Listen for three sharp sounds from the gun just before a ray of coldness bursts toward the target. If successful, this shot knocks the hero down. Run sideways to avoid taking the hit.

GEOFF ELLENOR
GAME DIRECTOR

We decided that in addition to having the "freeze gun" which could do a variety of freeze attacks, Mr. Freeze as a scientist could basically "form his own arena" for his boss battle, which meant we could have a super-cool (hahahaha) zone right in the middle of the tallest building in the financial district. We could build a towering pillar of ice, with an arena on top of it. This was not only badass (although it is great), but it guaranteed that we didn't have to worry about players trying to lure Freeze into an open world encounter where he could be cheesed easily . . . We could guarantee a solid, fun combat encounter by having the Villain control the arena.

Because the weather machine was the "active current danger" to Gotham City, it made sense that the weather machine should be central to the boss fight. We started experimenting with different ways that Freeze could use the weather machine to threaten the players, tweaking and controlling his machinery (after all, he built it) even while the players' disruptor gadget was trying to overload the Storm Engine and break it apart. We felt that this would let us structure cool phases for the fight, as the machine makes the arena more and more dangerous, and breaks up the pacing of the fight because of the "survival phases" during the battle.

With testing, we noticed that players would tend to try to stick close to Mr. Freeze, so we decided to increase the challenge by making Freeze do little "rocket jumps" with the freeze gun, to rapidly change position in the arena, and keep players moving. So today, Freeze uses his gun not only to attack the player(s), but also to move around quickly, including jumping on his weather machine to initiate survival phases where he bombards us with weather attacks.

JAY EVANS
ART DIRECTOR (CHARACTERS)

Mr. Freeze's suit is very much an environment protection suit, maintaining the cold temps for Freeze to survive as well as augmenting his strength and size. His spider mecha version is the high point of technology in our Gotham.

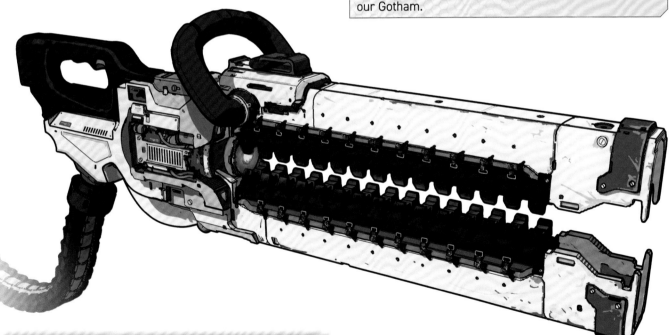

FROZEN

Some attacks by Mr. Freeze and his followers inflict the frozen status effect. This can freeze the hero in place. If this happens, rapidly press the button displayed on-screen to break free. The hero is vulnerable in this state, so break free as quickly as possible.

When the player character is close to the boss, Mr. Freeze has a forward and backhanded swing that knocks his target to the ground. Evade the strike and get in a quick attack.

After Freeze takes a knee, he prepares a grenade launcher on his back. After a few seconds, three grenades launch toward his target. Red targeting circles on the ground indicate the danger area. Run out of this area to avoid taking big damage. This is a good opportunity to circle behind the hostile and get in a few strikes or a special ability.

Watch for Freeze to raise the gun and plunge it into the ground. Red hexagons on the ground indicate the danger zone for a detonation attack a couple of seconds after insertion. To avoid taking damage himself, Mr. Freeze launches backward into the air. If he stands near a wall, he flies out toward the center. Move out of the highlighted area and hit him with ranged attacks. Be careful to not get too close before he lands, as he slams into the ground.

Evade Freeze's devastating attacks and get in strikes and special abilities whenever possible. After losing a certain amount of health, Mr. Freeze hops onto the storm engine. At this point, streams of ice jet from the machine, which spins, causing damage to anything in the way. Evade just as it passes to avoid taking damage. Next, large chunks of ice fall from the sky, blue hexagonal patterns indicating their impact locations. Stay on the move to avoid getting hit. Hit the boss with ranged attacks as the machine alternates between these two attacks.

Everything repeats in a second phase of the boss battle. Watch for the same attacks as before. Evade around to the side and get in some attacks from behind. After more of Freeze's health is knocked off, the storm engine attacks repeat, but stronger. Clear away from the machine, and stay moving when the ice falls from the sky. Deplete his health until Mr. Freeze goes down. The authorities whisk him away by helicopter en route to Blackgate Prison.

CASE FILE 1.5: ON THIN ICE

OBJECTIVE:
COMPLETE MR. FREEZE CHALLENGES

- **Location:** Gotham City

Hit the streets of Gotham City and defeat criminals loyal to Mr. Freeze. The Mr. Freeze challenges require the player to complete five crimes involving Regulators aligned with Freeze.

CASE FILE 1.6: BREAKOUT AT BLACKGATE

ASSAULT ON CELL BLOCK 5—OBJECTIVE:
DEFEAT THE FORCES ALIGNED WITH MR. FREEZE

- **Location:** Blackgate Courtyard, Blackgate Island
- **Faction:** Regulators

PRISON COURTYARD

Regulators have breached Blackgate Prison in an attempt to free Mr. Freeze from his cell. You drop into the courtyard between cell blocks 4 and 5 to find a group of Regulators. Defeat the hostiles as a small backup group arrives, including a shocker. Once they've been eliminated, follow the waypoints through a narrow opening.

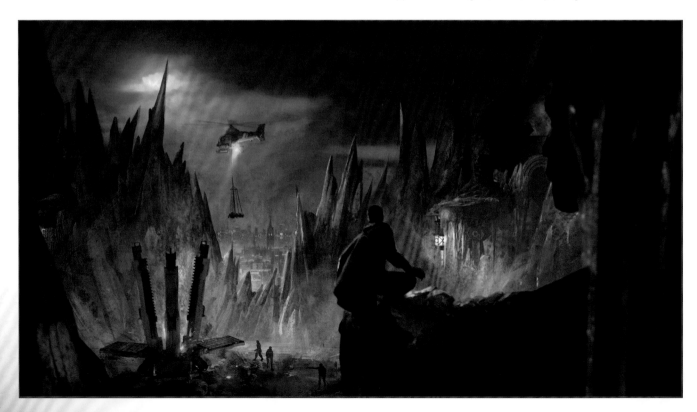

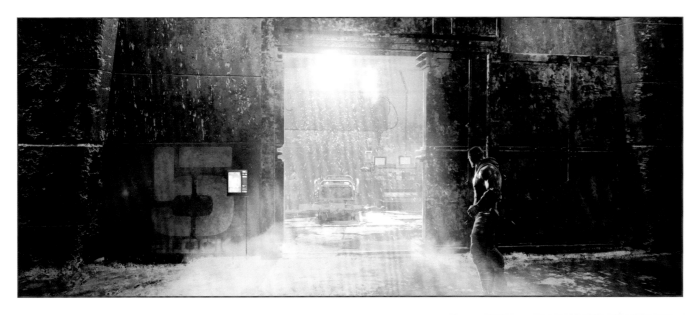

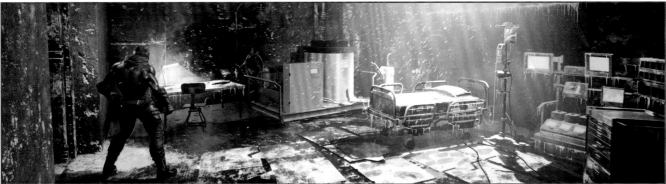

CELL BLOCK 5

The corridors lead into the second level of Cell Block 5. Duck behind cover, and when the light turret turns its gun to the side, quickly defeat the enemy before disabling the gun. Regulators occupy the cell block ahead, with light turrets guarding entry points on three sides. Brawlers and a shocker are stationed around the second floor, with a sniper watching from the third. One of the hostiles on the first floor patrols a loop around the turret locations. Stealth is the best option, but you could opt to join the Regulators in the center of the block and fight it out. Watch out when close to the surrounding turrets and try to stay clear of the sniper's view. Use AR to spot hidden chests around the cell block.

For a stealthy approach, sneak right from the start and quietly disable the turrets while performing Silent Takedowns on brawlers and shooters. Work around the upper floors before defeating hostiles on the bottom. At the corner, wait for the mobile guard to leave the area before dropping down. After defeating everyone except the hostiles who attempt to break into the control room, interrogate the brawler.

TALK TO THE LAWYER

Now talk to the lawyer in the booth about getting to Mr. Freeze. The GCPD officer is unable to open the door. The hero must re-create the guard's prints to gain access. Activate AR and scan the footsteps next to the door. Follow this trail to a bench in the corner, analyze the clipboard, and scan the print left on the board.

Next, the boot prints lead around the outer walkway into an open cell. Scan the guard's clipboard on the ledge, the guard's helmet in the cell, and the mug on the desk in the break room for fingerprints.

CLEAR THE REGULATORS IN THE CELL BLOCK

After scanning the third print, a mix of shooters, brawlers, and shockers floods the cell block. Fend off the hostiles and defeat them all to proceed.

SPECIAL CONTAINMENT BLOCK

Use the keypad next to the gate to gain access to the special containment block. Enter Freeze's cell, loot the chest, and exit through a narrow opening to the right. Follow the path of destruction to a small group of hostiles. Defeat them before returning to the courtyard through the narrow gap.

BOSS FIGHT: MECHA FREEZE

- **Weapons:** Mounted Grenade Launcher,
 Mounted Freeze Gun

PHASE 1

Mr. Freeze has abandoned his cryo-suit for a powerful upgrade. The villain pilots a mechanical spider suit equipped with a freeze gun on the right shoulder and a grenade launcher on the left. Two legs allow it to rear back, and four spider-like appendages on the front stab at the ground.

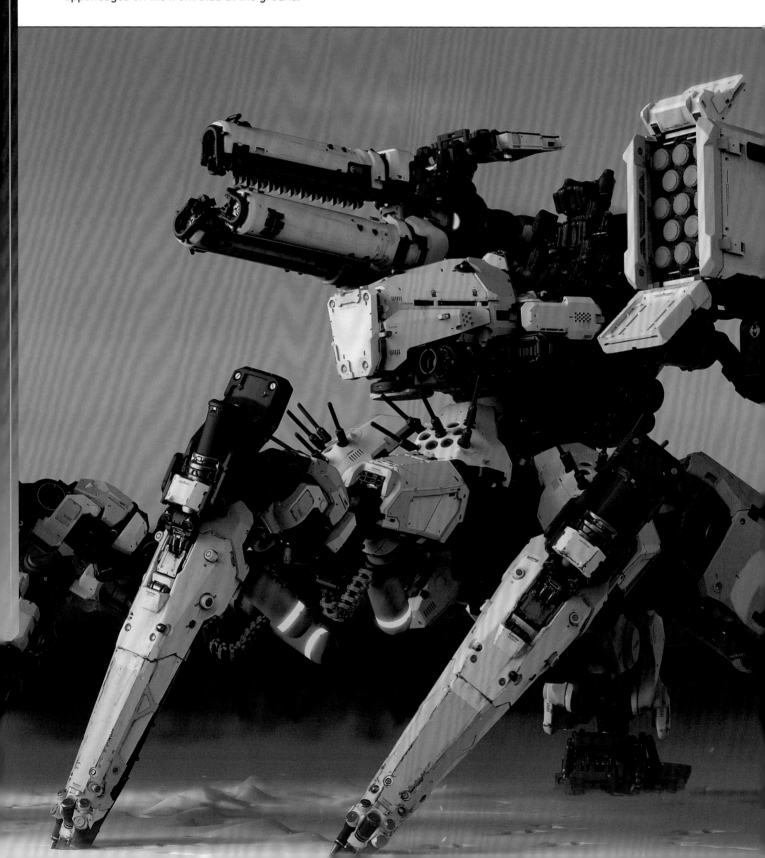

1 FRONT LEGS 前脚

x4

LG ❹
LG ❺
LG ❻
LG ❷
LG ❸
LG ❶

ASSEMBLED
組み立てられた

2 BACK LEG 後ろ足

x2

LG ❶
LG ❷
LG ❸
LG ❹
LG ❺

ASSEMBLED
組み立てられた

3 CORE UNIT コアユニット

❶ NOSE
❷ COCKPIT
❸ REACTOR
❹ ATTACHMENT POINT

CO ❷
CO ❸
CO ❶
CO ❹

BACK
裏面

4 MISSILE LAUNCHER ミサイルランチャー

RIGHT
右

ML ❹
ML ❺
ML ❶
ML ❷

❶ MOUNTING POINT
❷ DOOR COVER
❸ MISSILE
❹ TARGETING MODULE

ATTACHMENT
添付

CO ❺

5 FREEZE GUN フリーズガン

ASSEMBLED
組み立てられた

FG ❶
FG ❷
FG ❸ x2
FG ❹

FRONT
フロント

❶ BODY
❷ MANDIBLES
❸ PANNELS
❹ MOUNT

6 MIDDLE SECTION 中間セクション

CORE UNIT ❸
MS ❶
MS ❷
MS ❸
MS ❹

ASSEMBLED
組み立てられた

❶ STEWART PLATFORM
❷ HIP BONE
❸ PAD
❹ HIP JOINT
❺ FROST BEACON

x4

❼

PAD
パッド

7 FROST BEACONS 霜ビーコン

x6 FB ❶

STOWED

DEPLOYED

❷

8 LEG WEAK POINTS 脚の弱点

WP ❶

❶

9 ATTACHMENTS アタッチメント

❶ LASER TARGETING
❷ RADAR DISH
❸ COOLING UNIT
❹ THERMAL CAMERA

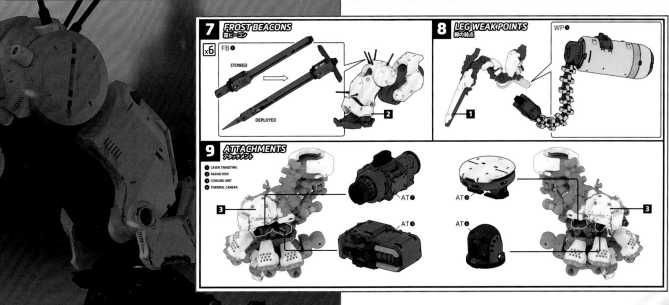

❸
AT ❶
AT ❷
AT ❸
AT ❹
❸

The freeze gun fires an ice blast similar to the first Mr. Freeze fight. Sprint to the side to avoid taking damage. Be careful not to get pinned against a wall. If possible, maneuver behind the villain for counterattacks.

A grenade launcher on the Mecha Freeze's left shoulder launches a trio of grenades at the target's location. Red circles indicate the danger area; quickly sprint around the villain as the explosives detonate on impact.

When Freeze rears onto his back legs, he exposes weak points in the mechanical suit. Focus all attacks on the legs to cause maximum damage. If successful, he collapses, providing more opportunity for the hero to attack. Don't stay too long, because he stabs the appendages into the ground just in front. Sprint around to the back of the boss if possible, as this ground attack has an area of effect.

Wear the Mecha Freeze down enough, and Mr. Freeze leaps high into the air and lands on the prison wall. Take this opportunity to launch several ranged attacks at the boss. Watch out—he continues to launch grenades and fire the freeze gun.

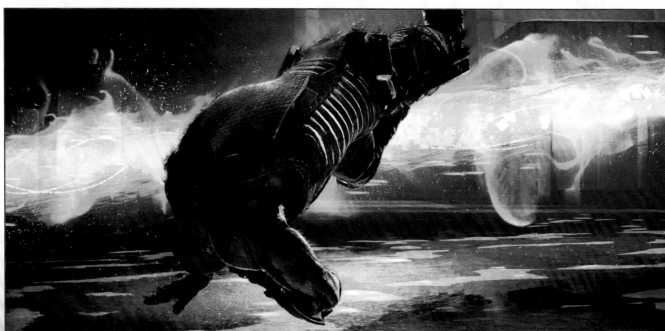

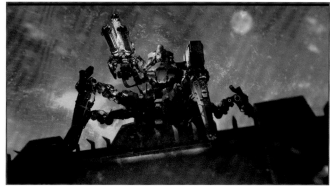

PHASE 2

Before Freeze can get away, the hero attaches their grapple to the mechanical suit's underside. The two end up in a frozen section of the harbor. Freeze introduces a large area-of-effect ice attack that can only be escaped by grappling to one of the perches around the perimeter. Be sure to get away before he releases the devastating ice attack. Continue to attack Freeze until about one third of his health remains.

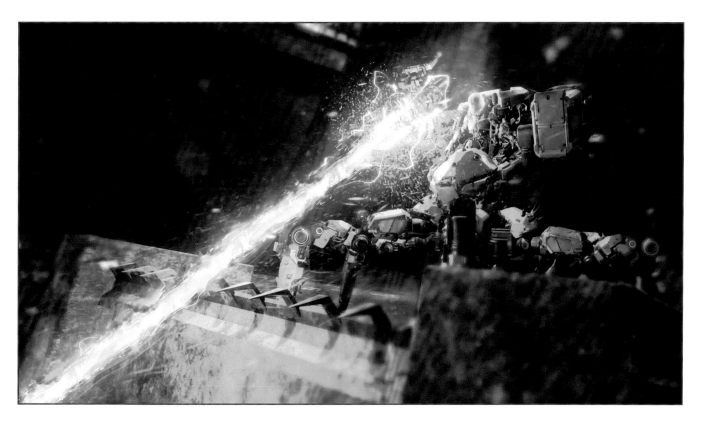

PHASE 3

At this point, Mr. Freeze leaps back onto a platform, where he continues to launch his attacks. At this moment, a few shooters join the fight. Fend them off while avoiding the boss's attacks. Stay alert as Mr. Freeze leaps back into the arena, causing massive damage where he lands. Continue to evade Mr. Freeze's powerful attacks, and counter with special abilities and combos whenever opportunities arise. Eventually, the boss falls in defeat.

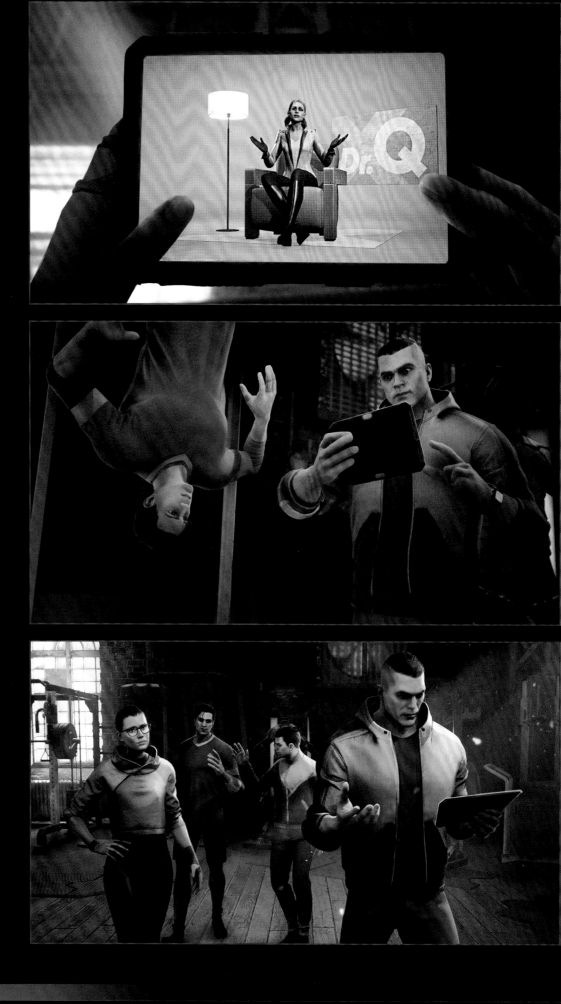

HARLEY QUINN

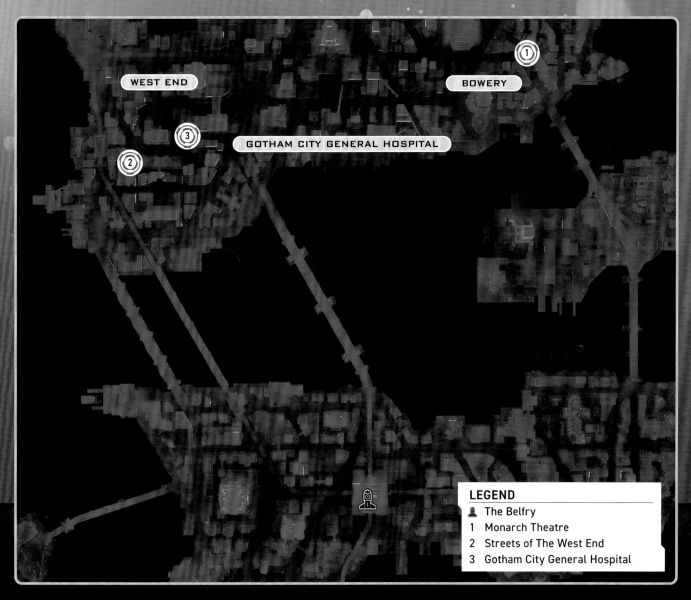

WEST END

BOWERY

GOTHAM CITY GENERAL HOSPITAL

LEGEND

🏛	The Belfry
1	Monarch Theatre
2	Streets of The West End
3	Gotham City General Hospital

- **Requirement:** Complete a Crime with the Freaks Faction

Main Objective: Defeat Harley Quinn

CASE FILE 1.1: HARLEY RETURNS

 OBJECTIVE:
COMPLETE HARLEY QUINN CHALLENGES

- **Location:** Gotham City

Harley Quinn's villain arc continues from the heroes' trip to Blackgate Prison. After exiting the prison, complete a crime with the Freaks faction to unlock new challenges. To continue the story arc, complete more Freaks crimes and an Armored Truck Robbery in North Gotham.

PATRICK REDDING
CREATIVE DIRECTOR

By the time of our game, Harley's a bit older, a bit more jaded. But she's never given up on herself. When she realizes that she can have the run of a Gotham City without a Batman (or a Joker) where none of the normal rules apply, she immediately sees an angle. I've always wanted to see Dr. Harleen Quinzel, the brilliant but twisted psychiatrist, really put that to work in the pursuit of supervillainy, and this was our chance.

Harley Quinn is at a crossroads. Her days with the Joker are well behind her, she's done her time with the Suicide Squad, and now she's ready for her third act. She might have reformed and put her abilities to use for the greater good, but she looks at Gotham City and how all of the moral pillars have disappeared and decides that if Gotham is getting a new Knight to protect it, then it deserves a new supervillain to menace it.

CASE FILE 1.2:
DR. Q AT MONARCH THEATRE

— DR. Q—OBJECTIVE:
INVESTIGATE MONARCH THEATRE

- **Location:** Monarch Theatre
- **Faction:** Freaks

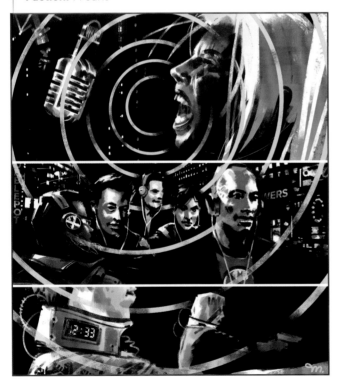

ALLEY

Travel to the Bowery in eastern New Gotham and find Monarch Theatre. A group of Freaks hangs out in the alley. Defeat them before scaling the fence at the end of the alley and sneaking through a hole in the side fence. Infiltrate the theatre.

WILSON MUI
CINEMATIC DIRECTOR

Infiltrating the Monarch Theatre to confront Harley, the heroes find themselves trapped onstage as part of her show in her alter persona as Dr. Q. Selling a powerful chip implant to her devotee fans onstage, she uses our heroes as a test case to show how powerful the implant is in action. As the Batman Family defeats her goons, we start to see her unravel slightly with the darker Harley Quinn we are used to seeing.

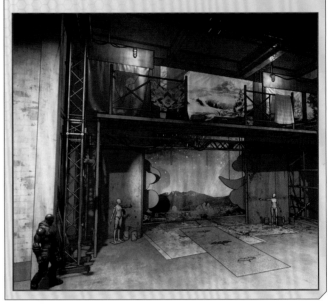

WORKSHOP

Use AR throughout the theatre to find hidden chests in side rooms and off the beaten path. Various items can be interacted with for added story. Follow the path around the corner and up to the second floor. A hole in the right wall grants direct access to the workshop, while ductwork in the wall ahead leads to a platform in the same room. Freak brawlers and a firestarter loiter inside, with more Freaks in the adjacent room, separated by a stage set. The stage set can be moved by interacting with the nearby button, but it's best to leave it alone until the first Freaks have been defeated. While exploring the theatre, notice how the carpet has been rolled out for the hero and helpful mannequins have been placed throughout. If ever unsure of where to go, let them lead the way.

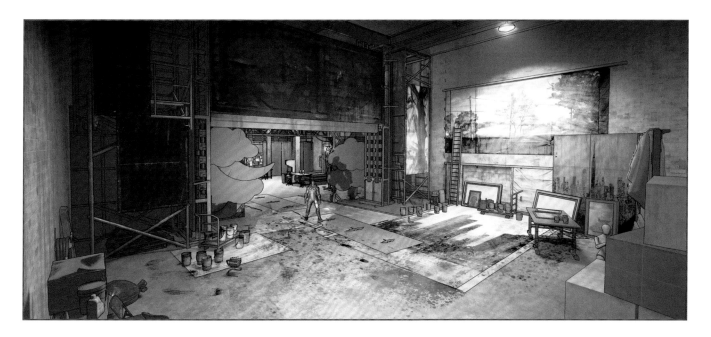

Extra experience is available for defeating these Freaks without taking damage. The railing along the upper platform is a great location from which to begin a stealthy approach. After defeating the first group, open the stage set and eliminate the hostiles that enter.

In the second room, scan the Dagget Labs crate as a small group of Freak reinforcements enters the room. Defeat them before exiting through the doors. Climb the stairs to reach the green room.

GREEN ROOM

The green room is a spacious area with several separate rooms, patrolled by a few Freaks. Silent Takedowns are the best approach here, but work quickly, as the hostiles roam between rooms. If they spot a body, they search for the player character. Another XP bonus is earned if the Green Room is completed without being detected.

After defeating them all, proceed backstage. There are two ways to get there. The back door in the production office leads to a duct that ends up in a corner. Follow the carpets and mannequins to a stairwell which leads down to the left side of the backstage.

BACKSTAGE

A few more Freaks occupy the backstage area. Perches on the walls provide vantage points to plot an attack and get Silent Takedowns from above. Observe the route of the patrolling brawler, and don't allow a hostile to find a body. An XP bonus is earned by performing three Silent Takedowns in the backstage area.

After defeating the Freaks backstage, pass through the gate to go onstage with Dr. Q.

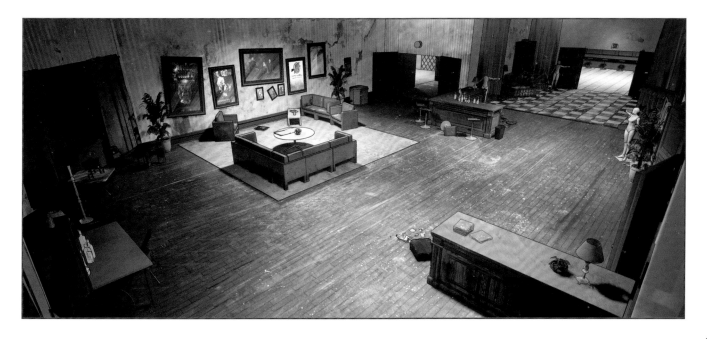

BOSS FIGHT: HARLEY'S HYENAS

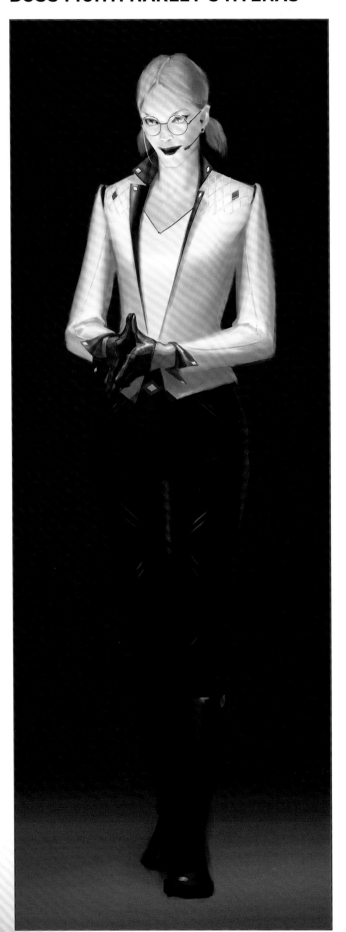

- **Weapons:** Shield / Ball and Chain

PHASE 1: HYENA WITH SHIELD

Harley shows off her new implant by trapping the hero onstage with enhanced Freaks. The boss fight is against Harley's hyena, an enhanced Freak bulldozer that carries a massive shield. It's joined by a Freak juicer and a group of brawlers. The hyena is the main target, but it is extremely helpful to defeat the juicer first. She is able to heal and enrage other hostiles, making them more powerful.

The hyena has two uninterruptible attacks with the shield, so be ready to evade or use a piercing ability. Up close the hyena may attempt a shield bash, though it can charge from distance before swinging the shield. The biggest attack is a leaping shield slam. After closing the distance to the hero, the hyena leaps forward. A targeting circle indicates the impact area as the villain slams the shield into the ground. Evade just before impact and follow up with an attack.

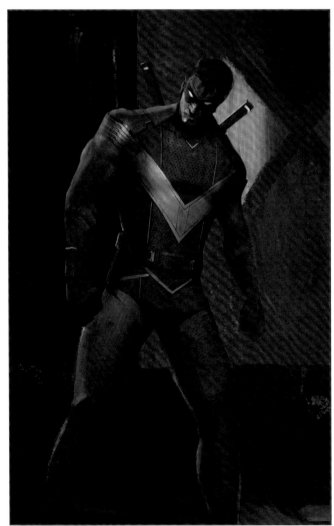

Fend off the other Freaks while fighting the hyena. When striking the boss, remember to use a heavy attack for a shield break. Then follow up with a combo. After the boss's health is lowered by a third, then again at two-thirds, more hostiles attack. Whenever possible, defeat the lesser foes to even the fight. Area-of-effect abilities help control the crowd.

PHASE 2: HYENA WITH MACE

After the first hyena is defeated, a second hyena joins the fight, along with any remaining Freaks. A firestarter also joins, so watch out for incoming explosives. This boss bulldozer carries a flaming ball and chain instead of a shield. Ranged and light attacks are effective against the boss now. However, the new weapon has wide range and hits hard.

The hyena has a pair of attacks: an overhand slam and a wide, forward swing. Evade laterally to avoid the overhand strike; move back out of range when the boss swings the weapon around. This hyena doesn't close in as quickly as the other. Like the first time, Freaks join in as the boss's health diminishes.

Once the hyena is defeated, the fight is over—no matter how many other Freaks are still around. The player character drops into the trap room below the stage.

PHASE 3: DISARM THE BOMBS

Harley has placed six custom bombs around the room: one in each corner and another on each side. Only one is activated at a time, with time between each activation. A warning appears, letting you know a bomb is being activated. Once activated, a timer counts down until

detonation. The front-left bomb is the first, indicated by the objective marker, so run over there and interact with the device to disarm it. If you fail to disarm a bomb, the game resets to the start of this phase.

At this point, a few Freak reinforcements are sent in. The hero must fend them off while dealing with the bombs. Be sure to keep an eye on the timer, and do not let one hit zero. Enemies can interrupt the process. Sprint to each bomb and immediately hold the button to disarm. Defeat this first group of Freaks to continue the fight.

Next, Harley calls in her hyenas. Now you must fight the two hyenas, as well as lesser Freaks added throughout the battle, while disarming the bombs as each one activates. Put some distance between the active bomb and hyenas before disarming, as they attempt to interrupt the hero.

Firestarters, juicers, and brawlers join the fight as you progress—especially after taking out the first hyena. Defeating Harley's hyenas and disarming the bombs are the objectives, but do not lose sight of firestarters and juicers.

After defeating the hyenas, continue to disarm bombs while fighting the remaining Freaks. Once the hostiles are eliminated, disarm the last bomb, if active. Then approach the pile of screens in the front of the room.

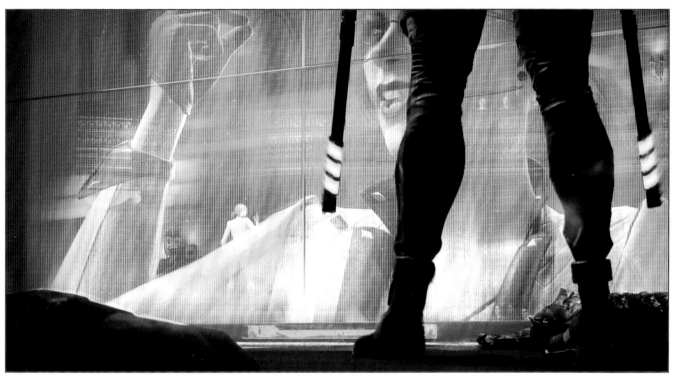

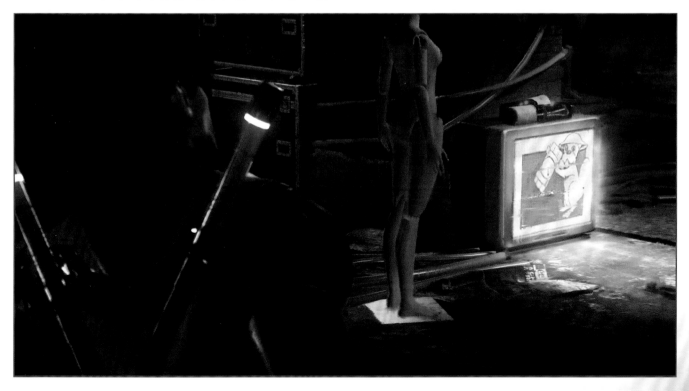

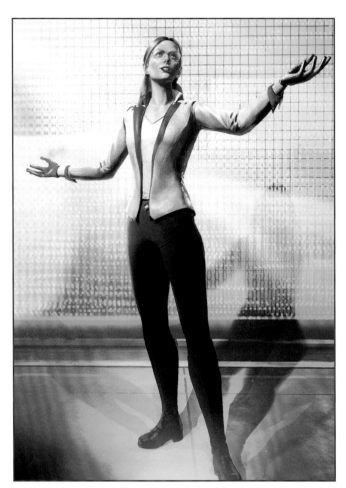

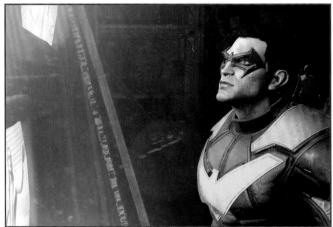

CASE FILE 1.3: PAGING DR. Q

OBJECTIVE:
COMPLETE HARLEY QUINN CHALLENGES

■ **Location:** Gotham City

Hit the streets of Gotham City and complete Harley Quinn challenges to progress through the story. Complete the Criminals in Hiding activity in eastern Tricorner Island and the Criminal Base at the Planetarium in North Gotham. Once the next Harley Quinn Case File is available, launch it from the Batcomputer.

CASE FILE 1.4: CHAOS IN GENERAL

CITY CHAOS—OBJECTIVE:
INVESTIGATE THE RIOTS

■ **Location:** Croydon Avenue, The West End
■ **Faction:** Freaks

STREETS OF THE WEST END

Riots are popping up all over Gotham, and they appear to be instigated by Harley Quinn. Mild-mannered Gothamites, caught up in Harley's experiment, fight the hero throughout this mission. For the most part, they can be left alone, but there are times the devotees will need to be taken down.

You drop onto Croydon Avenue in The West End and talk to Montoya behind the GCPD blockade. Scale the fence ahead to take on the Harley devotees, or grapple along the light posts to avoid confrontation. Continue down the street to find an ice cream truck.

Defeat the Freak brawlers, then examine the unconscious civilian behind the truck. Disable the truck's signal.

Continue down Prince Street to find two more trucks. Defeat the devotees and then disable the signals at the rear of both ice cream trucks. Montoya asks the hero to investigate the nearby hospital. Grapple onto the roof of Gotham General Hospital, east of Prince Street, where a group of Freaks, including a bulldozer, occupies the helipad. Defeat them all before entering the hospital.

WILSON MUI
CINEMATIC DIRECTOR

As riots race across Gotham City, the Batman Family track down Harley Quinn at the Gotham General Hospital eventually meeting a transformed Harley Quinn that has taken extraordinary measures to prepare for a final showdown. Her true colors come out as she discloses her master plan to our heroes, starting from the initial meeting in Blackgate. This is the new Harley Quinn, darker and more dangerous than she has ever been, complete with sledgehammer and ready to dish out some pain.

INSIDE THE HOSPITAL

Follow the waypoints through the hospital corridors, dealing with the Harley devotees along the way. Keep an eye out for chests hidden inside the hospital. Use AR to spot them through nearby walls. Climb the stairwell up to the next floor. Continue past the registration desk and defeat a group of devotees before dropping down the elevator shaft.

From the elevator, follow the path through the examination rooms and hallways as more civilians attack. This route leads into the pharmacy, where a group of Freak brawlers searches for valuables. Defeat the Freaks, then pass through the side door. Fight off more devotees in the operating rooms before grappling through the hole in the ceiling. The doors ahead lead to the Chapel balcony.

CITY CHAOS—OBJECTIVE:
③ FIND HARLEY AND STOP HER PLAN

- **Location:** Gotham General Hospital
- **Faction:** Freaks

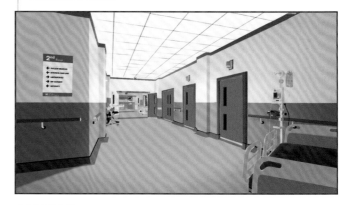

CHAPEL

A group of Freaks occupies the chapel below. Earn a bonus by defeating the firestarters without getting hit. The balcony railing and two beams provide great vantage points, allowing for quick takedowns from above. Use this method to take down a firestarter, then defeat the remaining Freaks. With the hostages saved, exit through the side door.

SECURITY ROOM

Follow the hallway to another stairwell. Before following the path downstairs, climb to the top landing to find a chest. Vault over the railing to drop to the bottom floor, and continue to the main desk.

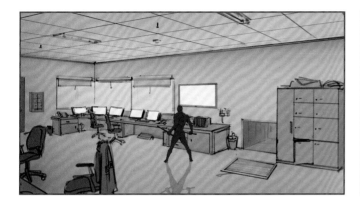

Defeat the hostiles before entering the doors behind the desk to enter the back corridor, currently being vandalized by Freak brawlers. Defeat them, then enter the security room. Interact with the terminal on the desk to find Harley's whereabouts on L3.

L3 WING

Enter the elevator and take it to the new hospital. A variety of Freaks occupy the lobby. Two electric carts create dangerous traps. Defeat the Freaks before climbing the steps to L3. Fight more Freaks while following the hallway to the right.

CAFETERIA

With L3 clear of Freaks, proceed through the doorway to reach the cafeteria. A few brawlers and firestarters patrol the room. Earn a bonus by performing Silent Takedowns on a set number of enemies.

ELECTRIC CARTS

Electric carts sit all around the new hospital and have been rigged to charge on proximity. Once a cart has fully charged, it explodes. If an explosion makes contact with the hero, you take damage and the shock status effect is added.

BOSS FIGHT: HARLEY QUINN

- **Weapons:** Large Hammer, Knives

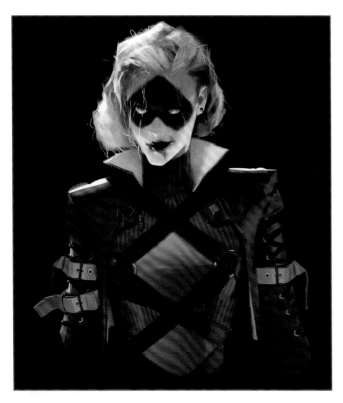

DEFEAT HARLEY

Harley is equipped with a sledgehammer, though that's not the only threat in the arena. Scattered electric carts and electrified walls force you to stay on your toes. Harley has two combos with the sledgehammer: one that's uninterruptible and another that can be canceled. She also carries small projectiles that can be thrown from distance.

ELECTRIC WALLS

The walls have been rigged with electrical equipment that discharges immediately on impact. Unlike the carts, the hazard does not go away after detonating. Avoid being knocked into the walls, but it's possible to use them to the hero's advantage. Knocking Harley into a wall does damage to her as well. In both cases, the walls only harm the character knocked into them.

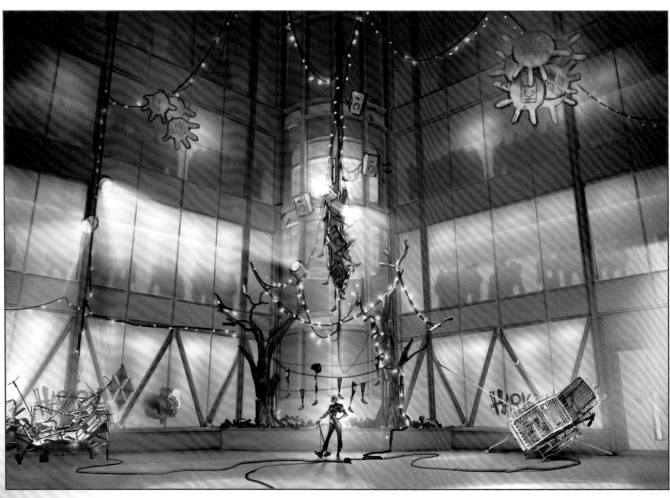

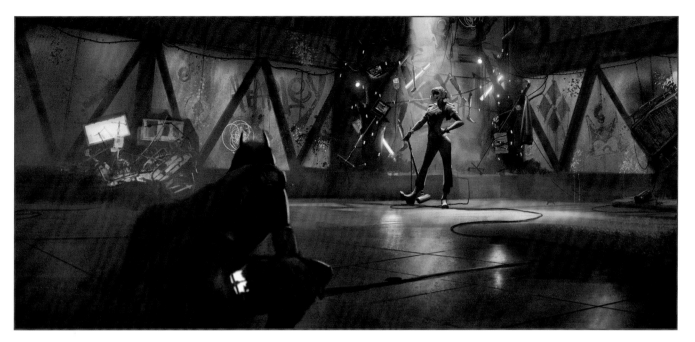

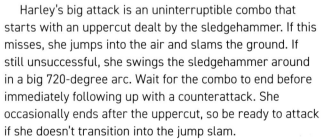

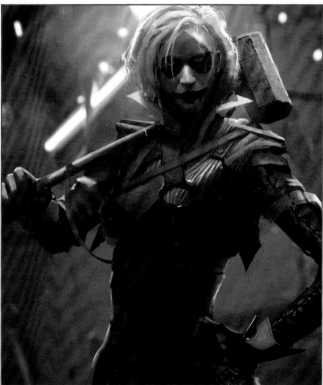

Harley's big attack is an uninterruptible combo that starts with an uppercut dealt by the sledgehammer. If this misses, she jumps into the air and slams the ground. If still unsuccessful, she swings the sledgehammer around in a big 720-degree arc. Wait for the combo to end before immediately following up with a counterattack. She occasionally ends after the uppercut, so be ready to attack if she doesn't transition into the jump slam.

Harley has a second, less-lethal combo that begins with a forward thrust, followed up with a side swing, then a powerful overhead strike. This combo can be interrupted. Again, she may end after the first attack.

She also has a forward sledgehammer thrust that cannot be interrupted. If she connects, she kicks her target back, sending the player into the electric wall if close enough. Harley can also grab the hero's hand and whip them into an electric wall.

Continue to evade Harley's sledgehammer attacks, counter them, and use the electrified traps against the boss until she hits the wall, literally.

DEFEAT THE DEVOTEES

A horde of Harley devotees pours in from the sides as Harley exits the arena. You must defeat the civilians to continue the boss fight. The devotees punch and kick, but all attacks are interruptible. Stay on the move while striking the hostiles, and be careful not to become surrounded.

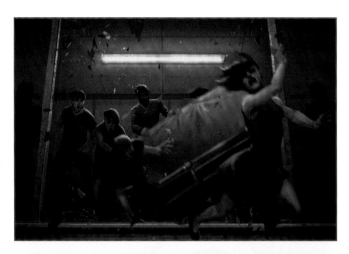

DEFEAT HARLEY (PHASE 2)

After you defeat all the devotees, Harley drops back into the fight. This time, she's joined by a group of civilians. Fend off the devotees while fighting the villain. Harley has no empathy for the civilians; she willingly fights through them to get to the hero.

Continue to fight the boss until the hero is able to get the device from Harley, freeing the devotees. Harley becomes more forceful, swinging the sledgehammer with desperation. Her uninterruptible combo becomes an uppercut into a cartwheel slam that hits the ground with a larger area of effect. She may only perform the cartwheel slam.

Don't let her get the upper hand when in close. She may transition a sledgehammer swing into a powerful body slam. Keep up the fight, evading her sledgehammer attacks and countering whenever possible, until she's finally defeated.

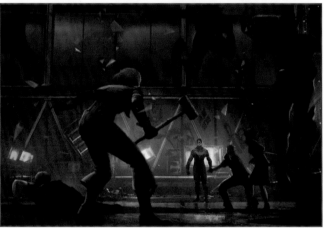

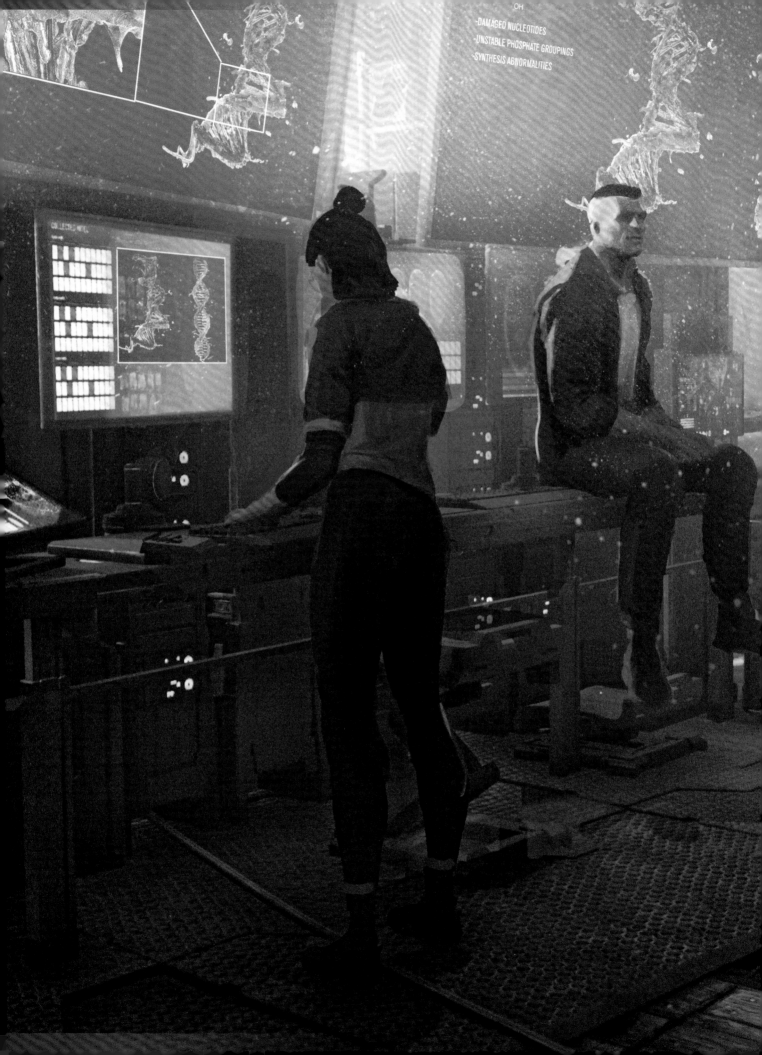

OH
-DAMAGED NUCLEOTIDES
-UNSTABLE PHOSPHATE GROUPINGS
-SYNTHESIS ABNORMALITIES

CLAYFACE

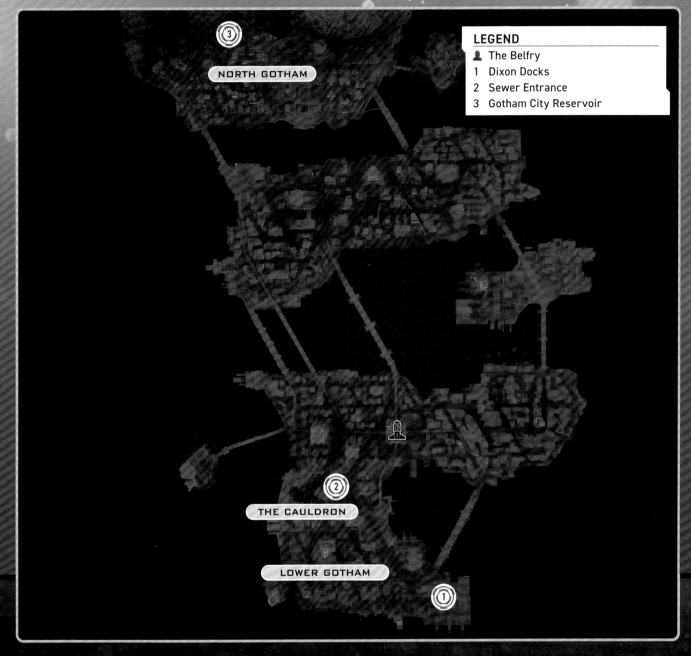

NORTH GOTHAM

LEGEND

🏛 The Belfry
1 Dixon Docks
2 Sewer Entrance
3 Gotham City Reservoir

③

②

THE CAULDRON

LOWER GOTHAM

①

- **Requirement:** Defeat a Clayface Faction Criminal on the West Side of New Gotham and Investigate the Body

Main Objective:
Defeat Clayface

After completing Case File 1.2, Clayface faction criminals appear in western New Gotham. After defeating one of these clay amalgamates, the body dissolves. This unlocks the Clayface challenges.

CASE FILE 1.1: THE MALLEABLE MUGGER

OBJECTIVE:
COMPLETE CLAYFACE CHALLENGES

- **Location:** Gotham City

Hit the streets of Gotham City and complete the Clayface challenges to unlock the first part of the Clayface villain arc. The player must collect four more samples of clay by completing Clayface faction crimes. Once complete, Disturbance at Dixon Docks can be launched from the Batcomputer.

CASE FILE 1.2:
DISTURBANCE AT DIXON DOCKS

 COMING TO A SEWER NEAR YOU—OBJECTIVE:
INVESTIGATE DIXON DOCKS

■ **Location:** Dixon Docks, Lower Gotham

DIXON DOCKS

Travel to Lower Gotham and find Dixon Docks on the far
east side of Southside. Approach the large warehouse
labeled Bay C and use AR to scan three crates to find
missing movie production equipment.

Scan the clay residue on the ground to reveal a trail.
Follow it outside and into another warehouse. Step onto
the railing and observe the hostiles below. Gangsters are
joined by an informant. Defeat the gangsters, and beat
up on the clay amalgamate. Once the option is available,
interrogate the hostile before they melt into a clay puddle.

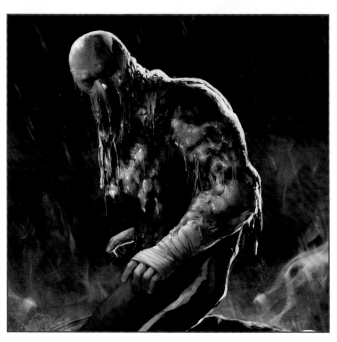

FIGHTING CLAY

Clayface and his fragments are all made of malleable clay. This allows them to shapeshift, though the ability is mostly seen in Clayface boss fights. This means their melee strikes become somewhat ranged attacks. Sidestep to avoid their long punches. They can also create clay explosives, so watch for red circles on the ground that indicate incoming bombs. A bulging clay fragment means they are explosive, so steer clear and use ranged attacks against them.

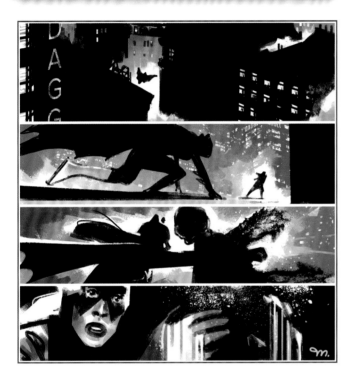

BATCYCLE CHASE

Scan the clay blob. After he escapes down the street, call the Batcycle and give chase. Stay close to the blob as he flees out of the docks, into the streets of Lower Gotham. He weaves northwest through the industrial part of Gotham City, then west underneath Burnley Street. Continue to follow the trail over a couple jumps onto a platform on the north side of the Cauldron.

 COMING TO A SEWER NEAR YOU—OBJECTIVE:
2 FIND CLAYFACE IN THE SEWERS

■ **Location:** Sewer Entrance, the Cauldron

THE SEWERS

Follow the clay blob to a large cavern where several clay amalgamates guard an entrance to Clayface's lair. Use the perches around the perimeter to silently take down the hostiles. These guys run between guard positions, so take a moment to observe them before dropping in. Knock out all clay hostiles before entering Clayface's lair.

The path leads up to a living area and then down. Scan Clayface's movie script that sits on the table next to a typewriter to earn a bonus. After the stairs, make an immediate right, duck under the gas leak, and turn right to find a chest. Return to the previous intersection and continue further inside the sewers.

WILSON MUI
CINEMATIC DIRECTOR

When the Batman Family encounters Clayface for the first time in the sewers, he is in a transitional state having been shredded into thousands of pieces in his last encounter with Batman at the reservoir. As part of a "hive mind" in body and voice, the pieces of himself have been gradually assembling back together with the amalgamates being in the most stable state. Clayface blames Batman for his misgivings and loses control when he learns of Batman's death and the fact that he is unaware of the time that has passed. It ultimately sends him in a fit of rage that progressively acts as a catalyst for his evolution into something scarier and more dangerous.

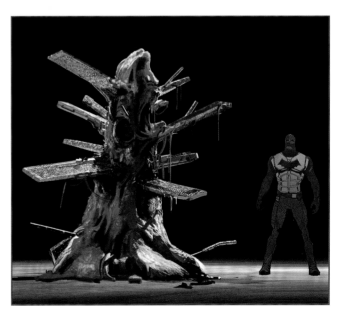

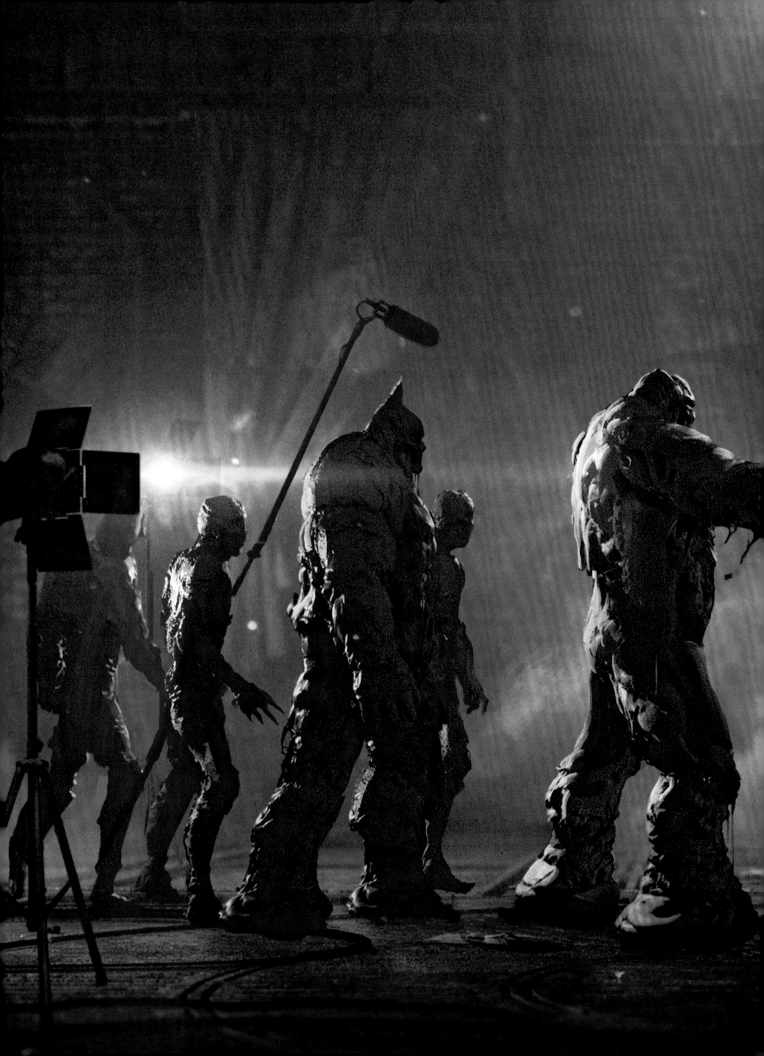

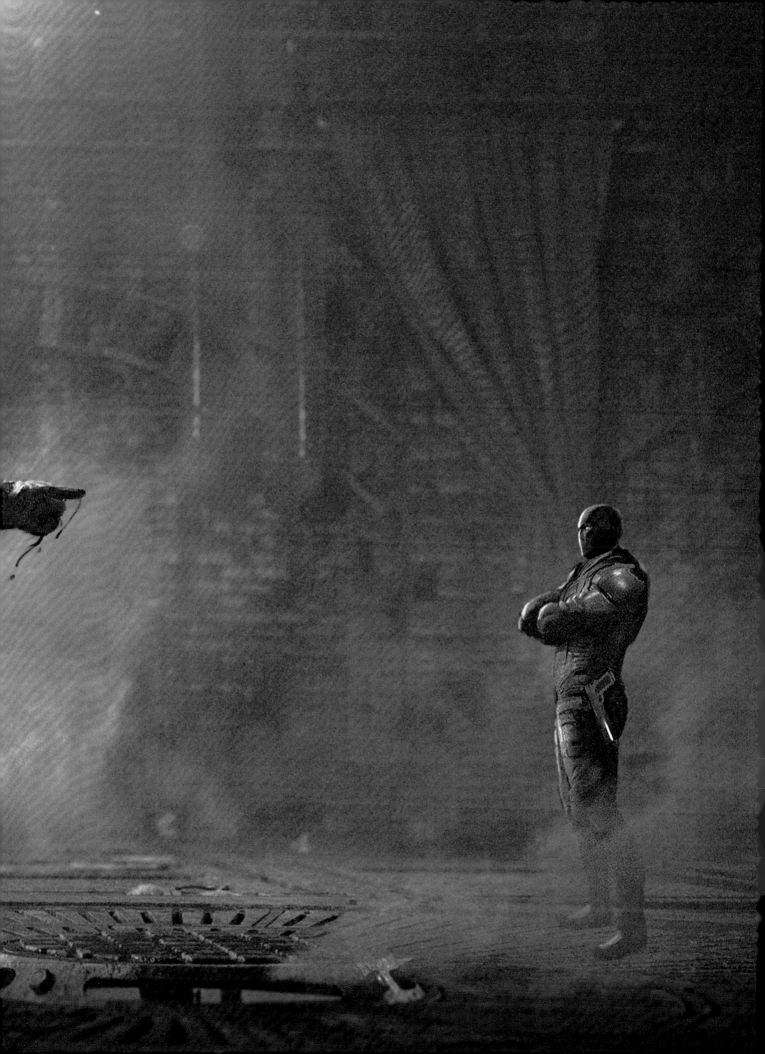

BOSS FIGHT: CLAYFACE AND HIS AMALGAMATES

■ **Weapons:** Shapeshifting Clay

PHASE 1

The player enters Clayface's lair, where Clayface films his biopic. The clay transforms into three amalgamates, triggering a challenging boss fight. An amalgamate can regenerate defeated amalgamates, so always attack the strongest one. Defeat the three in close succession to avoid fighting more hostiles. It's possible to interrupt an amalgamate while it heals the others. With a downed amalgamate or two, watch for the other one to plunge an arm into the ground.

The clay's shapeshifting abilities allow an amalgamate to shove an appendage under the platform. Clay oozes toward the target and juts upward, reforming into a cluster of thorns that damages the hero with any contact. A puddle develops under the hero, warning of an incoming attack. Stay alert, as the amalgamate often follows up with a jump ground punch that develops into another cluster of thorns.

An amalgamate can also fully liquefy underneath the arena, emerging closer to you with a swipe attack. Dodge the hostile and counter with a combo or special ability.

The amalgamate has an uninterruptible punch and overhead strike with long reach, which may continue into a combo. Evade laterally to avoid taking damage. Continue to evade and attack the amalgamates evenly in order to defeat them at about the same time.

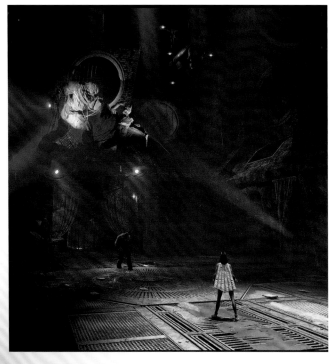

PHASE 2

A group of normal-sized fragments runs down the pipe, jumping into the arena to join the three amalgamates. The battle gets tougher with more targets on the field. Remember to split efforts between the three amalgamates so they're defeated at approximately the same time.

The amalgamate adds a powerful slam attack where it oozes under the platform before springing up toward the hero and slamming the ground with both clay fists. Keep all three big guys in view if possible, and move when one goes under. Try evading toward the emerging amalgamate, and attack from behind as it lands.

Watch for the long reach of clay hostiles, and retaliate with area-of-effect abilities if available. If a fragment begins to bulge and a white circle appears on the floor, clear out as that hostile is about to explode. Stay on the move while beating up on the clay until all three are defeated.

PHASE 3

At this point, the clay forms three more large amalgamates, along with another group of smaller fragments. As before, keep the amalgamates in view and evade their attacks. Use area-of-effect abilities if available, and continue beating up on Clayface. This time, the amalgamates don't heal one another. Once one is down, it's out. Deplete Clayface's health bar, and he flees his lair. The hero returns to the Belfry.

OBJECTIVE:
COMPLETE CLAYFACE CHALLENGES

■ **Location:** Gotham City

In order to continue the Clayface villain arc, the player simply needs to play four more night patrols. Launch Rumble at the Reservoir and the team tracks the clay to the reservoir in North Gotham.

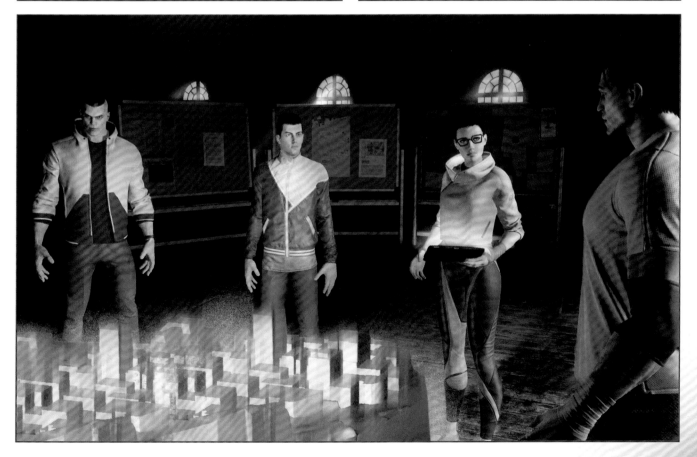

CASE FILE 1.4:
RUMBLE AT THE RESERVOIR

MUGSLIDE—OBJECTIVE:
3 INVESTIGATE THE RESERVOIR

■ **Location:** Gotham City Reservoir, North Gotham

THE RESERVOIR

Travel to North Gotham and meet up with Montoya at
Gotham City Reservoir. The entrance is blocked by a blob
of wet clay; you must find a way to remove it. Hit the valve
next to the door that leads to the entrance.

Return to the entrance, hit the pipe with a ranged attack
to release the gas, and quickly fire another projectile at the
dried clay to unblock the entrance. Step inside and follow
the corridor into the main chamber of the reservoir.

BOSS FIGHT: CLAYFACE

- **Weapons:** Shapeshifting Clay

PHASE 1

Clay pours in from above, forming into a clay giant with four arms—two main arms that reach most of the way across the arena and two draped over his shoulders. It's time to defeat Clayface for good. Clay flows constantly below the floor, which means hazards may form anywhere at any time; the villain no longer alerts you by reaching into the platform. Keep an eye out for puddles to form underfoot, and move out of range.

The clay's fluidity allows Clayface to shapeshift at will, making him a threat at almost any distance. When he lifts his arms above his head, evade laterally to avoid his two-arm slam. Get in a series of strikes before he recoils his arms.

Clayface also extends one arm to the side and opens his hand before sweeping in a 180-degree forward motion, knocking down any targets in the path. This attack lacks the range of his overhead slam, so move backward and hit him with a ranged attack.

You can choose to close distance to execute a good combo, but don't stay long. A large puddle of clay forms underneath the villain when the player gets close. After a few seconds, it bubbles into sharp, painful thorns.

Puddles of clay may also form underfoot when away from the villain. Quickly exit the area, as each becomes

a cluster of clay thorns, damaging anyone it comes in contact with.

Continue to attack whenever possible, while evading Clayface's transformations. Eliminate about a third of his health to knock him into the wall. Clayface retaliates by pulling a pipe down and heaving at the hero. This busts a hole in the floor, sending the player and Clayface down into a pool of water. It seems to finish the boss off, but it actually makes him stronger.

■ **Location:** The Aqueduct, North Gotham

BATCYCLE CHASE

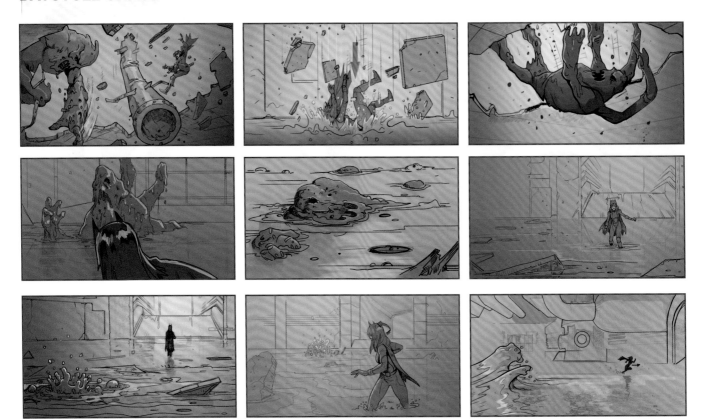

The hero hops onto the Batcycle and flees the inevitable death trap. Immediately accelerate as the clay chases the vehicle. The path winds through the Aqueduct's large pipes, wide enough to maneuver around clay hazards that pop in throughout the chase. When the player crashes through one of these hazards, they are damaged. Take several hits though and the game resets to the previous checkpoint.

While the large clay blob chases from behind, the rest of the clay attempts to stop the Batcycle by jutting from pipes on the sides, top, and bottom of the aqueduct. Perform wheelies to get ahead of the chaser, while focusing on the path ahead. Be ready to perform subtle movements to either side to avoid hazards. Because the aqueduct isn't straight, prepare to make sharp ninety-degree turns.

Watch out for clay spiraling between a pair of side pipes. Move to the center of the aqueduct to ride underneath the trap. At another later point, ramps on the sides help avoid low-flowing clay.

The aqueduct splits on a few occasions, so make quick decisions and guide the bike into one of the openings.

Turns become more frequent later on, so don't lose focus. Eventually, the hero leads Clayface into the smelting factory.

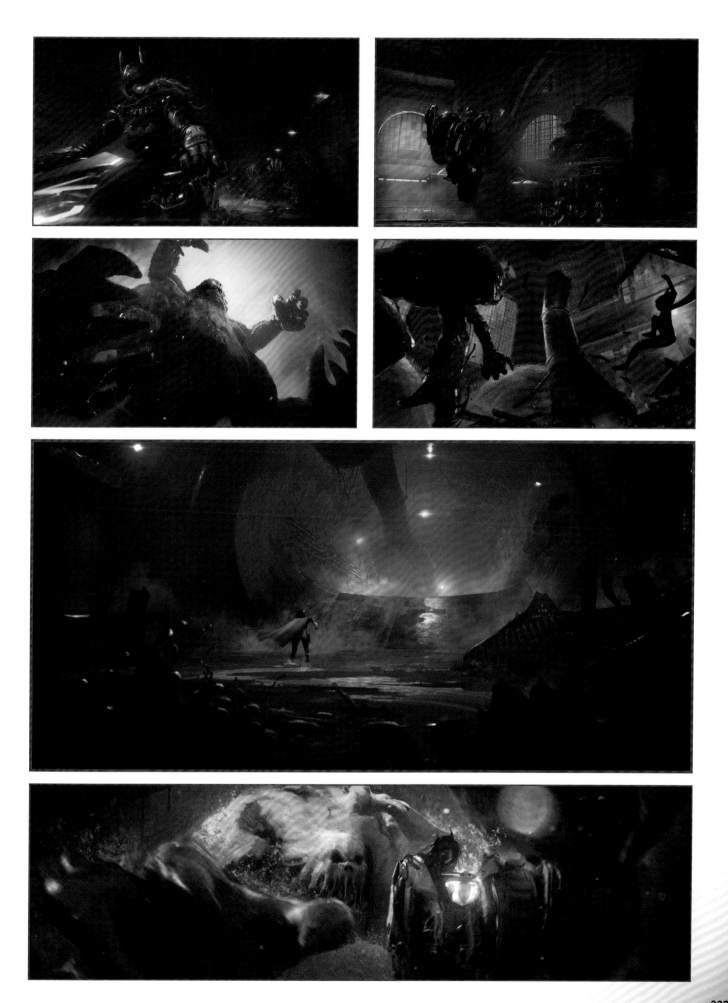

BOSS FIGHT: CLAYFACE

- **Weapons:** Clay Hammer / Morning Star

PHASE 2

The high temperatures in the boiler room harden the villain, changing his tactics drastically. Clayface's back arms become more formed, allowing him to fling clay at a fevered pace. The boss uses a pair of hands to pull a small amount of clay off his body and throw it toward the hero. It transforms into an arm that grabs at its target. Avoid these appendages, as they cannot be attacked. Each arm sticks around for about fifteen seconds before dissolving.

If the hero gets close to the villain, he jumps into the air before slamming into the ground with his powerful fists. Evade out of the immediate area when he leaps upward. He pauses after impact, so take this opportunity to get in some good attacks. Successful strikes shatter his arms, so keep it up until new arms regenerate.

When Clayface lifts an arm behind his shoulder, bail to the side to avoid a hit so strong it shatters the boss's fist. He follows this up with the other hand, so stay mobile. If he starts with his back arms, he continues with the front, so don't stop evading until all four fists have shattered. This is another opportunity to attack as he reforms his appendages.

Clayface still has the overhead slam and arm sweep from the first phase, as well as the defensive clay thorns that can form underneath the boss or near the hero. With about one-third health remaining, Clayface is knocked into a boiler, which sets him ablaze and causes him to fall apart—losing his rear arms in the process.

PHASE 3

Frustrated with how the fight is going, Clayface forms his left arm into a morning star that reforms into a hammer once shattered. His right arm becomes a sharp spike. He uses these new weapons to great effect as he pounds his fists into the ground with devastating force.

His leap attack is more powerful now, with better range and two hits before the arms shatter. His single-arm strike also takes two hits before shattering and is often followed up with a third hit. To make matters worse, appendages regenerate almost instantly. Don't stay in the area when he jumps or pulls his arm overhead. These attacks are tougher to counter with close combat, so ranged attacks and special abilities are more effective this round.

Clayface's devastating improvements aren't limited to close combat. He can now "fire" his hands at the hero. After he twists his right arm behind him, he throws his right spike, followed by his hammerhead or morning star.

Clayface is angry, and it shows in his onslaught of attacks, which includes a three-hit combo. Evade all the way through the spike uppercut, then immediately counter with powerful attacks. Continue to counter his attacks until he finally falls in defeat and is carted away by the GCPD.

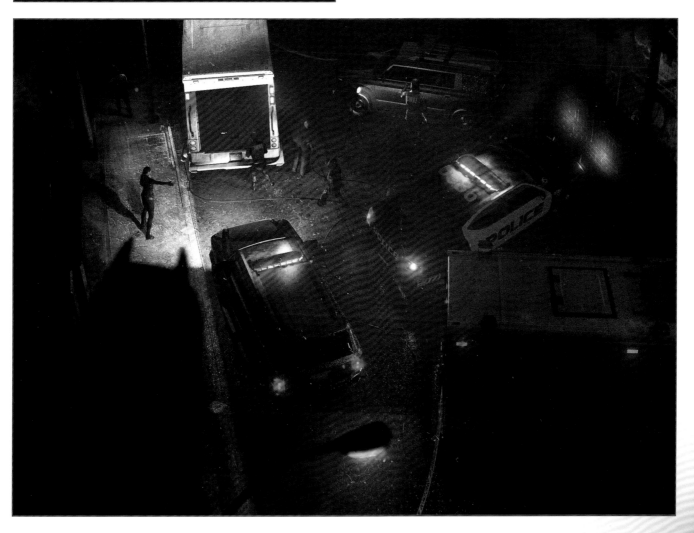

BUILDING THE EVIDENCE BOARD

As a key descriptive element of *Gotham Knights*, the Evidence Board underwent a lengthy evolution in its appearance and content during the game's development. A snapshot of this process is captured in these selections of early first pass concept art and final rendered images.

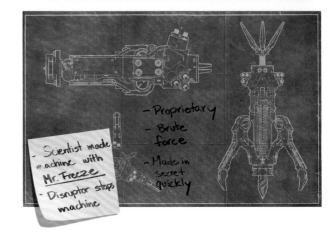

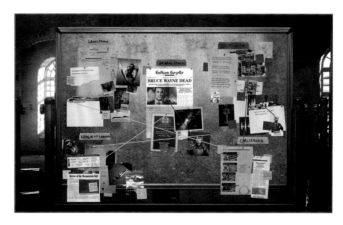

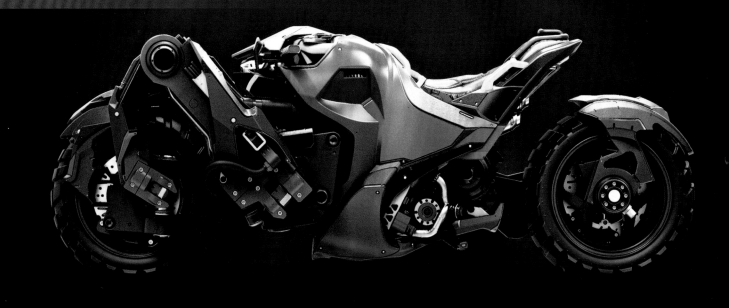
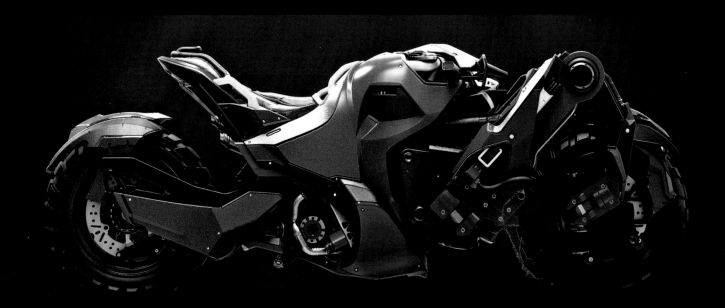
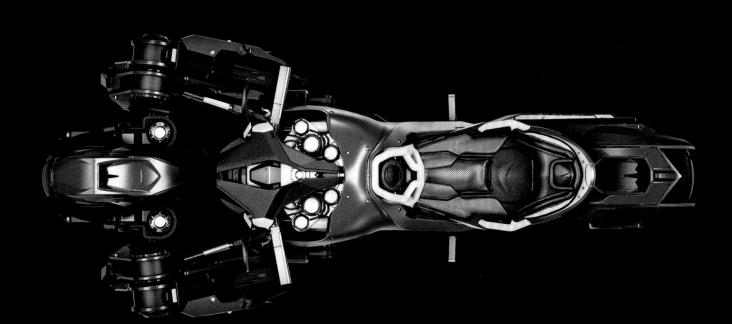

SIDE ACTIVITIES

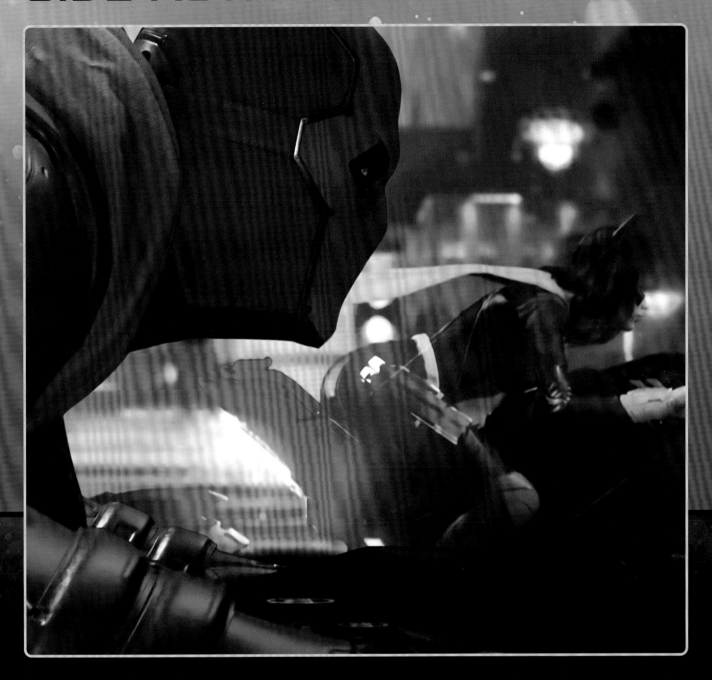

ANN LEMAY
NARRATIVE DIRECTOR

Easter eggs in game are a fun aspect of what devs get to do. But, they can also be complicated and delicate to implement in a way that's respectful of copyrights and various legalities. That said, lore easter eggs composed of easy to find references or very obscure references are always fun to inject when it makes sense to do so. We do have some in the game, but of course—it'd be a spoiler to list them all here. Have fun finding them!

The first side activity—the Batcycle Time Trial— becomes available with your first visit to the Belfry. As you complete various challenges and Case Files, you unlock more side activities like Heroic Traversal Time Trials (which put you against the clock as you navigate the streets and buildings of Gotham City) and Alibi Missions (which require you to plant fake data to keep Batman's identity secret). Talon caches, Secret caches, and Collectibles also provide valuable rewards, but you must discover their hidden locations.

BATCYCLE TIME TRIALS

- **Unlock Requirement:** Enter the Belfry
- **Trackable:** Yes
- **Description:** Drive the Batcycle through rings and reach the finish before time expires.
- **Objectives:** Reach the time trial and mount the Batcycle. Drive through all waypoints.

LOCATIONS

DISTRICT	LOCATION
Bowery	Superfast Shipping
Bowery	Monarch Theatre Parking Lot
Tricorner Island	Justice Plaza
Financial District	Trinity Church Parking Lot
Old Gotham	James Gordon Memorial
Southside	Dixon Docks Warehouse
Gotham Heights	Waterfront Plaza

Each time the player exits the Belfry, all of the Batcycle Time Trials are available. Begin a time trial by driving through the green start zone and waypoint. The arrows point toward the second waypoint, so be sure the Batcycle is oriented in the correct direction. A timer appears on-screen with a set amount of time, based on the trial you're attempting. Follow the blue circular waypoints that appear along the route ahead. Prepare for the next point by noting the direction the current waypoint faces. Each time you pass through one of these waypoints, a time bonus is added to the timer. Navigate the entire course and cross the finish line before the timer hits zero. If you fail to hit the next waypoint before the timer runs out, you can try again by returning to the start zone.

HEROIC TRAVERSAL TIME TRIALS

- **Unlock Requirement:** Unlock Each Hero's Heroic Traversal by Completing the First Knighthood Challenge
- **Trackable:** Yes
- **Description:** Race across a preestablished path, using Heroic Traversal and parkour to reach the finish before time expires.
- **Objectives:** Go to the location. Fly through the waypoints to the finish.

Each hero unlocks a unique Heroic Traversal ability by completing Knighthood challenges. This ability allows the player to stay in the air longer after grappling or leaping off a structure. Learn more about these abilities in the Batman Family section.

To begin the race, move through the starting waypoint, represented by green circles and arrows. Race through the circular waypoints and cross the finish before time expires. Each circular waypoint provides a time bonus. Rewards are given after you complete the circuit.

ALIBI MISSIONS

- **Unlock Requirement:** Complete Case File 02
- **Trackable:** Yes
- **Description:** Plant the fake data without being detected.
- **Objectives:** Go to the location. Remain undetected. Plant the fake data in the server.

You must disable all security measures that protect a server, where you must plant fake data to prevent Bruce's identity from being discovered. Every location is enclosed, with various security measures in place to protect the panel. **Security cameras** scan the nearby area, with a field of vision represented by a red cone. Spend too much time within the camera's view, and the alarm sounds. Note that it's usually possible to duck directly underneath the camera. **Detection beams** stretch across an opening and are represented by different-colored lines. Break one of these lines, and the alarm sounds. **Pressure plates** are installed in the floor. Spend too much time on this flooring, and the alarm sounds. Any of these alarms results in a failure, requiring you to return another night.

BATGIRL'S HACKING SKILLS

Note that an upgraded Batgirl, who possesses the hacking skill, has an easier time with this activity. Using the hack ability, disable each device before proceeding to the next. This removes the need to use the control panels.

A few locations add sentries, strong opponents who patrol a portion of the enclosed area. If they spot the hero, they attack on sight. It's best to flee at this point. Sentries patrol the same route repeatedly, pausing at the same points. Take a moment to learn their paths before attempting the activity.

Most electronic security measures can be toggled off with a corresponding control panel. Use AR to follow a connecting line between the device and matching controls. Interact with the control to disable that device. Note that pressure plate controls disable the device temporarily, so move quickly on these plates.

The player's objective is to figure out the order in which these controls must be disabled to gain access to the server. Interact with the server to complete the activity successfully. There are five Identity Shield activities, unlocked in the following order. Complete the first one to unlock the next on a subsequent night.

1 GOTHAM GAZETTE ROOFTOP, THE WEST END

- **Security:** Security Cameras, Detection Beams

Three rooms sit behind the GOTHAM GAZETTE sign atop their high-rise, with a walkway running the length of the middle room. This is where the server is located. Several security cameras watch the rooftop, some of which can be disabled with corresponding control panels. Despite all this security, only two camera panels require interaction, along with one that controls a set of detection beams.

From the eastern rooftop room, drop off the left side, toward the GOTHAM GAZETTE sign, avoiding the security camera's view. Just inside the fenced-in area ahead, a single, uncontrollable security camera watches a control panel. Wait for the camera to scan away from the panel, then quickly step inside and interact with the panel, which disables the detection beams ahead. Use the unprotected control panel to disable the security camera around the corner. This provides access to the walkway. Interact with the control panel on the right before planting the fake data in the server.

2 MCU LOWER ROOFTOP, THE WEST END

- **Security:** Security Cameras, Detection Beams

A sentry walks the perimeter of the fenced-in area. Two security cameras watch a pair of control panels, one on top of the platform and another on the back side. Along the back side of the platform, detection beams keep you from entering the area underneath, which is where the server is found. Always know the location of the sentry while navigating the activity. First, interact with a control panel on the front of the platform to disable the upper camera. Second, interact with the control panel that was under surveillance by the camera. Third, use the panel on the back side to remove the lines. Lastly, interact with the server.

3 WAYNE ENTERPRISES LOBBY, SOUTHSIDE

- **Security:** Security Cameras, Detection Beams, Pressure Plates

Security devices have been installed throughout the Wayne Enterprises lobby, protecting the server inside the eastern office. You must enter through a duct on the other side of the building. Sneak around the room's perimeter to avoid the security cameras, then grapple up to the decorative glass. Face the security camera to the south and time your jump to allow for enough time to use the panel to disable the detection beams. The pressure plate only sounds the alarm if the hero spends too much time on it, so quickly evade off if you make contact. Avoid more detection beams to enter the office and interact with the server.

4 GCPD BACK LOT, OLD GOTHAM

- **Security:** Security Cameras, Detection Beams, Pressure Plates

Find another server on the east side of the GCPD back lot, mounted above a pressure plate. Sentries patrol the lot. Keep an eye on them at all times, making sure they're looking the other way. Security cameras must be disabled to proceed. Find the first control panel on the western side of the northwest building. The second control panel is just north of the pressure plate on the outer wall. Use the low roofs and utility pole to avoid detection. Once the cameras are disabled, it's time to temporarily disable the pressure plate and plant the data by interacting with the nearby control panel. Quickly grapple over the wall between your location and the pressure plate and interact with the server.

5 ICEBERG LOUNGE, FINANCIAL DISTRICT

- **Security:** Security Cameras, Detection Beams, Pressure Plates

Find an opening on the south side of Iceberg Lounge and crawl through ductwork to reach a storage room. The server is directly opposite the duct, but you must weave around the fence walls to reach it. At the first pressure plate, wait for the security camera to scan the other way before disabling the device. Now disable more beams and then the final plate to reach the server. Loot the nearby chest before exiting the Iceberg Lounge.

SECRET CACHE

- **Unlock Requirement:** Complete Case File 02
- **Description:** Unlock the hidden cache by interacting with all emitters.
- **Trackable:** Yes
- **Objectives:** Go to the location. Ping the emitters' locations using AR. Use the switch to enable the emitters. Interact with all emitters. Collect Batman's secret cache.

LOCATIONS

DISTRICT	LOCATION
Financial District	Elliot Center
Gotham Heights	Gotham Residences
Bristol	Apartment Complex
The West End	Gotham City Federal Building
Otisburg	Atlantic First Trust Offices
Bowery	Monarch Theatre
Financial District	Quartz Labs
Gotham Heights	Gotham City Reservoir
Tricorner Island	New Tricorner Shipyard
Old Gotham	Gotham City Cathedral
The Cauldron	Paris Island
Southside	Cobblepot Steelworks

Batman has hidden twelve caches around Gotham City, but they must be earned before you reap the rewards. Find the cache location marked on the map, and use AR to ping the emitters' locations. The emitters project several beams of light, typically on nearby rooftops. Find a vantage point, usually on the side of a building, and climb on to begin the activity. Now you must find and activate all the emitters, producing a bat symbol. Return to the vantage point and use AR to scan the symbol, completing the activity and earning the rewards. One version of the activity requires the player to activate the emitters in a set time; in the other version, the emitters simply need to be found and activated.

COLLECTIBLES

AR BURNER

Number: 12
Only a dozen graffiti murals are scattered throughout the city. Use AR to scan each one to receive credit for the collectible.

LOST BATARANGS

Number: 60
Look for Batarangs stuck into the side of buildings all around Gotham City. These are fairly small, but do give off a purple glow. Keep an eye out for their signature effect as you patrol. They are automatically picked up when contact is made.

HISTORICAL PLAQUES OF GOTHAM

Number: 40
These plaques are typically found on a wall in front of the buildings. Keep an eye out for unique-looking, notable structures around the city. Use AR to find the gold plaques and interact with them to receive credit for the collectible.

HISTORIA STRIGIDAE

Number: 42
Collect the pages of the secret book from the Court of Owls. Use AR to help you find them scattered throughout the city.

TALON CACHE

- **Unlock Requirement:** Complete Case File 06
- **Description:** Find secret locations around Gotham City that reveal hidden rewards.
- **Trackable:** No
- **Objectives:** Find the cache. Scan the bas relief. Interact with the switch.

LOCATIONS

DISTRICT	LOCATION
Bowery	Falcone Residence, Above the West Entrance
Financial District	Elliot Center Underground Mall
Gotham Heights	Gotham City University, Eastern Side of Fradon Hall
Old Gotham	Gotham City Hall, South of Fountain
Southside	Ocran Chemicals, North West Waterfront

Talon caches are secret locations all around Gotham City that never appear on the map or compass. Find the bas relief at each of the locations. You will know you're close when you hear a cue from Alfred that there is a strange energy signature nearby. Approach the bas-relief and interact with it to open the cache and claim the rewards. All five locations are available after completing Case File 06.

CRIMES

Crime is at an all-time high in Gotham City. Earn XP and other rewards by resolving them. Nearby active crimes are visible on the compass. Access the Map or Activity View to find and track revealed crimes. A variety of crimes reward the player with XP and resources when resolved. These major crimes are listed in the following pages. Petty crimes also occur throughout the city that simply reward XP and clues once criminals are defeated. Keep an eye out for criminals entangled with civilians and GCPD officers. Saving them may also satisfy challenges.

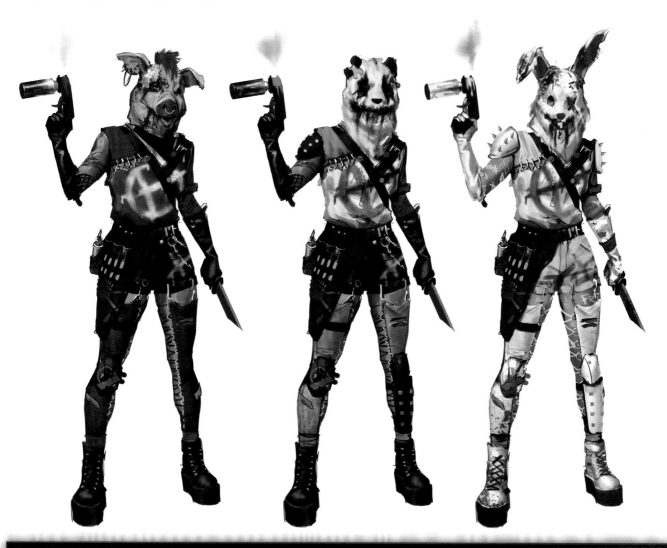

INFORMANTS AND CLUES

A white triangle on the map or compass indicates a crime with an informant. As you approach the crime, scan enemies with AR to identify the informant. To interrogate an informant you must approach them in stealth, or reduce their health significantly in combat, allowing you to grab them and press the interrogate button. This process can be interrupted, so it's a good idea to either use a stealth approach or save the informant for last. Successfully interrogating an informant reveals new ongoing crimes, or rewards you with a large amount of clues if all crimes have already been revealed. Clues are also dropped by defeated enemies. Once back at the Belfry, clues are processed by the Batcomputer to reveal crimes for your next night of patrol. The more clues you collect during a night, the more crimes will be revealed the next night and the better you can prepare.

ARMORED TRUCK ROBBERY

- **Description:** Defend the armored transport and stop the thieves.
- **Objectives:** Find the armored truck. Defeat the thieves. Stop the robbery.

At the crime location, an armored truck is being forced open, with a group of thieves ready to move bags of cash from the armored truck to their own vehicle. It only takes a few seconds for a laser drill to open the truck. At this point, $500,000 appears on-screen. Each time a criminal moves a bag of cash into their vehicle, $50,000 is subtracted from the total. When they're not moving money, they attack the player. Focus on anyone who approaches the armored truck, while defeating the criminals. When all hostiles are eliminated before the cash hits zero, the activity is a success, and the player receives the reward.

BOMB THREAT

- **Description:** Disarm the explosives on the hostages.
- **Objectives:** Reach the hostages. Disarm bombs.

A group of criminals has taken two or three civilians hostage, arming them with explosives. It's up to you to find the hostages, disarm all the bombs, and defeat everyone responsible. Sometimes, the hostiles place a camera to oversee each hostage. Fortunately, each camera has a corresponding control panel on a nearby wall. Interact with the panel to disable that camera. If the player character moves into a camera's field of vision and stays there for a few seconds, an alarm sounds. This attracts nearby hostiles and starts the bomb timer.

Use stealth to defeat the hostage takers. Some locations allow you to reach every hostile from a perch above. Silent Takedowns keep you undetected and the hostages safe. If detected, the hostile triggers the bomb timer. At this point, the hostages are the main concern. When the timer hits zero, any armed bombs detonate, injuring the attached hostages. If at least one bomb is disarmed and all hostiles are defeated, you successfully complete the crime and are rewarded.

CRIMINAL STRONGHOLD

- **Description:** Bring the fight into enemy territory, and take the criminal stronghold down.
- **Objectives:** Go to the stronghold. Retrieve items. Defeat the criminals. Perform Silent Takedowns undetected.

Each of the main factions has a criminal stronghold in Gotham City that can be taken down by the vigilantes. To get full credit for the activity, you must defeat all criminals inside the stronghold, perform a set number of Silent Takedowns, and collect evidence or free hostages. Each stronghold also holds two or three chests, so loot them before exiting the stronghold. The Freaks have set up in the planetarium in Robinson Park. The criminals hold a few hostages in cages. There are three entrances into the building, including a duct on the roof and another right of the rear entrance. Explore the second-story walkway first, for simpler Silent Takedowns, before heading downstairs for more. The Freaks are typically distracted with their vandalism, so they're often susceptible to stealth attacks. Free the hostages while defeating the Freaks on the main floor.

In northeastern West End, Electroclean, a washing machine manufacturer, is a front business for the Mob. Enter the first-floor base through one of three entry points; the rear window provides a nice vantage. Several criminals work at various locations inside the business. Although they're spread apart, some move around, so observe their routes. Beams, rails, and shelves provide great perches for the hero before dropping in for Silent Takedowns. After defeating the seven hostiles, interact with the laptops and loot the chests.

Just northwest of the Cauldron, find 8-Bit Bar. The Regulators have established the basement as a criminal stronghold. Enter through the bar, or find a busted fan southeast of the establishment. There are only a few criminals, but they're close to one another. Move quickly to get Silent Takedowns before a hostile discovers a body. Interact with the computers and loot the chests before leaving.

CRIMINAL DEAL

- **Description:** Prevent dangerous goods from falling into the wrong hands.
- **Objectives:** Reach the deal. Sabotage the deal (retrieve goods). Defeat enemies. Perform Silent Takedowns.

The Batman Family has learned that dangerous goods are being swapped between two factions. This is a great opportunity for you to keep these goods out of the wrong hands. When you arrive at the scene, a group of criminals from both factions sorts out the details for the deal. Sometimes the deal takes place out of their vehicles outside, sometimes inside the privacy of a building, and other times on a rooftop. Always the crime involves two groups of hostiles and two or three goods. To resolve the crime, all hostiles must be defeated, and you must interact with all marked goods. Performing a set number of Silent Takedowns awards a bonus. The hostiles tend to be close to one another, so plan carefully.

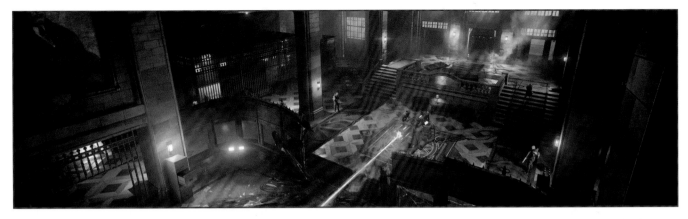

CRIME SCENE INVESTIGATIONS

- **Description:** Solve a murder.
- **Objectives:** Search the scene for clues to learn how the victim died and where the perpetrators are hiding. Mark the right clue to solve the crime.

Five clues will be present at each scene you investigate. Some will tell you more about who was killed and what happened. Read the clues carefully to discover the location where the murderers are hiding. Once all clues have been found, you will be able to mark the clue you think contains the location of your targets. To see if you're right, attempt to solve the crime. If you're unsuccessful, don't worry. You'll get another chance. With the right answer selected, solving this crime will unlock the Criminals in Hiding crime.

CRIMINALS IN HIDING

- **Description:** Defeat the criminals before they finish planning their next crime.
- **Objectives:** Go to the hideout. Possibly investigate the hideout. Defeat criminals.

Find groups of criminals hiding out at various locations around Gotham City as they plan their next crimes. Defeat the criminals to resolve the crime.

ILLEGAL HACK

- **Description:** Prevent hackers from stealing sensitive information.
- **Objectives:** Reach the hacking site. Don't let the data download reach 100%. Defeat all enemies.

Hackers have infiltrated the network of a Gotham City organization, and they're ready to steal sensitive information. It's up to you to put a stop to it. At the scene, a progress bar appears on-screen, indicating the amount of data stolen. Once the bar fills completely, the crime is failed. Security cameras are often deployed at the hacking sites, so stay out of their detection area.

A computer is always used to hack the server, and a hacker must be actively using the device to steal the information. Therefore, keep an eye on the laptop while fighting the hostiles, and focus attention on anyone who approaches it. You must defeat all enemies, while not allowing the progress bar to completely fill, to successfully finish the crime and be rewarded. The League of Shadows makes some of these encounters a challenge, so be prepared. If a camera or hostile detects the player character, reinforcements may be called in to the site. The stealthier you are, the fewer hostiles there are to defeat.

ARMED ROBBERY

- **Description:** Stop the robbery in progress and prevent the criminals from escaping.
- **Objectives:** Arrive at the heist's location. Prevent the money bags from reaching the enemies' vehicle. Defeat the criminals.

A robbery is in progress in Gotham City. Robbers attempt to move bags of money from a business to their getaway vehicle. A dollar amount appears in the middle of the screen, increasing each time a criminal delivers a bag to their car. A bank robber marked with a gear icon is currently moving money between the vault and the getaway car.

It's your job to defeat all criminals and stop the robbery before the money count maxes out. There are often multiple entry points to the crime scene, but the clock is running, so don't take too long to strategize. As usual, a stealth approach is best. Stay out of view of security cameras, or the alarm sounds. If an alarm sounds or a hostile detects the player character, the criminals attack. Finish off any remaining hostiles before they get all the cash.

If all criminals are defeated before they grab all the loot, the crime is a success, and the player is rewarded. With an active alarm, don't stick around. GCPD arrives on the scene and attacks the hero on sight. This includes the GCPD helicopter, which continues to search for the hero. Flee the area until the helicopter can no longer be heard.

OFFICERS UNDER ATTACK

- **Description:** GCPD officers are in trouble and need help.
- **Objectives:** Find the officers. Defeat the criminals. Save the GCPD officers.

GCPD officers are pinned down by criminals and require a little assistance to survive. The number of hostiles attacking the officers, as well as how many GCPD officers are present, may differ, but the idea is the same. Defeat the criminals before all officers are defeated to successfully complete the "Officers Under Attack" crime.

Police badge icons in the center of the display represent the officers. The white fill depletes as the criminals attack the GCPD. The officer is defeated once their badge depletes completely. Try to keep the officers in view when attacking the hostiles, and focus on the ones who attack the weakest officer. If all GCPD are defeated, the crime is failed. After the criminals are defeated, don't stick around. SWAT soon arrives, and they attack on sight.

PRISONER TRANSPORT ATTACK

- **Description:** Criminals are attacking a prisoner transport convoy to free the criminals inside.
- **Objectives:** Head to the prisoner convoy. Save the GCPD officer. Stop the breakout.

A prisoner transport convoy is being attacked by criminals, while the GCPD officer has been taken hostage to the side. You have two objectives here: Save the GCPD officer, and keep the criminals from breaking into the vehicle. A meter appears on-screen that represents the strength of the vehicle door. Once it maxes out, the criminals are free and the activity is failed. Focus attention on anyone attacking the doors, while also looking out for the GCPD officer. Once you find the officer, defeat the hostage taker to complete the first objective. Defeat the remaining criminals to resolve the crime and claim the reward.

Cutlines / No FX

Safe · Running out of time · Too late

ORGAN TRAFFICKING

- **Description:** Secure the stolen organs before they are moved by the criminals.
- **Objectives:** Go to the hideout. Locate and scan the cryogenic containers. Obtain the canister. Get the canister to the ambulance.

Criminals have stolen valuable organs and are ready to transport them. To resolve the crime, you must collect a cryogenic canister and deliver it to an ambulance. Quietly take down the hostiles at the hideout. Once you find the cryogenic containers, a two-minute timer begins. If the canister is not delivered before the timer hits zero, the crime is failed. The glowing canister is hard to miss; interact with it to collect the organ. Quickly travel to the ambulance location indicated by the objective marker. A couple of hostiles must be defeated before you interact with the back of the ambulance.

WITNESS UNDER ATTACK

- **Description:** Protect the vehicle or building containing the witness.
- **Objectives:** Go to the location. Protect the witness. Defeat the enemy wave.

A witness is held up inside a vehicle or building, while a group of criminals attempts to break down the door and reach them. You must protect the witness by fighting off the hostiles. A damage meter is displayed on-screen, indicating the strength of the door. If this fills completely, the door breaks down and the crime is failed. Focus attention on any criminals attacking the door. You must fight three waves of hostiles, so remain alert.

ABOUT THE AUTHORS

Michael Owen got his start at BradyGames in 1994 and transitioned into a full-time author in 2010. For almost a decade, he wrote numerous strategy guides for BradyGames and Prima Games. His guides include *God of War*, *Destiny*, *The Last of Us*, *Tomb Raider*, and *Batman: Arkham Knight*. He spends much of his time on his PC and Nintendo Switch, based out of the Indianapolis area with his wife, Michelle.

Sebastian Haley is a lifelong Pokémon trainer and the best-selling author of *Playing With Super Power* and *30 Years of Mega Man*.

SPECIAL THANKS TO THE *GOTHAM KNIGHTS* TEAM

EXECUTIVE PRODUCER

Fleur Marty

CREATIVE DIRECTOR

Patrick Redding

MARKETING

Matthieu Bagna
Pauline Zampolini

CINEMATICS TEAM

Cinematics Director: Wilson Mui
Eliott Beaudon
Manny Chatha
Jose Holder
Sara Hum
Randy Humphries
Jean-Philippe Marcotte
Alex B. O'Dowd
Daniel Payette
Marc Rosete
Manuel Vallelunga
Producer: Sabrina Jacques
Prod Coordinator: Ivana Angeleska

CONCEPT ART TEAM

Art Director: Daniel Kvasznicza
Lead: Yan Bohler
Michel Chassagne
Mathieu Duchesne
Amira Hennes
Elkhan Kildibekov
Nicolas Oroc
Mohammad Qureshi
Erkal Efe Vardar
Eric Gagnon
Ben Redekop

WRITING TEAM

Narrative Director: Ann Lemay
Associate Producer: Valerie Vezina
Lead: Ceri Young
Writers:
Li Kuo
Elize Morgan
Gabrielle Goulet
Ben Gelinas
Alix Markman
Susan Patrick
Ashley Cooper
Mitch Dyer
Cassandra Khaw

CHARACTER TEAM

Character Art Direction: Jay Evans
Lead: Yanick Desrosiers
Alexander Owen

ART

Director: Olaf Quinzaños
Director: Mathieu Houle
Martin Zhang

PRODUCTION

Producer: Bryan Theberge
Mathieu Tremblay
Anne-Kathia St-Laurent
David Miele
Célia Menier

CONCEPT

Associate Art Director: Jianli Wu
Andre-Lang Huynh
Emmanuel Julian
Krist Miha
Fred Rambaud
Adrian Wilkins
Fernando Acosta

WORLD LEVEL DESIGN

Director: Kristofor McMahan
Denis Jr Clément
Christophe St-Onge
David Alexandre Dupont
Francis Aird

MODELING

Florence Thibault
Maximilien Albert
Couture Samuel
Jing Wen Wei
Yunlong Li
Olivier Primeau
David Robert
Olivier Chatel
Pascal Beaulieu
Brad Waddingham
Frederic D'Aoust
Emil Mujanovic
Stuart Heald

GAME DESIGN

Game Director: Geoff Ellenor
Greg Belacel

OUTSOURCE PARTNERS

Keos Masons
Airship Images
OF3d
AtomHawk

INSIGHT
EDITIONS

PO Box 3088
San Rafael, CA 94912
www.insighteditions.com

Find us on Facebook: www.facebook.com/InsightEditions
Follow us on Twitter: @insighteditions

ISBN: 978-1-64722-494-3

Publisher: Raoul Goff
VP of Licensing and Partnerships: Vanessa Lopez
VP of Creative: Chrissy Kwasnik
VP of Manufacturing: Alix Nicholaeff
VP, Editorial Director: Vicki Jaeger
Design Manager: Megan Sinead-Harris
Designer: Dan Caparo
Senior Editor: Jennifer Sims
Associate Editor: Maya Alpert
Senior Production Editor: Elaine Ou
Senior Production Manager: Greg Steffen
Senior Production Manager, Subsidiary Rights: Lina s Palma-Temena

Thanks to Pauline Zampolini, Matthieu Bagna, and Ann Lemay at WB Games Montréal
for their invaluable assistance with this book.

Insight Editions, in association with Roots of Peace, will plant two trees for each tree used in the manufacturing
of this book. Roots of Peace is an internationally renowned humanitarian organization dedicated to eradicating
land mines worldwide and converting war-torn lands into productive farms and wildlife habitats. Roots of Peace
will plant two million fruit and nut trees in Afghanistan and provide farmers there with the skills and support
necessary for sustainable land use.

Manufactured in China by Insight Editions

10 9 8 7 6 5 4 3 2 1